JAMES LEE BYARS

james lee byars

leben, liebe und tod life, love, and death

Herausgegeben von
Edited by

KLAUS OTTMANN
MAX HOLLEIN

mit Beiträgen von
with contributions by

KLAUS OTTMANN
MARTINA WEINHART VIOLA MICHELY

HATJE CANTZ

INHALT CONTENTS

I MAKE YOU BELIEVE

Wie geht man mit dem Werk eines herausragenden Künstlers nach dessen Tod um, der meisterhaft in der Inszenierung der eigenen Person war und der einen unvergleichlichen Beitrag geleistet hat, um das Verhältnis von Kunstwerk und Betrachter, von Kunst und Leben zu egalisieren? »Leben, Liebe und Tod« – eine umfassende Ausstellung über das Werk von James Lee Byars versteht sich in diesem Zusammenhang als erste kritische Retrospektive, der die Abwesenheit ebendieses Künstlers, der vor sieben Jahren verstarb, durchaus anzumerken ist. Bei der Vorbereitung sind wir insofern auch der Frage nachgegangen, wie ein solch personengebundenes und performatives Œuvre wie das von Byars posthum angemessen zu präsentieren wäre. Der Künstler selbst ist bewusst ambivalent mit der Veräußerbarkeit seiner Arbeiten umgegangen: Konstatierte er 1978 noch »I cancel all my works at death«, so begann er doch ausgerechnet in dieser Zeit mit dauerhaften Materialien wie Stein oder auch Marmor zu arbeiten. Immer wieder hat er Teile seiner Werke zerstört, umbenannt, neu zusammengestellt, hat sie aber auch fest in Museen installiert und beließ sie damit in der Schwebe zwischen Flüchtigkeit und Dauer. Sein performativer Umgang mit der eigenen Kunst führte so weit, dass er 1994 der Gesellschaft für Moderne Kunst am Kölner Museum Ludwig sogar *The Perfect Smile,* das kurze Aufflackern eines Lächelns, übereignete. Diesem konzeptuellen Geniestreich ist es zu verdanken, dass erstmals eine Performance Teil einer Sammlung wurde. Zugleich drückt sich hier Byars' expliziter Wunsch aus, das Lächeln selbst über die Bindung an die eigene Person hinaus für die Zukunft ausstellbar zu machen. In unserer Präsentation gehen wir nicht nur diesem Wunsch nach, sondern sorgen dafür, dass die existenziellen Fragestellungen um Leben, Liebe und Tod, die der Künstler selbst stetig wiederholt und neu formuliert hat, über seinen Tod hinaus präsent bleiben.

James Lee Byars' Werk ist in seiner Symbiose aus Konzeptkunst, Minimalismus und Fluxus einzigartig – seine Bedeutung in der Kunstentwicklung ab den sechziger Jahren vor allem auch im europäischen Raum kann nicht hoch genug eingeschätzt werden. Der 1932 in Detroit gebo-

How does one approach the work of an outstanding artist after his death, one who was masterly in staging his own personality and who contributed incomparably to making the relationship of artwork and viewer, of art and life, one of equals? *Life, Love, and Death*—a comprehensive exhibition on the work of James Lee Byars is to be seen in this context as the first critical retrospective in which the absence of precisely that artist, who died seven years ago, is certainly noticeable. In preparing it we have also considered the question of how a performative oeuvre as linked to the artist as that of Byars can be adequately presented posthumously. The artist himself was consciously ambivalent about whether his works could be alienated from his person: in 1978 the artist stated "I cancel all my works at death." Yet in that very period he began working with enduring materials like stone and even marble. Again and again he destroyed parts of his work, renamed them, or put them together in different ways, but he also had them installed permanently in museums and thus left them hovering between the ephemeral and the enduring. His performative approach to his own art went so far that in 1994 he donated *The Perfect Smile,* the brief flickering of a smile, to the Gesellschaft für Moderne Kunst at the Museum Ludwig in Cologne. Thanks to this conceptual stroke of genius, it was the first performance to become part of a collection. At the same time this explicitly articulated Byars's desire that it be possible to exhibit the smile for the future even beyond its connection to his person. In our presentation we not only honor that wish but also ensure that the existential questions of life, love, and death that the artist himself constant repeatedly and reformulated remain present even beyond his death.

James Lee Byars's work is unique in its symbiosis of Conceptual art, Minimalism, and Fluxus. His significance for the developments in art from the sixties onward, particularly in Europe, cannot be esteemed highly enough. The artist, born in Detroit in 1932, led an almost nomadic existence between Japan, Europe, and the United States. Through his journeys, which were always accompanied by exhibitions and actions, Byars also established a lasting presence in Germany. He was represented at documenta in Kassel several times, and he was regularly exhibited by Michael Werner, also in Cologne, from

rene Künstler führte ein geradezu nomadisches Dasein zwischen Japan, Europa und den Vereinigten Staaten. Bei seinen Reisen, die immer wieder von Ausstellungen und Aktionen begleitet wurden, verschaffte sich Byars auch in Deutschland eine nachhaltige Präsenz: Hier war er mehrfach auf der *documenta* in Kassel vertreten und wurde von Michael Werner von den siebziger Jahren an regelmäßig auch in Köln ausgestellt. Byars erhielt künstlerisch wie persönlich wohlwollende Unterstützung von Sammlern, wie dem Kölner Reiner Speck und selbstverständlich auch Kuratoren wie Thomas Deecke und Jürgen Harten, die ihn in Bremen und Düsseldorf in Einzelpräsentationen würdigten. Seine ungewöhnliche Freundschaft mit Joseph Beuys fand in einer legendären Dichte an Briefen wie auch gemeinsamen Aktionen und Ausstellungsprojekten ihren Niederschlag.

Nach Byars' Tod widmete ihm die Kestner Gesellschaft 1999 in Hannover die erste – und bisher letzte – umfassendere Ausstellung in Deutschland. Nach weiteren fünf Jahren konstatiert die Schirn Kunsthalle nun unter dem Titel »Leben, Liebe und Tod« die herausragende Bedeutung des Lebenswerks von James Lee Byars und seiner Suche nach dem Erhabenen und der Konzentration auf existenzielle Fragen des Seins auch für das beginnende neue Jahrtausend. Diese Retrospektive schlägt in bisher nie gesehener Spannbreite einen Bogen von den frühen, in Japan entstandenen minimalistischen, leisen Arbeiten aus Ton, Papier oder auch Stoff zu den exaltierten Werken aus Gold, Marmor und Samt. Dabei werden einige frühe Stein- und Keramikskulpturen sowie die amerikanische Flagge aus dem Film *Two Presidents* zum ersten Mal überhaupt öffentlich gezeigt. Artverwandte Objekte wie die *Tantric Figures* werden erstmals gemeinsam präsentiert. Die überwältigende Bodeninstallation *The Red Angel of Marseille* von 1993 war zuvor noch in keinem anderen deutschen Ausstellungshaus zu sehen.

Mit höchstem kuratorischem Einfühlungsvermögen wurde die Werkpräsentation entsprechend dem inszenierten Umgang des Künstlers mit dem Rezeptionsverhalten seines Publikums konzipiert. Während bei manch anderer Ausstellung die restauratorische Sorge der künstlerischen Intention zuwiderläuft, wird hier Byars' künstlerisches Kalkül streng berücksichtigt: So wird der Blick auf manche raumgreifenden Arbeiten bewusst eingeschränkt oder durch Ton-in-Ton-Setzungen von Objekt und Umraum nivelliert. Vom Künstler selbst konzipierte Glasvitrinen unterstreichen den Anspruch des Kunstwerks auf Distanz und Wertschätzung. Oft scheint es, als setze Byars physikalische Gesetze außer Kraft: Mannsgroße Chaiselongues aus schwarzem Samt gehen eine Symbiose mit ihrem Umfeld ein, kiloschwere Marmorkugeln scheinen in purem Weiß zu schweben. Begegnet uns der Künstler hier noch mit kolossaler erhabener Geste, entzieht er sich dort bereits wieder in verschwindender Flüchtigkeit. Am Ende des Gangs durch die Ausstellung darf man

the seventies onward. Byars received kind support, both artistic and personal, from collectors like Reiner Speck in Cologne and naturally from curators like Thomas Deecke and Jürgen Harten as well, who each paid tribute to him with solo exhibitions in Bremen and Düsseldorf. His unusual friendship with Joseph Beuys was manifested in a legendary series of letters and in joint actions and exhibition projects.

After Byars's death the Kestner Gesellschaft dedicated the first—and, until now, last—comprehensive exhibition in Germany. Five years later, under the title *Life, Love, and Death,* the Schirn Kunsthalle affirms the towering significance for the incipient millennium of James Lee Byars's life oeuvre, his search for the sublime, and his concentration on existential questions of being. This retrospective describes an unprecedented span from the early quiet Minimalist works in clay, paper, or even cloth that he executed in Japan to the exalted works in gold, marble, and silk. Several early stone and ceramic sculptures and the American flag from the film *Two Presidents* are exhibited for the first time ever. Related objects like the *Tantric Figures* are shown together for the first time. The overpowering floor installation *The Red Angel of Marseille* of 1993 has never been seen before in a German exhibition.

With the greatest possible curatorial empathy, the presentation of the work has been conceived in accordance with the artist's dramatic approach to the ways in which his audience received the works. Whereas in some other exhibitions, concerns about conservation can run counter to the artistic intention, here Byars's artistic calculation is very much taken into account. For example, the prospect on some of the more expansive works has been deliberately restricted, or leveled out by means of tone-in-tone settings of objects and environment. Display cases that the artist conceived himself emphasize the artwork's claim to distance and appreciation. It often seems as if Byars repealed the laws of physics: full-size chaise longues of black silk form a symbiosis with their surroundings, a marble sphere weighing several kilos seems to float in pure white. If the artist confronts us with colossal, sublime gestures here, there he withdraws again in vanishing ephemerality. After passing through the exhibition one can see, but not enter, a room titled *The Death of James Lee Byars*, which is entirely lined in gold leaf.

To the individual lenders, both institutions and private collectors, we owe extraordinary thanks for the trust they have shown us and this ambitious exhibition project: in New York, the Whitney Museum of American Art and Miani Johnson; in Paris, the Fonds national d'art contemporain and the Galerie de France; the IVAM, Instituto Valenciano de Arte Moderno, Generalitat Valenciana; the Magasin 3 Stockholm Konsthall; in Brussels, Marie-Puck Broodthaers; in Torhout, Walter Vanhaerents; in Vaduz, the Kunstmuseum Liechtenstein; in Berlin, the Sammlung Hoffmann; the Staatsgalerie Stuttgart; in Bremen, the Neues Museum Weserburg and the Sammlung Tu; in Cologne, the Gesellschaft für Moderne Kunst am Museum Ludwig and especially Reiner Speck.

The Death of James Lee Byars, einen so betitelten Goldraum, zwar einsehen, nicht aber betreten.

Wir sind jedem einzelnen Leihgeber – den Institutionen wie den Privatpersonen – zu außerordentlichem Dank für das Vertrauen verpflichtet, das sie uns und diesem ehrgeizigen Ausstellungsprojekt durch ihre Zusage entgegengebracht haben: in New York dem Whitney Museum of American Art und Miani Johnson, dem Fonds national d'art contemporain und der Galerie de France in Paris, dem IVAM, Instituto Valenciano de Arte Moderno, Generalitat Valenciana, dem Magasin 3 Stockholm Konsthall, in Brüssel Marie-Puck Broodthaers, in Torhout Walter Vanhaerents, dem Kunstmuseum Liechtenstein in Vaduz, der Sammlung Hoffmann in Berlin, der Staatsgalerie Stuttgart, dem Neuen Museum Weserburg und der Sammlung Tu in Bremen, der Gesellschaft für Moderne Kunst am Museum Ludwig, Köln sowie insbesondere auch Reiner Speck in Köln.

Vor allen anderen seien hier aber Michael Werner wie die Mitarbeiter seiner Galerien in Köln und New York genannt, die den Nachlass von James Lee Byars verwalten und uns nicht nur mit zahlreichen Leihgaben, sondern zu jeder Zeit mit fachkundigem Rat zur Seite standen. Ich möchte mich sehr herzlich für diese gute Zusammenarbeit bedanken. Gwendolyn Dunaway, die Witwe des Künstlers, hat unser Ausstellungsvorhaben von Anfang an mehr als begrüßt und damit unverzichtbare Weichen für dessen Verwirklichung gelegt.

Ganz besonderen Dank möchte ich an den Gastkurator Klaus Ottmann aus New York richten, der den Anstoß zu diesem Projekt gab und das Konzept erstellte und auch für die Kataloggestaltung verantwortlich ist. Diese Ausstellung ist das Resultat seiner langjährigen Arbeit mit dem Werk dieses Künstlers, und ich freue mich über die hervorragende Zusammenarbeit, die zur Realisation dieser wichtigen Ausstellung geführt hat.

Gedankt sei auch den weiteren Autoren für ihre kenntnisreichen Beiträge im Katalog: der Kunsthistorikerin und Byars-Expertin Viola Michely sowie Martina Weinhart, Kuratorin an der Schirn Kunsthalle.

Nur durch die finanzielle Unterstützung hochrangiger und international agierender Unternehmen wird uns als Kunsthalle die Realisierung eines solch aufwändigen Projektes ermöglicht. Wir danken hier der Kultur-Stiftung der Deutschen Bank, insbesondere Tessen von Heydebreck und Michael Münch, sowie auch der ŠkodaAuto Deutschland GmbH, namentlich Nikolaus Reichert und Christoph Ludewig, für die fortwährende Unterstützung und das große Interesse an unserer Arbeit. Besonderer Dank gilt auch unserem Medienpartner hr2 – das Kulturradio des Hessischen Rundfunks. Gedankt sei außerdem Swarovski für die großzügige Leihgabe von fünf Kristallen aus der eigenen Kollektion für den Goldraum *The Death of James Lee Byars* und schließlich den Mitglie-

Above all, however, we wish to mention Michael Werner and his colleagues in his galleries in Cologne and New York, who administer the estate of James Lee Byars and who not only provided numerous loans but were always at our side with expert advice. I would like to express my sincere thanks for this excellent collaboration. Gwendolyn Dunaway, the artist's widow, was more than welcoming to the exhibition plan from the beginning and cleared the path for its realization in indispensable ways.

I would like to offer special thanks to New York-based guest curator, Klaus Ottmann, who provided the impetus for this project, drew up the proposal, and has been responsible for the catalogue. This exhibition is the result of his working with the artist's oeuvre for many years, and I am pleased that our outstanding cooperation led to the realization of this important exhibition.

Thanks are also due to the other authors for their knowledgeable contributions to the catalogue: the art historian and Byars expert Viola Michely as well as Martina Weinhart, curator at the Schirn Kunsthalle.

The realization of such an elaborate project at the Schirn is only possible with the financial support of distinguished international companies. We are grateful to the Cultural Foundation of Deutsche Bank, especially Tessen von Heydebreck and Michael Münch, as well as ŠkodaAuto Deutschland GmbH, namely, Nikolaus Reichert and Christoph Ludewig, for their continued support and great interest in our work. Special thanks also go to our media partner Hessischer Rundfunk, Cultural Channel hr2. We are especially grateful that Swarovski generously agreed to lend us five crystals from its own collection for the golden room *The Death of James Lee Byars* and that the friends of the Schirn Kunsthalle e. V. gave their support in realizing the *Rose Table of Pefect*.

Naturally, as with every exhibition, our gratitude goes to the city of Frankfurt and, as a representative for all its policy makers, its mayor, Petra Roth, and the head of its cultural department, Hans-Bernhard Nordhoff, for making our work possible in the first place.

The team at the Schirn Kunsthalle Frankfurt has once again demonstrated its complete dedication in all phases of the exhibition's preparation and execution: Martina Weinhart and Carla Orthen have shown great enthusiasm from the beginning in attending to this complex project. For their outstanding support and their highly professional curatorial contribution to the exhibition and catalogue, I owe them profound appreciation.

My thanks also go to Ronald Kammer and his team for technical direction, to Karin Grüning and Elke Walter for organizing the loans, to Andreas Gundermann and the installation team, and to Stefanie Gundermann for supervising the conservation. A special thanks to Inka Drögemüller, Lena Ludwig, and Tanja Schuchardt as well, for the marketing of the exhibition and attending to the sponsors and partners, to Dorothea Apovnik and Jürgen Budis for the publicity work, and also to Simone Boscheinen, who was responsible, along with Irmi

dern des Vereins der Freunde der Schirn Kunsthalle e. V., die bei der Realisation des *Rose Table of Perfect* mitgewirkt haben.

Selbstverständlich gilt unser Dank wie bei jeder Ausstellung der Stadt Frankfurt und stellvertretend für alle Entscheidungsträger der Oberbürgermeisterin Petra Roth und dem Kulturdezernenten Hans-Bernhard Nordhoff, die unsere Arbeit überhaupt erst ermöglichen.

Erneut hat das Team der Schirn Kunsthalle in Frankfurt am Main höchstes Engagement in allen Phasen der Ausstellungsvorbereitung und -durchführung bewiesen: Martina Weinhart und Carla Orthen haben dieses komplexe Projekt von Anfang an mit großem Enthusiasmus betreut. Für ihre herausragende Arbeit und ihre äußerst professionelle kuratorische Beteiligung an Ausstellung und Katalog möchte ich ihnen herzlich danken.

Gedankt sei ebenso Ronald Kammer und seinem Team für die technische Leitung, Karin Grüning und Elke Walter für die Organisation der Leihgaben, Andreas Gundermann und dem Hängeteam sowie Stefanie Gundermann für die restauratorische Betreuung. Besonderer Dank gilt auch Inka Drögemüller, Lena Ludwig und Tanja Schuchardt für das Marketing zur Ausstellung und die Betreuung der Sponsoren und Partner, Dorothea Apovnik und Jürgen Budis für die Pressearbeit, darüber hinaus Simone Boscheinen, die mit Irmi Rauber für das pädagogische Programm verantwortlich ist, Klaus Burgold, Katja Weber und Selina Reichardt für die Abwicklung in der Verwaltung und nicht zuletzt Hanna Alsen für ihre Unterstützung in zahlreichen Belangen.

Kai Krippner und sein Grafikteam vom Atelier Krippner haben bei der Gestaltung der Werbekampagne kreativen Einsatz und Professionalität gezeigt. Mark Michael Maier und Stefan Kaulbersch von Enorm waren für die ausgezeichnete grafische Umsetzung der Dokumentationswand innerhalb der Ausstellung verantwortlich. Ausdrücklicher Dank geht schließlich auch an den Hatje Cantz Verlag, insbesondere an Ute Barba, Christiane Wagner und Tas Skorupa für das wie immer zuverlässige Lektorat.

Rauber, for the education program and to Klaus Burgold, Katja Weber, and Selina Reichardt handling administration, and not least to Hanna Alsen for her assistance in numerous matters.

Kai Krippner and his team of graphic artists at Atelier Krippner have demonstrated their creative dedication and professionalism in designing the advertising campaign. Mark Michael Maier und Stefan Kaulbersch at Enorm were responsible for the outstanding graphic design of the documentation wall in the exhibition. Finally, our express thanks goes also to Hatje Cantz Publishers, in particular to Ute Barba, Christiane Wagner, and Tas Skorupa for their always reliable editorial work.

. . . But to apprehend
The point of intersection of the timeless
With time, is an occupation for the saint—
No occupation either, but something given
And taken, in a lifetime's death in love,
Ardour and selflessness and self-surrender.
For most of us, there is only the unattended
Moment, the moment in and out of time . . .

T. S. Eliot, from: "The Dry Salvages" (*Four Quartets*)

... Jedoch den Punkt,
Wo sich Zeitloses schneidet mit Zeit, zu erkennen,
Ist eine Beschäftigung für Heilige –
Nicht Beschäftigung nur, etwas, das gegeben
Und genommen wird durch das Absterben eines ganzen Lebens
In Liebe, Eifer, Selbstlosigkeit und Selbstentäußerung.
Die meisten von uns kennen nur den einzelnen absichtslosen
Augenblick, den Augenblick in und außer der Zeit, ...

T. S. Eliot, aus: »The Dry Salvages« (*Vier Quartette*)

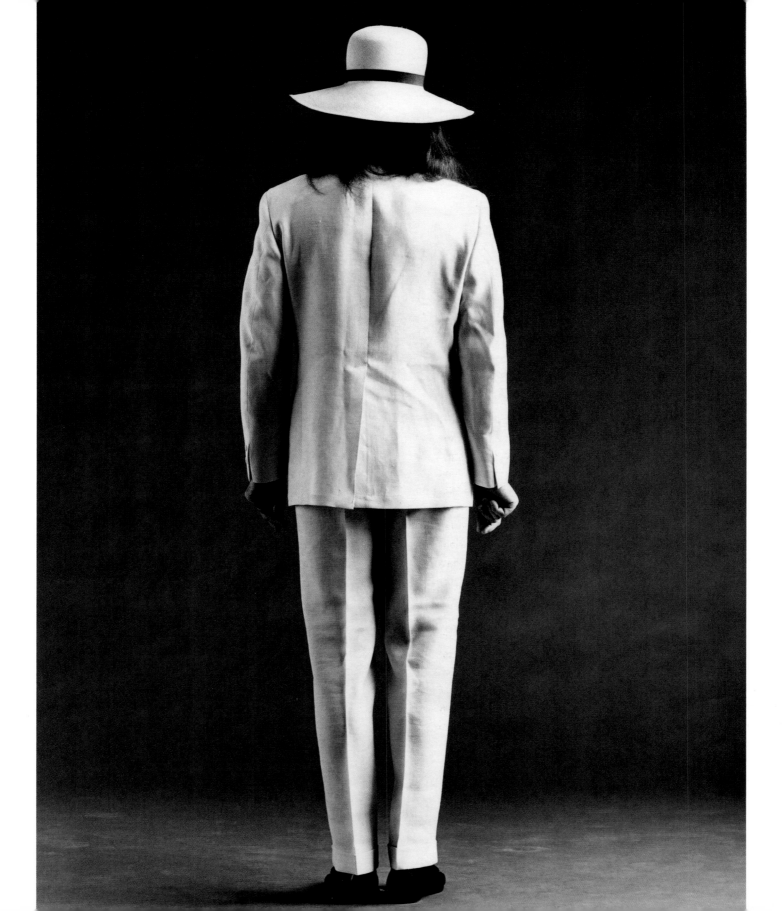

EPIPHANIEN DER SCHÖNHEIT UND DES WISSENS
DIE LEBENSWELT DES JAMES LEE BYARS

KLAUS OTTMANN

EPIPHANIES OF BEAUTY AND KNOWLEDGE
THE LIFE-WORLD OF JAMES LEE BYARS

Das Leben des Künstlers

»Jeder Mensch ist ein einmaliger Mensch und tatsächlich für sich gesehen, das größte Kunstwerk aller Zeiten.«
Thomas Bernhard, *Der Untergeher* (1983)

In seinem Essay »Tradition und individuelle Begabung« schreibt T. S. Eliot: »Je vollkommener der Künstler ist, um so entschiedener wird sich ihm eine Kluft auftun zwischen dem erlebenden Menschen und dem schaffenden Geiste; um so vollkommener wird der letztere die Leidenschaften, die seinen Stoff bilden, in sich verarbeiten und verwandeln.«[1] In seinem Testament legte Eliot fest, dass nie eine Biografie über ihn geschrieben werden dürfe. Er war der Ansicht, dass das Leben eines Dichters so sehr in das Werk einfließe und es durchdringe, dass es einer eigenen Beschreibung nicht bedürfe. Anders als bei dem älteren W. B. Yeats, der schrieb, dass der Intellekt des Mannes dazu gezwungen sei, die Vollkommenheit des Lebens oder die der Arbeit zu wählen, wird die Frage über das Verhältnis zwischen täglichem Leben und kreativer Arbeit nie von Eliot aufgeworfen.

Diese Fragestellung trifft in hohem Maße auch auf den Künstler, Poeten und Philosophen James Lee Byars zu. Wie Eliot glaubte auch Byars an eine Präsenz des Vollkommenen, an den vollkommenen Künstler, der sein Leben völlig in sein Werk aufnimmt. James Lee Byars (1932–1997) studierte Kunst, Psychologie und Philosophie an der Wayne State University in seiner Heimatstadt Detroit. In den späten fünfziger Jahren verließ er Detroit, um in Kyoto, Japan, zu leben. Die folgenden zehn Jahre verbrachte er abwechselnd in Japan und Amerika und lebte nach seiner endgültigen Rückkehr aus Japan zeitweise in New York, Venedig, Florenz, Bern und Santa Fe. In Japan hatte er das Ephemere als eine eigene Qualität in der Kunst kennen gelernt und übernahm das

The Life of the Artist

"Each human being is entirely unique, and each is the greatest work of art ever created."
Thomas Bernhard, *The Loser* (1983)

In his essay "Traditional and Individual Talent," T. S. Eliot wrote, "The more perfect the artist, the more completely separate in him will be the man who suffers and the mind which creates; the more perfectly will the mind digest and transmute the passions which are its material."[1] In his will, Eliot stipulated that no biography of his life was ever to be written. He believed that his life was in his poetry and that books alone constituted the life of the poet. Unlike the elder W. B. Yeats, who wrote that "The intellect of man is forced to choose / Perfection of the life, or, of the work," the question about the relationship between everyday life and creative work is never raised by Eliot.

This is even more true about the American artist, poet, and philosopher James Lee Byars. Like Eliot, Byars believed in the presence of perfect, in the perfect artist whose life is entirely absorbed into his work. James Lee Byars (1932–97) studied psychology, philosophy, and art at Wayne State University. In the late fifties he left his hometown, Detroit, to live in Kyoto, Japan, shuttling back and forth for the next ten years. After his final return from Japan he resided, at one time or another, in New York, Venice, Florence, Bern, and Santa Fe. In Japan he learned to appreciate the ephemeral as a valued quality in art and adopted the ceremonial as a continuing mode in his life and work, which became inseparable. During these formative years, Byars adapted the highly sensual, abstract, and symbolic practices found in Japanese Noh theater and Shinto rituals (often involving folded white papers or uncarved stones) to Western science, art, and philosophy. Known for his luxurious and enigmatic objects and his pursuit of the "perfect," which originated from a unique synthesis of Oriental practices, Conceptual art, Minimalism, and Fluxus, infused

Zeremoniell als eine seine Einheit von Leben und Werk bestimmende Modalität. In diesen prägenden Jahren übertrug Byars die sinnlichen, abstrakten und symbolischen Praktiken des japanischen No-Spiels und der Shinto-Rituale (in denen oft gefaltetes, weißes Papier oder unbehauene Steine eine Rolle spielen) auf die Wissenschaft, Kunst und Philosophie des Westens. Bekannt geworden durch seine luxuriösen und rätselhaften Objekte und sein Drängen nach »Vollkommenheit«, das einer einzigartigen Synthese aus orientalischen Praktiken, Concept Art, Minimalismus und Fluxus entsprang, angereichert mit Aspekten aus Happening, Body Art und Installation Art, ist Byars heute als eine der Hauptfiguren der Kunst des 20. Jahrhunderts anerkannt.

Auch wenn Byars kaum jemals das Schreiben seiner Biografie untersagt hat, ist doch bis auf die lückenhafte »Memorabilia«[2] bislang keine geschrieben worden. Für den Katalog zu der Ausstellung *James Lee Byars, Der Palast der Philosophie* (Kunsthalle Düsseldorf, 1986), von Jürgen Harten begonnen, wurde der Text der »Memorabilia« von James Elliott ergänzt und 1990 unter dem Titel »Notes towards a Biography« im Anhang des Kataloges zur Ausstellung von Byars' Werken im University Art Museum von Berkeley veröffentlicht. Beide Darstellungen basieren auf größtenteils anekdotischem Material, das vom Künstler selbst oder aus seinem Umkreis stammt. Jeder Umstand seiner Biografie wurde mit seinem Wirken als Künstler in Verbindung gesetzt und mit dokumentarischen Fotos seiner Performances und Installationen illustriert. Als peripatetischer Künstler bewahrte Byars nur wenige Aufzeichnungen auf; erhaltene schriftliche Notizen und Briefe befinden sich im Besitz seiner vielen Freunde und Förderer auf der ganzen Welt. (Der größte Teil seiner dokumentarischen Fotografien aus seiner privaten Sammlung ging 1971 verloren, nachdem er sie an die Zeitschrift *Newsweek* geschickt hatte.) In Byars' Werk sind autobiografische Anklänge jedoch im Übermaß vorhanden: Er sammelte die aus jeweils einem einzelnen Satz bestehenden Autobiografien von 50 Personen; im Alter von 37 Jahren (damit war die Hälfte der Lebenserwartung eines Amerikaners erreicht) schrieb er ferner seine »halbe Autobiografie« *(1/2 an Autobiography)* und produzierte einen »Film« mit

with aspects of the happening, body and installation art, Byars is now recognized as a major figure in twentieth-century art.

Although Byars never objected to any biographies being written about him, no definite account of his life has so far been undertaken, with the exception of the sketchy *Memorabilia: A Necessarily Incomplete List of Works with Notes for a Chronology of Almost Forgotten Circumstances in the Life of James Lee Byars.* Begun by Jürgen Harten on the occasion of the exhibition "James Lee Byars: The Philosophical Palace" at the Städtische Kunsthalle, Düsseldorf, in 1986, and included in the accompanying catalogue, it was amended by James Elliott in 1990 and published under the title *Notes toward a Biography* in the catalogue for his survey of Byars's works at the University Art Museum in Berkeley. Both accounts were based on mostly anecdotal evidence supplied by the artist and his circle of friends and supporters. Every aspect of his biography was related to Byars's practice as an artist and illustrated by numerous documentary photographs of his performances and installations. A notoriously peripatetic artist, Byars kept few notes, and any records and letters that survived are dispersed among his many friends and supporters all over the world. (The majority of documentary photographs in his personal collection were lost in 1971, after he sent them to *Newsweek* magazine.) The notion of autobiography, however, is very much in evidence in Byars's works. He collected single-sentence autobiographies by fifty individuals, wrote *1/2 an Autobiography* at the age of thirty-seven (half the life-expectancy of the American man), and even produced a film entitled *Autobiography (*1970). Always in need of money to finance his travels to Japan, he early on submitted autobiographical lists of his accomplishments to various foundations, such as the John Simon Guggenheim Memorial Foundation, in order to receive grants. This early practice already manifests signs of his later fondness for hyperbolic and eccentric statements. For example, on his 1961 Guggenheim application he wrote,

My current exhibition materials weigh 16 kg, one suitcase full. I am equipped to handle time from 1/2500 MS up and single objects areas 1/2 cm to 800 ground feet.[2]

Byars employed a strategy of distancing, cloaking, and anonymity,

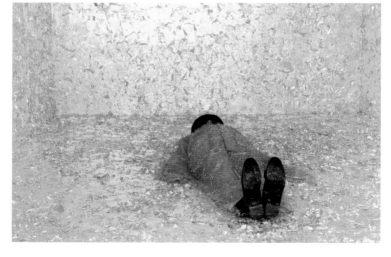

THE DEATH OF JAMES LEE BYARS **DER TOD DES JAMES LEE BYARS**
PERFORMANCE GALERIE MARIE-PUCK BROODTHAERS, BRUSSELS **BRÜSSEL** 1994

dem Titel *Autobiography* (1970). Um seine Reisen nach Japan zu finanzieren, stellte er schon früh für einige Stiftungen, wie die John Simon Guggenheim Memorial Foundation, autobiografische Auflistungen seiner künstlerischen Erfolge auf, um so in den Genuss von Fördermitteln zu kommen. In dieser frühen Praxis zeigen sich bereits Vorboten seiner späteren Begeisterung für übertriebene und exzentrische Äußerungen. In der Bewerbung für die Guggenheim Foundation 1961 schrieb er:

»Mein augenblickliches Ausstellungsmaterial wiegt 16 kg und passt in einen Koffer. Ich bin in der Lage, Zeiten ab einer 1/2500 ms und Einzelobjekte mit einer Grundfläche zwischen 1/2 cm und 800 Fuß zu bearbeiten.«[3]

Byars legte sich eine Strategie des Distanzierens, Verschleierns und Anonymisierens zu, die an Kierkegaards Gebrauch von Pseudonymen erinnert. In seiner »Abschließenden unwissenschaftlichen Nachschrift« schreibt Kierkegaard: »Meine Pseudonymität oder Polyonymität hat keinen *zufälligen* Grund in meiner *Person* gehabt [...], sondern einen *wesentlichen* Grund in der *Produktion* selbst [...] Ich bin nämlich unpersönlich oder persönlich in dritter Person ein Souffleur, der *dichterisch Verfasser* hervorgebracht hat, deren *Vorworte,* ja deren *Namen* wieder ihre Produkte sind. So ist in den pseudonymen Büchern nicht ein einziges Wort von mir selbst; nur als Dichter habe ich eine Meinung über sie, nur als Leser ein Wissen von ihrer Bedeutung, ich habe nicht das entfernteste private Verhältnis zu ihnen.«[4]

Byars' Absicht war es, ähnlich wie es Kierkegaard durch seine indirekte Kommunikation anstrebte, als eigenständige Person zu verschwinden, um so die Aufmerksamkeit ausschließlich auf das reine, flüchtige Moment des IST, des Im-Moment-Seins, zu lenken. Seine Akte des Verschwindens nahmen vielfältige Formen an. In den frühen sechziger Jahren schenkte er einige Werke Museen, unter anderem dem Carnegie Museum of Art in Pittsburgh und dem Museum of Modern Art in New York, immer mit der Auflage, den Künstler als »unbekannt« und das Werk als »ohne Titel« zu führen. (Erst später betitelte er die meisten seiner Arbeiten und gab die Erlaubnis, sie unter seinem Namen auszustellen.) Bei der *documenta 5* im Jahr 1972 stand Byars auf dem Tympanon des Museums Fridericianum in Kassel, den unten stehenden Menschen den Rücken zugewandt, oder er saß in rote Seide gehüllt in einem Baum und rief den Passanten deutsche Vornamen (Pseudonyme?) durch ein Megafon zu. Byars' frühe Strategien der Anonymität und des Verschwindens deuten bereits auf seine Beschäftigung mit dem Thema Tod in den späteren »Todesarbeiten«. Diese begannen 1975 mit der Arbeit *The Perfect Epitaph,* als er in Bern zusammen mit seiner ständigen

reminiscent of Kierkegaard's use of pseudonyms. In *Concluding Unscientific Postscript* (1846), Kierkegaard wrote, "My pseudonymity or polyonymity has not had an *accidental* basis in my person . . . but an *essential* basis in the *production* itself . . . I am impersonally or personally in the third person as a *souffleur* [prompter] who has poetically produced the *authors,* whose *prefaces* in turn are their productions, as their *names* are also. Thus in the pseudonymous books there is not a single word by me. I have no opinion about them except as a third party, no knowledge of their meaning except as a reader, not the remotest private relation to them."[3]

Byars's intention, like Kierkegaard's indirect communication, was to make himself "disappear" in order to focus attention exclusively to the pure, fleeting moment of IS, the being-present. His disappearing acts assumed many forms. In the early sixties he donated a number of works to museums, including the Carnegie Museum of Art in Pittsburgh and the Museum of Modern Art in New York, always with the stipulation that the artist be listed as "anonymous" and the works as "untitled." (Only later did he title most of the works and give permission to use his name.) In 1972, during "documenta 5" Byars stood on the tympanum of the Museum Fridericianum in Kassel with his back turned to the onlookers below, or sat high up in a tree, cloaked in red silk, shouting German first names (pseudonyms?) through a megaphone at the passersby. This early strategy of anonymity and disappearance is related to his later death works. Byars started dealing with the theme of death in 1975 with *The Perfect Epitaph,* a work performed in Bern, where he rolled a red lava rock through town, with his companion, B. B. (Bibi) Grögel, at his side. During a performance in 1984, *The Perfect Death of James Lee Byars,* Byars lay on the gold-painted ground in front of the Philadelphia Museum of Art in one of his gold-lamé suits. The effect of gold on gold made his body "invisible." This effect was repeated ten years later in Brussels with the installation *The Death of James Lee Byars* at the Galerie Marie-Puck Broodthaers.

He once proclaimed, "I cancel all my works at death." Or he demanded, "Never show them again." Part strategy of disappearance, part implacable honesty, these statements recall T. S. Eliot's paradoxical phrase, "The Poetry does not matter." The life of the poet-artist does matter, and for Byars, the life of the artist also includes living his death. In 1994 Byars presented the performance *The Perfect Smile* to the Museum Ludwig in Cologne, as a gift with the request that it be exhibited like any other work in its collection. Again he dressed in gold lamé, wearing a black top hat, black gloves and shoes, and a black silk scarf wrapped around his head, which obscured his eyes and most of his face, except for parts of his mouth and nose. The performance consisted of a very subtle movement of his mouth to indicate the briefest smile possible, before it vanished from his face.

Begleiterin B. B. (Bibi) Grögel eine Kugel aus rotem Lavastein durch die Straßen rollte. Bei der Performance *The Perfect Death of James Lee Byars* (1984) legte er sich, in einen seiner Goldlamé-Anzüge gekleidet, auf den mit Goldfarbe bemalten Boden vor dem Philadelphia Museum of Art. Sein Körper schien dabei zu verschwinden. Diesen Effekt wiederholte er zehn Jahre später in Brüssel bei der Eröffnung der Installation *The Death of James Lee Byars* in der Galerie Marie-Puck Broodthaers.

Einmal erklärte er: »Ich lösche alle meine Werke mit dem Tod aus.« Und er verlangte: »Zeigt sie niemals wieder!« Einerseits sind diese Äußerungen Teil der Strategie des Verschwindens, andererseits zeugen sie von unerbittlicher Ehrlichkeit und verweisen auf den paradoxen Satz von T. S. Eliot: »Die Dichtung ist nicht wichtig.« Das Leben des Dichters und Künstlers ist wichtig, und für Byars war es die Lebensaufgabe des Künstlers, seinen Tod zu leben. 1994 schenkte Byars dem Museum Ludwig in Köln die Performance *The Perfect Smile* mit der Auflage, sie wie jedes andere Werk der Sammlung auszustellen. Er war wiederum in Goldlamé gekleidet, trug einen schwarzen Hut, schwarze Handschuhe und Schuhe und einen schwarzen Seidenschal um den Kopf geschlungen, der seine Augen und den größten Teil seines Gesichtes bis auf Mund und Nase verhüllte. Das perfekte Lächeln bestand aus einer winzigen Bewegung des Mundes, die das kürzestmögliche Lächeln darstellte, bevor es von dem Gesicht verschwand.

Mythologien

»Ich lese [...] von einem Regenkönig in Afrika, zu dem die Leute um Regen bitten, *wenn die Regenperiode kommt.* Aber das heißt doch, dass sie nicht eigentlich meinen, er könne Regen machen, sonst würden sie es in den trockenen Perioden des Jahres, in der das Land ›a parched and arid desert‹ ist, machen [...] Der Unsinn ist hier, dass Frazer es so darstellt, als hätten diese Völker eine vollkommen falsche (ja wahnsinnige) Vorstellung vom Lauf der Natur, während sie nur eine merkwürdige Interpretation der Phänomene besitzen. Das heißt, ihre Naturerkenntnis, wenn sie sie niederschrieben, würde von der unseren sich nicht *fundamental* unterscheiden. Nur ihre *Magie* ist anders.«
Ludwig Wittgenstein, *Bemerkungen über Frazers »The Golden Bough«* (1931)

Die rechte und die linke Hemisphäre des Gehirns sind durch Bündel dicker Nervenstränge, das *Corpus callosum,* miteinander verbunden.

Mythologies

"I am reading . . . about a rain king in Africa, whom the people ask for rain *at the beginning of the rain season.* But that means that they don't really believe that he could make rain, otherwise they would do it during the dry periods of the year, when the land is 'a parched and arid desert.' . . . The nonsense here is that Frazer represents it as if these people had a totally wrong (even mad) idea of the way of nature whereas they only possess a strange interpretation of the phenomena. That is, their knowledge of nature, if written down, would not differ *fundamentally* from ours. Only their magic is different."
Ludwig Wittgenstein, *Remarks on Frazer's "The Golden Bough"* (1931)

The right and the left hemispheres of the brain are connected by a massive tract of nerve bundles, the *corpus callosum,* through which information flows from one side of the brain to the other. In severe cases of epilepsy, the *corpus callosum* is severed in order to prevent seizures that begin in one hemisphere from spreading to the other. This procedure is highly efficient and has no effects on personality, mood, or behavior of the patients but leaves them unable to name anything that lies within their left visual field (which is linked to the right, nonverbal brain). When a command is flashed to the right brain, the patient will execute that command but, because the separated left brain that controls language and general cognition is unaware of the command, it will provide a confabulatory explanation. The neuropsychologist Michael S. Gazzaniga, who carried out a pioneering series of studies on split-brain patients, attributes the formation of religious beliefs and philosophical ideas to the brain's capacity for invention: "Our species has a special brain component I will call the 'interpreter.' . . . This special capacity, which is a brain component found in the left dominant hemisphere of right-handed humans, reveals how important the carrying out of the behaviors is for the formation of many theories about the self. The dynamics that exist between our mind modules and our left-brain interpreter are responsible for the generation of human beliefs."[4]

Byars was a master fabulist. In his art and life, events became legends and legends turned into myths. An admirer of Roland Barthes, much of his work as an artist was defined by and dependent on the invention of a metalanguage of mythologies. When I met with Byars at Mary Boone/Michael Werner Gallery in New York during his 1988 exhibition, he pointed at the gallery walls, which were painted a deep red, and told me excitedly how he had Puerto Rican girls wearing red lipstick kiss the walls. Another example of his tendency to exaggerate was his description of a dinner given in his

Hierdurch fließen die Informationen von einer Hirnhälfte in die andere. In schweren Fällen von Epilepsie wird das *Corpus callosum* durchtrennt, um so das Übergreifen eines epileptischen Anfalls von einer Hälfte des Gehirns auf die andere zu verhindern. Dieses medizinisch sehr wirkungsvolle Verfahren hat keine Auswirkungen auf die Persönlichkeit, die Stimmung oder das Verhalten des Patienten, es macht es ihm jedoch unmöglich, etwas zu benennen, das sich in seinem linken Gesichtsfeld befindet (das mit der rechten, nonverbalen Hirnhälfte gekoppelt ist). Empfängt die rechte Gehirnhälfte einen Befehl, wird der Patient diesen zwar ausführen, aber da die linke abgetrennte Hirnhälfte, die für Sprache und kognitive Verarbeitung zuständig ist, von diesem Befehl nichts weiß, wird sie eine einleuchtende, aber erfundene Erklärung bieten. Der Neuropsychologe Michael S. Gazzaniga, der als einer der ersten Untersuchungen an Patienten mit isolierten Gehirnhälften durchgeführt hat, schreibt die Ausbildung von religiösen Überzeugungen oder philosophischen Ideen der Erfindungsfähigkeit des Gehirns zu. »Unsere Spezies verfügt über eine spezielle Hirnkomponente, die ich als ›Interpreten‹ bezeichnen möchte [...] Diese spezielle Fähigkeit – eine Gehirnkomponente, die bei Rechtshändern der dominanten linken Gehirnhälfte zugeordnet wird – zeigt, wie wichtig das Ausführen von Verhaltensweisen für die Bildung vieler Theorien über uns selbst ist. Die zwischen den Modulen unseres Geistes und unserem Interpreten-Modul in der linken Gehirnhälfte wirksame Dynamik ist verantwortlich für die Entstehung von Überzeugungen.«[5]

Byars war ein Meister der Fabulierkunst. Die Ereignisse in seiner Kunst und seinem Leben wurden zu Legenden und diese Legenden wurden zu Mythen. Als Bewunderer von Roland Barthes definierte sich ein Großteil seiner künstlerischen Arbeit durch die Metasprache der Mythologien und hing gleichzeitig von deren Erschaffung ab. So erzählte mir Byars 1988 begeistert, dass die tiefroten Wände bei seiner Ausstellung in der Mary Boone/Michael Werner Gallery in New York ihre Farbe der Tatsache verdankten, dass er puerto-ricanische Mädchen eingeladen habe, die Wände mit ihren Lippenstiftmündern zu küssen. Ein weiteres Beispiel seines Hangs zur Übertreibung war die Beschreibung eines Essens, das zu seinen Ehren gegeben worden war und an dem ich, obwohl eingeladen, nicht hatte teilnehmen können. Er erzählte mir nachher, dass die einzige Speise, die bei diesem Essen gereicht worden war, eine goldene Kugel (sein Selbstporträt) gewesen sei; diese war nach seinen Anweisungen so hergestellt worden, dass sie das menschliche Verdauungssystem in genau zwanzig Minuten passieren konnte und nach Reinigung von jedem Gast geschluckt wurde. Wer mit Byars in Kontakt kam, wurde absichtlich oder unabsichtlich zum Mitwirkenden – als Zuhörer seiner fantasievoll ausgeschmückten

honor, to which I was invited but which I was unable to attend. He told me afterwards how the only food served at the dinner was a small golden sphere (his self-portrait), made to his specification to pass through the human digestive system in exactly twenty minutes. After being cleaned, the sphere was swallowed consecutively by each guest. Everyone who ever came in contact with Byars has wittingly or unwittingly participated in Byars's tales—by listening to his stories, witnessing his performances, or by passing on what they heard or saw to others, often at the request of the artist. It was in part a form of participatory art and in part Byars's strategy of promoting himself. A 1975 letter by the Bern gallery owner Toni Gerber addressed to the De Appel Center for Contemporary Art in Amsterdam and the Galerie Germain in Paris illustrates this twofold action. The letter begins with, "it is james lee byars' urgent wish that i give you a report of a very strange and very beautiful thing that he did last sunday in the old city . . ." It continues with a description of his performance *The Perfect Epitaph* and ends with a plea to his addressees to finance a similar performance in Amsterdam and Paris, respectably: "james now has the urgent wish to have the perfect epitaph become an event in amsterdam and paris too. but that means that we gallery owners share the cost . . . at last, this presents something that can be sold, together with the accompanying photodocumentation."[5]

The Europe and America of today are much like two sides of a brain that was separated long ago by "split-brain surgery." Just like the sectioned brain hemispheres in Gazzaniga's studies, the relation of Europe and America is characterized by the capability to produce political, economic, and cultural fictions, such as the theories of Marxism and psychoanalysis, or the invention of the Other (that which Victor Segalen named "exotism"). Byars can be regarded as a direct effect of the severed *corpus callosum aestheticum* that once connected both continents. He was long ignored in his native country, but immediately embraced by Europeans as one of their own (while giving little attention to his "Americanism"). Responsible to a great extent for Byars's early success in Europe were the art historian Anny de Decker and the artist Bernd Lohaus, who in 1966 founded the alternative gallery Wide White Space in Antwerp. They began showing Byars in 1969, when, according to de Decker, "other American artists had no time at all for Byars. They tended to make fun of him . . . There have always been misunderstandings and ill-will between Byars and the rest."[6] But to the end, Byars's heart remained in Japan, his adopted home for more than ten years and the place to which he returned before his death and where he made his last performance (in Nara), before passing away shortly thereafter in Cairo.

As Dave Hickey rightly reminds us, Byars was as much Midwestern American as he was European or Oriental.[7] His golden suits were equally inspired by Elvis Presley's 1957 gold-lamé tuxedo as they were by Rembrandt's 1658 self-portrait in a golden garment, now in the Frick Collection. His pink

Geschichten, als Augenzeuge seiner Performances oder als Vermittler dessen, was man gehört oder gesehen hatte, oft auf Wunsch des Künstlers. Dies gehörte sowohl zum partizipatorischen Aspekt seiner Kunst als auch zu seiner Strategie der Selbstpromotion. Ein Brief des Berner Galeristen Toni Gerber aus dem Jahr 1975 an das De Appel Zentrum für bildende Kunst in Amsterdam und die Galerie Germain in Paris verdeutlicht diese zweifache Aktionsform. Der Brief beginnt mit den Worten: »es ist der dringende wunsch von james lee byars, dass ich ihnen einen bericht gebe von einer sehr merkwürdigen und schönen sache, die er letzten Sonntag in der alten stadt getan hat ...« Es schließt sich ein Bericht über die Performance *The Perfect Epitaph* an, und das Schreiben endet mit einem Appell an die Adressaten, eine ähnliche Performance in Amsterdam und Paris zu finanzieren: »james hat jetzt den dringenden wunsch, dass der vollkommene epitaph jetzt auch in amsterdam und paris aufgeführt wird. aber das bedeutet, dass wir galeristen uns die kosten teilen müssen [...] schließlich kommt auch etwas dabei heraus, das verkauft werden kann, mit der begleitenden fotodokumentation.«[6]

Das Europa und Amerika von heute ähneln in vieler Hinsicht zwei seit langer Zeit chirurgisch voneinander getrennten Hirnhälften. Wie in der Studie von Gazzaniga ist das Verhältnis von Amerika und Europa durch das Potenzial, politische, ökonomische und kulturelle Fiktionen zu produzieren, bestimmt, wie die Theorien des Marxismus und der Psychoanalyse oder die Erfindung des Anderen (dessen, was Victor Segalen als »Exotismus« bezeichnete). James Lee Byars kann als ein direktes Resultat des durchtrennten *Corpus callosum aestheticum,* das beide Kontinente einst verband, angesehen werden. Wenn er auch in seinem Geburtsland lange Zeit wenig beachtet wurde, so wurde er doch von den Europäern bald als einer der ihren aufgenommen (ohne dass allerdings sein Amerikanisch-Sein genügend gewürdigt wurde). Die Kunsthistorikerin Anny de Decker und der Künstler Bernd Lohaus, die zusammen im Jahre 1966 die alternative Galerie Wide White Space in Antwerpen gründeten, waren in hohem Maße für Byars frühzeitigen Erfolg in Europa verantwortlich. Sie begannen Byars 1969 in ihrer Galerie zu einer Zeit auszustellen, als, de Decker zufolge, »Byars [...] bei den amerikanischen Künstlern überhaupt nicht gut gelitten [war]. Sie machten sich eher über ihn lustig [...] Zwischen Byars und den anderen hat es ständig Missverständnisse und Anfeindungen gegeben.«[7] Doch bis zuletzt hing sein Herz an Japan, das für mehr als zehn Jahre seine Wahlheimat gewesen war. Es war auch das Land, in das Byars vor seinem Tode zurückkehrte, um dort, in Nara, seine letzte Performance zu geben. Kurz darauf starb er in Kairo.

silk garments were as much informed by Elsa Schiaparelli's silk taffeta as they were by the pink Jain temples of Jaipur. Moreover, with names such as *The Letter Reading Society* (1987), many of his actions and works recall the philosophical societies or metaphysical clubs prevalent in nineteenth-century America.

Presentness Is Style

"Everyone's mind, however eager it may be for information, offers a certain resistance to the reception of somebody else's ideas. Before one can take them in, the shape, connection, and tendency of one's own ideas have to yield to those same features in the other person's . . . He does so with the aid of a great many devices which, when regularly used, are called the qualities of his speech or writing. These qualities go by such names as: Clarity, Order, Logic, Ease, Unity, Coherence, Rhythm, Force, Simplicity, Naturalness, Grace, Wit, Movement. But these are not distinct things; they overlap and can reinforce or obscure one another, being but aspects of the single power called Style . . . They are the by-product of an intense effort to make words work. By 'making them work' we mean here reaching the mind of another and affecting it in such a way as to reproduce there *our* state of mind."
Jacques Barzun, *The Modern Researcher* (1957)

After returning from Kyoto in 1967, Byars began to design participatory garments, such as *Four in a Dress, Three in a Pants, Two in a Hat,* and *Dress for 500,* as well as performative silk objects, such as *Gun, The Pink Silk Airplane (for 100 People),* all tailored from black, white, or pink acetate silk by "Mr. North South," Byar's Chinese sewer, and often featuring the "Imperial Court Underwear Stitch." This "Imperial" stitch, which allowed the individual pieces of silk to stay closed without any buttons or ties, was not, as Byars tried to make believe, an Oriental invention but actually refers to the patented 1910 "Klosed-Krotch" men's underpants made by the Wisconsin-based Cooper Underwear Company, later sold by the Imperial Underwear Company.

Four in a Dress (1967) consists of a circular piece of black silk cloth, sixteen feet in diameter with four holes cut out for the performer's heads. When worn, preferably with no clothes underneath, it comes to the ankles. A possible precursor was given by Byars to his Japanese lover Taki Sachiko in 1967, a large circular piece of white Chinese paper, six meters in diameter with four evenly spaced holes. According to Taki, it was a prototype for a series of performances, which were abandoned by because of technical difficulties.

Dave Hickey hat zu Recht darauf hingewiesen, dass Byars ebenso sehr ein Amerikaner aus dem Mittleren Westen wie auch ein Europäer und Orientale war.[8] Seine goldenen Anzüge waren sowohl durch das Selbstporträt Rembrandts in goldener Kleidung von 1658 (heute in der Frick Collection in New York) als auch durch Elvis Presleys Goldlamé-Smoking von 1957 angeregt. Seine rosafarbene Seidenkleidung verweist gleichermaßen auf das Pink des Seidentafts von Elsa Schiaparelli wie auf das Rosa der Jain-Tempel von Jaipur. Viele seiner Aktionen und Arbeiten mit Namen wie *The Letter-Reading Society* (1987) erinnern zudem an die philosophischen Gesellschaften oder metaphysischen Clubs, die im Amerika des 19. Jahrhunderts weit verbreitet waren.

Gegenwärtigkeit ist Stil

»Der Verstand eines jeden Menschen, wie sehr er auch nach Informationen lechzt, setzt der Aufnahme von Ideen anderer Menschen einen gewissen Widerstand entgegen. Bevor diese aufgenommen werden können, müssen sich die Form, Verbindung und Tendenz der eigenen Ideen den Ideen des anderen beugen [...] Er tut dies mit einem Instrumentarium, das, wenn er es regelmäßig verwendet, zu einer nur ihm eigenen Art des Schreibens oder Sprechens wird. Diese Erkennungszeichen können sein: Klarheit, Ordnung, Logik, Leichtigkeit, Einheit, Zusammenhang, Rhythmus, Kraft, Einfachheit, Natürlichkeit, Anmut, Witz, Bewegung [...] Sie sind nur die einzelnen Aspekte, durch deren Zusammenspiel die Kraft entsteht, die wir Stil nennen [...] Sie sind das Nebenprodukt, das entsteht, wenn wir uns bemühen, Worte wirkungsvoll zu machen. Unter ›wirkungsvoll machen‹ verstehen wir hier das Erreichen des Geistes eines anderen Menschen und ihn so zu berühren, dass er *unseren* Geisteszustand nachvollziehen kann.«
Jacques Barzun, *Der moderne Forscher* (1957)

Nach seiner Rückkehr 1967 aus Kyoto begann Byars, partizipatorische Kleidungsstücke zu entwerfen, wie *Four in a Dress, Three in a Pants, Two in a Hat* und *Dress for 500, Gun* und *The Pink Silk Airplane (for 100 People)*. Alle waren von »Herrn Nord-Süd«, Byars' chinesischem Näher, aus schwarzer, weißer oder rosa Kunstseide geschneidert, oft unter Verwendung des »Imperial Court Underwear Stitch«. Durch diese Stichart konnten die einzelnen Seidenteile ohne Knöpfe oder Schnüre miteinander verbunden werden. Der Imperial Stitch war nicht, wie Byars glaubhaft

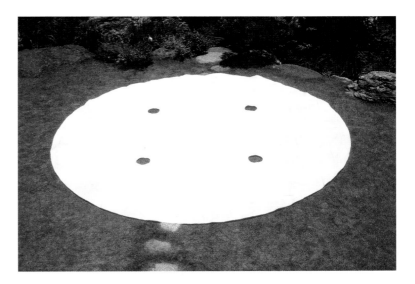

UNTITLED **OHNE TITEL** 1966/67

In 1968 Byars sent Dorothy C. Miller, the curator of painting and sculpture at the Museum of Modern Art in New York, several proposals for "plays" (none of which were accepted), including *Street Egg,* to be performed on Easter Sunday on Fifth Avenue and Fifty-seventh Street in New York:

An ellipse 100 x 150 feet of white China silk [by] 100 people in the street sitting down with this structure over them evenly spaced (or having the amount of silk in proportion to the amount they have paid/purchased) . . . Mr. North South (Chinese Sewer) can have this made ready in a week. Because of the Imperial Court Stitch, which would permit the silk ellipse to look all sewn together, all people have to do is pull their necks and segmentation will occur. The structure changes from a single play (in the metaphysical sense of the word) to a multiple one. The purpose is to involve the city in a serious play. Extra (100) yellow cab company would take the participatory people home (and would serve as road blocks during the play).[8]

Byars's insistence in the sixties and seventies that his performances be regarded as "plays" is an indication that his works should neither be considered merely phenomenological nor conceptual, but, in the sense of Wittgenstein's "language-games," as social activities: "Here the term 'language-*game*' is meant to bring into prominence the fact that the 'speaking' of language is part of an activity, or form of life. Review the multiplicity of language games in the following examples, and in others:

machen wollte, orientalischen Ursprungs, sondern wurde erstmals bei der 1910 patentierten Klosed-Krotch-Unterhose angewendet, die von der in Wisconsin ansässigen Cooper Underwear Company hergestellt und später von der Imperial Underwear Company verkauft wurde.

Four in a Dress (1967) besteht aus einem runden Stück schwarzer Seide mit einem Durchmesser von 16 Fuß (ca. 480 cm), in das vier Löcher für die Köpfe der beteiligten Personen geschnitten sind. Es sollte am besten ohne weitere Kleidung darunter getragen werden und reichte bis zu den Knöcheln. Einen möglichen Vorläufer hatte Byars 1967 seiner japanischen Geliebten Taki Sachiko geschenkt, ein riesiges, kreisrundes Stück weißes chinesisches Papier mit einem Durchmesser von sechs Metern und vier gleich großen Löchern. Nach Takis Aussage war dies der Prototyp für eine ganze Reihe von Performances, die aber wegen technischer Schwierigkeiten letztendlich nicht verwirklicht wurden.

Im Jahre 1968 schickte Byars an Dorothy C. Miller, Kuratorin am Museum of Modern Art in New York, einige Vorschläge für »Plays«, von denen jedoch keines angenommen wurde. Eines nannte sich *Street Egg* und hätte am Ostersonntag an der Ecke der Fifth Avenue/57. Straße in New York stattfinden sollen:

»Eine Ellipse von der Größe 100 x 150 Fuß [ca. 30 x 45 m] aus weißer chinesischer Seide wird gleichmäßig über einhundert auf der Straße sitzenden Menschen ausgebreitet (oder die Größe richtet sich nach der Höhe des Betrages, den sie für ihre Teilnahme gezahlt haben) [...] Herr Nord-Süd (ein chinesischer Näher) kann dies innerhalb einer Woche fertig haben. Wegen des Imperial Court Stitch, durch den die Seidenellipse als einheitlich zusammengenähtes Stück erscheint, müssen die Leute nur noch ihre Hälse etwas ausstrecken und die Segmentierung tritt ein. Die Struktur ändert sich von einem Einzelspiel (im metaphysischen Sinne des Wortes) zu einem vielfältigen. Der Sinn ist es, die Stadt an einem ernsten Spiel zu beteiligen. Extra (100) Yellow Cab Company Taxis werden die Teilnehmer nach Hause bringen (und während des Spiels als Straßensperre dienen).«[9]

Byars' Beharren in den sechziger und siebziger Jahren, seine Performances als »Plays« (Spiele) anzusehen, ist als Hinweis darauf zu verstehen, dass seine Arbeiten weder rein phänomenologisch noch konzeptionell aufgefasst werden sollten, sondern im Sinne Wittgensteins als »Sprachspiele«, als soziale Aktionen: »Das Wort ›Sprachspiel‹ soll hier hervorheben, dass das Sprechen der Sprache ein Teil ist einer Tätigkeit, oder einer Lebensform. Führe dir die Mannigfaltigkeit der Sprachspiele an diesen Beispielen, und anderen, vor Augen:

Giving orders, and obeying them—
Describing the appearance of an object, or giving its measurements—
Constructing an object from a description (a drawing)—
Reporting an event—
Speculating about an event—
Forming or teasing a hypothesis—
Presenting the results of an experiment in tables and diagrams—
Making up a story; and reading it—
Singing catches—
Guessing riddles—
Making riddles—
Making a joke; telling it—
Solving a problem in practical arithmetic—
Translating from one language into another—
Asking, thanking, cursing, greeting, praying.[9]

In September 1968 Byars performed a number of silk works on East Sixty-fifth Street as part of a series of participatory events dealing with communication and behavior, entitled *Mr. Byars and Six Plays,* sponsored by the Architectural League of New York. The six plays, based on definitions of the word "play" that Byars had found in the Oxford English Dictionary, were titled *Do, Fly, Can't, Talk, Breathe,* and *Try.* Among the silk works performed were *100 in an Airplane, Twelve in Pink Pants,* and *The Mile-Long Strip.* One of the participants, Shere Hite, model and future author of *The Hite Report on Female Sexuality* (1976), was seen taking off her bra underneath the mile-long communal red silk garment, as witnessed by Grace Glueck, art critic for the *New York Times.* The previous year, in 1967, Byars had been put in contact with a Mr. Fink from Los Angeles who was supposedly interested in making one million copies of *Four in a Dress.* (This may have been Hyman Fink, the owner of the first bargain closeout store in Los Angeles.) There is no evidence that anything ever came of it. In 1968 the photographer Bert Stern, who had achieved fame by taking the last portraits of Marilyn Monroe, opened

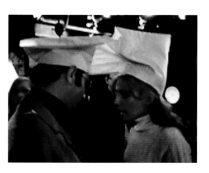

A HAT FOR TWO **EIN HUT FÜR ZWEI** 1968
ON 1ST, NEW YORK

Befehlen, und nach Befehlen handeln –

Beschreiben eines Gegenstands nach dem Ansehen, oder nach Messungen –

Herstellen eines Gegenstands nach einer Beschreibung (Zeichnung) –

Berichten eines Hergangs –

Über den Hergang Vermutungen anstellen –

Eine Hypothese aufstellen und prüfen –

Darstellen der Ergebnisse eines Experiments durch Tabellen und Diagramme –

Eine Geschichte erfinden und lesen –

Theater spielen –

Reigen singen –

Rätsel raten –

Einen Witz machen; erzählen –

Ein angewandtes Rechenexempel lösen –

Aus einer Sprache in die andere übersetzen –

Bitten, Danken, Fluchen, Grüßen, Beten.«[10]

THE GUN WENT OVER THE HILL **DIE KANONE GING ÜBER DEN BERG**
THE EXPERIMENTAL WORKSHOP, UNIVERSITY OF SANTA CRUZ 1968/69

Im September 1968 führte Byars in der 65. Straße in New York einige seiner Seidenarbeiten vor; sie waren Teile einer Reihe von Veranstaltungen, die sich unter Einbeziehung von Teilnehmern mit Kommunikation und Verhalten beschäftigten. Die Serie hieß *Mr. Byars and Six Plays* und wurde von der Architectural League von New York gefördert. Die sechs Spiele, denen Definitionen des Wortes »play« aus dem Oxford English Dictionary zugrunde lagen, waren *Do, Fly, Can't, Talk, Breathe* und *Try*. Bei den Seidenarbeiten handelte es sich unter anderem um *100 in an Airplane, Twelve in a Pants* und *The Mile-Long Strip.* Eine der Teilnehmerinnen, Shere Hite, Fotomodell und spätere Verfasserin des *Hite Report. Das sexuelle Erleben der Frau* (1976), wurde von der Kunstkritikerin der *New York Times,* Grace Glueck, dabei beobachtet, wie sie sich unter diesem eine Meile langen gemeinschaftlichen roten Seidenbekleidungsstück ihres Büstenhalters entledigte. Ein Jahr zuvor, 1967, war Byars mit einem Mr. Fink aus Los Angeles in Kontakt gekommen, der angeblich an der Produktion von einer Million Exemplaren von *Four in a Dress* interessiert gewesen war. (Es könnte sich hierbei um Hyman Fink, den Eigentümer des ersten Billigramschladens in Los Angeles gehandelt haben.) Es gibt keinen Hinweis, dass jemals etwas aus diesem Vorhaben geworden ist. 1968 eröffnete der Fotograf Bert Stern, der mit seinen Porträts von Marilyn Monroe zu Ruhm gekommen war, eine Boutique mit dem Namen »On 1st« auf der First Avenue in der Nähe der 63. Straße. In dieser Boutique wurden erstmals von Künstlern entworfene Kleidungsstücke angeboten.

a boutique, "On 1st," at 1159 First Avenue, near Sixty-third Street, which pioneered fashion designed by artists. Stern asked Byars to be the artist-in-residence, and his boutique carried several of Byars's "many people" designs, including *A Hat for Two* and *Bikini for Thirteen*. Stern also photographed Byars and others wearing *Four in a Dress,* and printed the image on black shopping bags. An article in the January 15, 1969, issue of *Vogue* magazine depicts Byars wearing his signature black-felt high hat, adjusting a large banana-shaped garment made from yellow acetate silk for five cast members of the musical *Hair.* It was described as "a banana for five people (or a hundred or a thousand—firmly packed) to climb in and play together."[10]

In the sixties and seventies Byars, who was a prolific letter writer, regularly corresponded with Sam Wagstaff, a collector and curator at the Wadsworth Atheneum in Hartford, Connecticut, who later became a curator at the Detroit Art Institute in Byars's hometown. Among Wagstaff's papers related to Byars is a photocopy, sent to him by Byars, of a page with the following definition of style by the physicist J. Robert Oppenheimer, the director of the Institute for Advanced Study at Princeton, and former director of the Manhattan Project: "The problem of doing justice to the implicit, the imponderable, and the unknown is of course not unique to politics. It is always with us in science, it is with us in the most trivial of personal affairs, and it is one of the great problems of writing and of all forms of art. The means by which

Stern ernannte Byars zu seinem Hauskünstler, und die Boutique führte einige seiner »Viele-Leute«-Entwürfe in ihrem Angebot, unter anderem *A Hat for Two* und *Bikini for Thirteen*. Stern fotografierte Byars, wie er gemeinsam mit drei anderen mit *Four in a Dress* Modell stand und ließ dieses Bild auf schwarze Einkaufstaschen drucken. In einem *Vogue*-Artikel vom 15. Januar 1969 erschien ein Bild von Byars mit seinem Markenzeichen, einem schwarzen, hohen Filzhut auf dem Kopf, wie er ein riesiges, bananenförmiges Kleidungsstück aus gelber Kunstseide fünf Ensemblemitgliedern des Musicals *Hair* anpasst. Es war beschrieben als »eine Banane für fünf Leute (oder hundert oder tausend – eng gepackt) für gemeinsames Klettern und Spielen.«[11]

In den sechziger und siebziger Jahren korrespondierte Byars, der unablässig Briefe verfasste, regelmäßig mit Sam Wagstaff, Sammler und Kurator am Wadsworth Atheneum in Hartford, Connecticut, und späterem Kurator am Detroit Art Institute in Byars' Heimatstadt. In dieser Korrespondenz befindet sich auch die Fotokopie eines Textes, den Byars an Wagstaff geschickt hatte. Hierbei handelt es sich um einen Text des Physikers J. Robert Oppenheimer, des Direktors am Institute for Advanced Study in Princeton und ehemaligen Direktors des Manhattan Projects, in dem dieser eine Definition des Begriffs »Stil« gibt: »Die Frage, wie dem Impliziten, Unberechenbaren und Unbekannten Gerechtigkeit widerfahren kann, beschränkt sich natürlich nicht auf die Politik. Sie stellt sich uns immer in der Wissenschaft, bei den trivialsten persönlichen Dingen und ist eines der größten Probleme beim Schreiben und allen Formen der Kunst. Der Weg, der zur Lösung führt, wird manchmal Stil genannt. Es ist Stil, der der Sicherheit die Beschränkung und Bescheidenheit hinzufügt; es ist Stil, der es ermöglicht, wirkungsvoll, aber nicht absolut zu handeln [...] vor allem aber ist es der Stil, durch den sich die Macht der Vernunft beugt.«[12]

In »Kunst und Objekthaftigkeit« schreibt der Kritiker Michael Fried über Minimal Art: »Ich möchte die Aufmerksamkeit auf die schrankenlose Verbreitung – beinahe Universalität – der Sensibilität oder Seinsweise lenken, die ich vom Theater korrumpiert oder pervertiert genannt habe. Wir sind alle Literalisten, fast immer. Gegenwärtigkeit ist Anmut.«[13]

Für Byars bedeutete dies: Gegenwärtigkeit ist Stil.

it is solved is sometimes called style. It is style which complements affirmation with limitation and with humility; it is style which makes it possible to act effectively, but not absolutely . . . it is above all style through which power defers to reason."[11]

In *Art and Objecthood*, the critic Michael Fried wrote on the subject of Minimal Art, "I want to call attention to the utter pervasiveness—the visual universality—of the sensibility or mode of being which I characterized as corrupted by theater. We are all literalists most or all of our lives. Presentness is grace."[12]

For Byars, presentness was style.

From the Theatrical to the Theoretical

In 1970 Byars made two sixteen-millimeter "movies" in Hollywood: *Autobiography* and *100 Minds;* and in the mid-seventies, the twenty-one-second Super-8 film *Two Presidents*. During that time he began writing in his letters about making a "big gold movie" and signing them "movie mogul Byars":

Just to begin a new medium of such rich rich passion. I can hardly wait to tell you my discoveries and show you but I will—who owns a movie house in NY we can use? Love Movie mogul Byars.[13]

100 Minds was first shown in 1971 at the Los Angeles County Museum as *Thinking—A Movie for a Single Person*. (He considered the film both biographical and autobiographical: one hundred biographies forming one autobiography). He wrote to Wagstaff about *100 Minds,*

The subject of the movie is thinking? The movie is used to call attention to a specific thought? 100 minds the epigrammatist movie? Helicopter movies? A still moment becomes a movie? 100 biogs? To say the fantastic in a very simple way?[14]

When the movie, which featured one hundred people lying on their backs (filmed from a helicopter?) was shown to students at the School of Art and the Memorial Art Center in Atlanta, the audience was asked to watch it while lying on their backs and looking up at a projection on the ceiling. Later, during an event in front of the Metropolitan Museum of Art in New York, Byars cut the film into single frames, which he gave away. *Autobiography,* on the other hand, consists of a single frame, lasting all of one twenty-fourth of a second. When projected, it flashes an image of the artist, wearing a white suit, shoes, and hat, floating inside an enormous black space.

Vom Theatralischen zum Theoretischen

1970 drehte Byars in Hollywood zwei 16-mm-»Filme«: *Autobiography* und *100 Minds;* Mitte der siebziger Jahre drehte er den 21 Sekunden langen Super-8-Film *Two Presidents.* Von dieser Zeit an schrieb er in seinen Briefen über seine Pläne zu einem »big gold movie« und unterzeichnete seine Briefe mit »movie mogul Byars«:

> »Kurz davor ein neues Medium mit so einer Riesenleidenschaft anzufangen. Ich kann es kaum erwarten, dir alle meine Entdeckungen zu erzählen und zu zeigen – wem in NY gehört ein Kino, das wir benutzen können? Alles Liebe, Filmmogul Byars.«[14]

100 Minds wurde erstmals 1971 im Los Angeles County Museum unter dem Titel *Thinking – A Movie for a Single Person* gezeigt. (Byars betrachtete den Film sowohl als biografisch als auch als autobiografisch: 100 Biografien werden zu einer Autobiografie.) Über *100 Minds* schrieb er an Wagstaff:

> »Das Thema des Films ist Denken? Der Film soll die Aufmerksamkeit auf einen bestimmten Gedanken lenken? 100 Minds, der epigrammatische Film? Helikopter-Filme? Eine Standaufnahme wird zum Film? 100 Biogs? Das Fantastische ganz einfach sagen?«[15]

Der Film, der 100 auf dem Rücken liegende Personen zeigt (aus dem Helikopter gefilmt?), wurde vor Studenten der School of Art and Memorial Art Center in Atlanta gezeigt, die ebenfalls während der Vorführung auf dem Rücken lagen und die Projektion an der Decke sahen. Bei einer späteren Aktion vor dem Metropolitan Museum of Art in New York zerschnitt Byars den Film in einzelne Bilder und verteilte sie. *Autobiography* bestand nur aus einem einzigen Bild, das eine 1/24stel Sekunde anhielt. Die Projektion zeigte blitzartig die kleine Frontalfigur des Künstlers, mit weißem Anzug, Schuhen und Hut bekleidet, in einem riesigen schwarzen Raum treibend.

Der Film *Two Presidents* wurde im Hof eines mir unbekannten Gebäudes gedreht und zeigt zwei »Schauspieler«, die, als »Uncle Sam« verkleidet, beide mit den gleichen hohen Hüten im Abraham-Lincoln-Stil auf dem Kopf, eine vereinfachte amerikanische Flagge in Rot, Weiß und Blau (mit nur sechzehn Sternen und vier Streifen) vor sich halten. Die einzige »Handlung« besteht im Spiel des Windes mit der langen Seidenflagge. Durch eine Schwarz-Weiß-Fotografie ist eine Performance der Flagge dokumentiert, diesmal in einem geschlossenen Raum, offenbar einem Museum oder einer Galerie. Die Flagge mit

Two Presidents was filmed in the outdoor courtyard of an unknown location and shows two "actors" dressed as "Uncle Sam" in identical Abraham Lincoln-style stovepipe hats holding up a simplified red, white, and blue American flag (it features only sixteen stars and four stripes), with the only "action" being the wind moving the long silk flag. A black-and-white photograph documents a performance of the flag, this time indoors, in what appears to be a museum or gallery space. The flag, which measures approximately 9.5 by 2.25 meters, is still located in Byars's estate in Santa Fe. *Two Presidents* was most likely conceived (but not performed) in 1972 during "documenta 5" in Kassel, where, in September, Byars sent telegrams to the world leaders Richard Nixon, Mao Zedong, Willy Brandt, Georges Pompidou, and Queen Elizabeth II, all with identical messages. The one to Nixon reads:

> GREAT NIXON WHITE HOUSE WASHINGTON/DC
> IT IS PERFECT AND LOGICAL THAT A GREAT HEAD OF STATE WOULD VISIT THE WORLD'S GREATEST ART SHOW AND GIVE GREAT COMMENT? MAY I INVITE YOU TO DOCUMENTA 5 IN KASSEL GERMANY ON OCTOBER 7TH OR 8TH
> SINCERELY JAMES LEE BYARS
> PS. OR YOUR REPRESENTATIVE OR BY PHONE [15]

He then followed up with another series of telegrams. The one to Mao read:

> GREAT MAO PEKING = = =
> CORRECTIONS: A GREAT COMMENT? 7TH OR 8TH?
> BY PHONE?
> SINCERELY JAMES LEE BYARS[16]

He sent Sam Wagstaff copies of the telegrams as well as a letter on "documenta 5" stationery, which reads (in Byars's by then customary abbreviated writing style):

> Sammy Baby
> I want you to be one
> of the 2 Pres (only 4 hrs)
> mayb with me immed.
> upon ret. (just as an open Que?)[17]

(The underlined "I want you" refers to James Montgomery Flagg's famous World War I United States army recruiting poster.)

den ungefähren Maßen 9,5 x 2,25 Meter befindet sich noch in Byars' Nachlass in Santa Fe. *Two Presidents* wurde vermutlich 1972 während seines Aufenthalts auf der *documenta 5* in Kassel konzipiert, aber dort nicht aufgeführt.

In diesem Zusammenhang stehen die Telegramme, die Byars an die Staatsoberhäupter Richard Nixon, Mao Tse-tung, Willy Brandt, Georges Pompidou und die Königin von England, Elizabeth II., mit jeweils gleicher Botschaft schickte. Das Telegramm an Nixon lautete:

»GROSSER NIXON WEISSES HAUS WASHINGTON/DC
ES IST PERFEKT UND LOGISCH, DASS EIN GROSSES STAATS-
OBERHAUPT DIE GRÖSSTE KUNSTAUSSTELLUNG DER WELT
BESUCHT UND EINEN GROSSARTIGEN KOMMENTAR ABGIBT?
DARF ICH SIE ZUR DOCUMENTA 5 IN KASSEL DEUTSCHLAND
FÜR DEN 7. ODER 8. OKTOBER EINLADEN
HOCHACHTUNGSVOLL JAMES LEE BYARS
P.S. ODER IHREN VERTRETER ODER TELEFONISCH«[16]

Es folgte eine weitere Serie von Telegrammen. Das an Mao hatte folgenden Inhalt:

»GROSSER MAO PEKING = = =
KORREKTUREN: EIN GROSSER KOMMENTAR? 7. ODER 8.?
TELEFONISCH?
HOCHACHTUNGSVOLL JAMES LEE BYARS«[17]

Byars schickte Sam Wagstaff Kopien der Telegramme sowie einen Brief auf *documenta-5*-Briefpapier mit folgendem Inhalt (in seinem zu dieser Zeit üblichen stark abkürzenden Schreibstil):

»Sammy Baby
Ich will dich als einen
der 2 Präs (nur 4 Std)
evtl mit mir sof.
nach Rückk. (nur als offene Frag?)«[18]

(Das unterstrichene »Ich will dich – I want you« ist offenbar eine Anspielung auf das berühmte US-Rekrutierungsplakat aus dem Ersten Weltkrieg von James Montgomery Flagg.)

In einem weiteren Brief, der von Wagstaff auf 1974 datiert wurde und der auf dem Briefpapier von CERN, dem europäischen Kernforschungszentrum in Genf geschrieben ist, das Byars 1972 besucht hatte, identifiziert Byars Nixon als einen der beiden Präsidenten.

In another letter, dated 1974 by Wagstaff, on stationary from CERN (the European Organization for Nuclear Research, in Geneva, which Byars visited in 1972), Byars identified Nixon as one of the two "presidents" depicted:

My '2 Pres's' so powf
help me. Nix needs it
to be the one.[18]

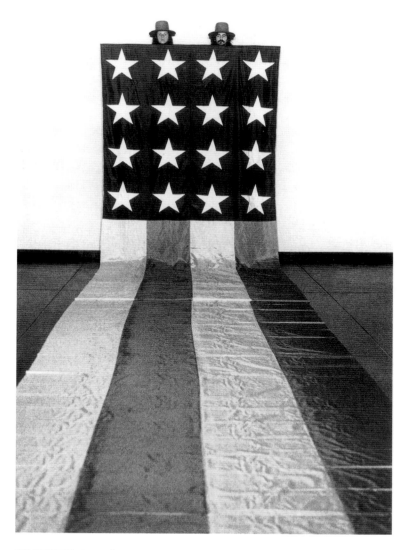

TWO PRESIDENTS **ZWEI PRÄSIDENTEN**
PERFORMANCE CA. 1974

»Meine ›2 Präs‹ so mächt
hilf mir. <u>Nix</u> muss
einer sein«[19]

Dieser sehr kryptische und mit extremen Verkürzungen arbeitende Brief enthielt auch eine Bitte an Wagstaff, ihm dabei zu helfen, mit dem amerikanischen Außenminister Henry Kissinger (»er würde mich mögen«) in Kontakt zu treten. Ein weiterer möglicher Hinweis lautet:

»Der <u>V.P.</u> benimmt sich wie
P^res... «[20]

Die Briefe an Wagstaff legen den Schluss nahe, dass es sich bei den beiden Präsidenten um Präsident Nixon und Vizepräsident Gerald Ford handeln könnte. (Nixon trat am 8. August 1974 von seinem Amt zurück. Die erste Amtshandlung seines unmittelbaren Nachfolgers, Gerald Ford, war die Begnadigung von Nixon).

Es gibt auch Anspielungen auf den Vietnamkrieg in Byars' Briefen an Wagstaff aus dieser Zeit, die ein politisch motiviertes Handeln seinerseits vermuten lassen. Auch wenn er der Tagespolitik fern zu stehen schien, war seine Kunst doch ihrer Definition nach eine friedliche Meditation, und damit gegen den Krieg. Dies zeigt sich in einer frühen Performance, von der William Lindley Hubbell (auch bekannt als Hayashi Shuseki), ein in Amerika geborener japanischer Shakespeare-Kenner und Professor für englische Literatur an der Doshisha Universität in Kyoto, 1967 in einem Brief an Dorothy Miller berichtete. Taki Sachiko stand um Mitternacht unangemeldet vor Hubbells Tür. Sie trug ein Kleid aus weißen Straußenfedern und überreichte Hubbell ein kleines, rundes Papierstück, auf das in mikroskopisch kleinen Buchstaben das Wort PEACE gedruckt war. Ebenfalls im Jahr 1967 führten zwei der Förderer von Byars, der Rechtsanwalt James Butler und seine Ehefrau Eugenia aus Los Angeles, auf Anregung des Künstlers eine schweigende Prozession von 350 Menschen den Hollywood Boulevard entlang, um so gegen die brutalen Übergriffe der Polizei bei einem Anti-Vietnam-Marsch am Tag zuvor zu protestieren; sie waren alle durch einen goldenen Faden miteinander verbunden, den sie in ihren Händen hielten.

Two Presidents war möglicherweise auch beeinflusst von *WAR*, einem Stück mit Spielcharakter, das von 31 Mitgliedern des Judson Dance Theater unter der Choreografie von Yvonne Rainer aufgeführt wurde. Dieses Stück basierte auf Kriegstaktiken, wie sie in der *Ilias* geschildert werden, und auf Darstellungen des Vietnamkrieges. In ihm kam auch eine riesige, orange-weiß-grüne amerikanische Flagge vor, die nach Rainers Aussage nach einem Gemälde von Jasper Johns

The very cryptic and highly abbreviated letter also included a plea to Wagstaff to help introduce him to the then secretary of state Henry Kissinger ("he'd dig me"). Another line offers an additional clue as to who was meant to be the second "president":

The <u>V.P.</u> just acts like
P^res . . .[19]

The letters to Wagstaff suggest that the two "presidents" may have been President Nixon and Vice President Gerald Ford. (Nixon resigned from office on August 8, 1974, and Ford immediately succeeded him in office, pardoning Nixon as his first executive act.)

There are also references to the Vietnam War in Byars's letters to Wagstaff during that time, which may suggest a sort of politically-motivated intervention on Byars's part. Although Byars seemed fairly distanced from everyday politics, his art was not only a peaceful meditation, but decidedly anti-war. This is apparent from an early performance, which William Lindley Hubbell (a.k.a. Hayashi Shuseki), an American-born Japanese Shakespeare scholar and professor of English literature at Doshisha University in Kyoto, described in a 1967 letter to Dorothy Miller: Calling unannounced one midnight at Hubbell's house in Kyoto, Taki Sachiko, wearing a white ostrich-feather garment handed Hubbell a small round piece of paper. Printed on it, in microscopic letters, was the word PEACE. Also in 1967, two of Byars's supporters, the Los Angeles attorney James Butler and his wife Eugenia, led a silent procession of 350 people carrying a long golden thread along Hollywood Boulevard to demonstrate against the police brutality that occurred the day before during an anti-Vietnam War march there.

Two Presidents may also have been influenced by *WAR,* a game-like piece for thirty-one people performed by the Judson Dance Theater with choreography by Yvonne Rainer. Based on military tactics found in the *Iliad* and accounts of the Vietnam War, it featured a large orange, white, and green American flag, which, according to Rainer, was designed after a painting by Jasper Johns. *WAR* was performed twice, first at Douglass College in New Brunswick, New Jersey, and later at the Loeb Student Center at New York University. Formally, Byars's film also evokes the well-known publicity shots of the Beatles posing with an American flag prior to their first visit to the United States in January 1964.

As the performance critic RoseLee Goldberg notes, "Performance in the United States began to emerge in the late thirties with the arrival of European war exiles in New York. By 1945 it had become an activity in its own right, recognized as such by artists and going beyond the provocations of earlier performances."[20] Black Mountain College in North Carolina became the center of performance art in the United States, beginning in the thirties with the

entstanden war. Das Stück wurde zweimal aufgeführt, zuerst am Douglass College in New Brunswick, New Jersey, und später am Loeb Student Center in der New York University. In formaler Hinsicht hat *Two Presidents* auch Ähnlichkeit mit den bekannten Fotos der Beatles, die zu Werbezwecken im Vorfeld ihres ersten USA-Besuchs im Januar 1964 entstanden, auf denen sie mit der US-Flagge posieren.

Die Kritikerin RoseLee Goldberg schreibt: »Performance wurde von Kriegsflüchtlingen aus Europa nach New York gebracht und tauchte in den Vereinigten Staaten erstmals in den späten dreißiger Jahren auf. Bis zum Jahr 1945 hatte sie sich zu einer eigenständigen Form entwickelt, wurde als solche von Künstlern anerkannt und hatte die Provokationen der frühen Performances hinter sich gelassen.«[21] Das Black Mountain College in North Carolina wurde durch die dort tätigen Annie und Josef Albers in den dreißiger Jahren zu einem Zentrum der Performancekunst in den USA. In den frühen fünfziger Jahren lebte der Einfluss des Black Mountain College durch das vom Zen-Buddhismus inspirierte musikalische und tänzerische Schaffen von John Cage und Merce Cunningham erneut auf. Cages Ansicht nach »sollte sich Kunst nicht vom Leben unterscheiden, sondern ein Handeln im Leben sein, genau wie das ganze Leben, mit all seinen Unfällen und Zufällen, seiner Verschiedenheit und Unordnung und nur zeitweiligen Schönheiten.«[22] Das Judson Dance Theater hatte sich aus einem choreografischen Workshop heraus entwickelt, den der Musiker Robert Dunn am Merce Cunningham Studio gegeben hatte. Die Arbeit war von John Cages kompositorischen Ideen beeinflusst, die bahnbrechende Werke hervorbrachten, die die Bereiche Kunst, Dichtung und Tanz miteinander in Verbindung setzten. Die Gruppe war 1962 unter anderem von den Tänzern und Choreografen Yvonne Rainer, Trisha Brown, Lucinda Childs, Steve Paxton und David Gideon gegründet worden und trat in der Turnhalle der Judson Memorial Church in New York auf. Es gab eine regelmäßige Zusammenarbeit mit Künstlern wie Robert Rauschenberg, Robert Morris und Carolee Schneemann.

Mitte der sechziger Jahre war der amerikanische experimentelle Tanz stark von der wachsenden Hinwendung zum Minimalismus in der Kunst beeinflusst. Film und Video wurden von Künstlern wie Yvonne Rainer, Stan VanDerBeek, Nam June Paik, Keith Sonnier und Peter Campus in die Kunst und den Tanz integriert. *Homemade* ist der Name eines Tanzwerkes von Trisha Brown, bei dem sie einen Filmprojektor auf dem Rücken festgeschnallt hatte, der Sequenzen eines Films zeigte, den der Künstler Robert Whitman von Brown gemacht hatte. Ein Stück von Simone Forti, ebenfalls Mitglied des Judson Dance Theater, zeigt Menschen bei der Bewältigung profaner Aufgaben. Dieses Stück mit dem Titel *Huddle* wurde 1961 erstmals aufgeführt und war von der

residencies of Annie and Josef Albers. In the early fifties the college's influence resurged with the Zen Buddhism-inspired music and dance activities of John Cage and Merce Cunningham. For Cage, "Art should not be different than life but an action within life. Like all of life, with its accidents and chances and variety and disorder and only momentary beauties."[21] The Judson Dance Theater grew out of a choreographic workshop led by musician Robert Dunn, held at the Merce Cunningham Studio. Influenced by John Cage's compositional ideas about music, it generated groundbreaking works that brought together ideas from the arts, poetry, music, and dance. Established in 1962 by, among others, dancers and choreographers Yvonne Rainer, Trisha Brown, Lucinda Childs, Steve Paxton, and David Gideon, the group performed in the gym of the Judson Memorial Church in New York. The group regularly collaborated with artists such as Robert Rauschenberg, Robert Morris, and Carolee Schneemann. By the mid-sixties, American experimental dance was strongly influenced by the rising move to Minimalism in art, and film and video became incorporated into art and dance by such performers and artists as Yvonne Rainer, Stan VanDerBeek, Nam June Paik, Keith Sonnier, and Peter Campus. *Homemade,* a dance by Trisha Brown, involved a film projector strapped to her back (showing a sequenced film of Brown made by artist Robert Whitman). One piece, *Huddle,* by Judson member Simone Forti, showed people engaged in mundane tasks. First performed in 1961, it was inspired by the simplicity of an environmental art piece by the Japanese artist Saburo Murasaki of the Gutai group, in which he had walked through many layers of paper attached to wooden frames. Recently, Mikhail Baryshnikov's White Oak Dance Project revived a number of these early Minimalist dance performances at the Brooklyn Academy of Music, in a program entitled *Past Forward.* One of the pieces performed was Yvonne Rainer's *Chair/Pillow* (1970), in which chairs and pillows are used to execute simple actions, such as sitting, standing, holding, and throwing.

There appear to be definite affinities between the Judson Dance Theater's choreographies and Byars's plays and performances. In 1963, Byars asked Yvonne Rainer to dance at the opening at Richard Bellamy's Green Gallery, giving her complete artistic freedom (this was somewhat uncharacteristic, as Byars was known to be rather authoritarian, which often led to tensions with his "presenters"). During the event two scrolls of white paper were unrolled onto a platform made of white cubes by two people, one wearing a "bird's-egg head," the other, a costume designed by Balenciaga. Wearing a black dress, Rainer improvised by responding to the audience's movements and reactions. Among the audience was the pop artist and filmmaker Andy Warhol, who unbeknownst to Byars and Rainer, briefly filmed Rainer's performance, the footage of which was recently found in the Andy Warhol Film Project at the Whitney Museum of American Art. Rainer later wrote an essay about her improvised dance ("Some Thoughts on Improvisation"), which was

Einfachheit einer Environment-Installation des japanischen Künstlers und Mitglieds der Gutai-Gruppe, Saburo Murasaki, inspiriert, in der dieser durch an hölzernen Rahmen befestigte Papierlagen schritt. Vor kurzem sind einige dieser frühen minimalistischen Tanzwerke von Michail Barischnikows Tanzgruppe, White Oak Dance Project, in der Brooklyn Academy of Music unter dem Titel *Past Forward* wieder aufgeführt worden. Eines der dort gezeigten Werke war das Stück *Chair/Pillow* von Yvonne Rainer aus dem Jahr 1970, in dem Stühle und Kissen dazu benutzt werden, einfache Handlungen wie Sitzen, Stehen, Halten und Werfen darzustellen.

Zwischen den Choreografien des Judson Dance Theater und Byars' Spielen und Performances scheint es eine deutliche Affinität zu geben. 1963 bat Byars Yvonne Rainer bei der Eröffnung der Green Gallery zu tanzen; er gewährte ihr hierbei völlige künstlerische Freiheit. Was ungewöhnlich war, da Byars bekanntlich ziemlich autoritär war; dies führte oft zu Spannungen mit seinen »Darstellern«. Während der Aufführung wurden zwei Papierrollen aus weißem Papier auf einer Plattform, die aus weißen würfelförmigen Schachteln bestand, von zwei Personen entrollt. Die eine Person trug eine Kopfmaske in Form eines Vogeleis, die andere ein von dem Modeschöpfer Balenciaga entworfenes Kostüm. Yvonne Rainer, in einem schwarzen Kleid, antwortete mit ihrer tänzerischen Improvisation auf die Bewegungen und Reaktionen des Publikums. Im Publikum befand sich auch der Popkünstler und Filmemacher Andy Warhol, der, ohne dass Byars oder Rainer es bemerkten, kurze Passagen der Performance filmte. Dieser Film wurde erst kürzlich im Andy Warhol Film Project im Whitney Museum of American Art in New York gefunden. Später schrieb Yvonne Rainer einen Essay über ihre Tanzimprovisation (»Some Thoughts on Improvisation«), der in ihrem Buch *Work 1961–73* veröffentlicht wurde. Ihr Essay wurde auch auf Tonband gesprochen und 1964 beim Once Festival in Ann Arbor, Michigan, abgespielt, während Rainer mit einer weißen Garnrolle improvisierte. Dieser Essay enthält nicht nur die erste Formulierung einer Theorie des Improvisationstanzes, sondern beschreibt auch sehr gut die komplexe Wirkung, die Byars' Aktionen und Arbeiten zu dieser Zeit auf Publikum und Gleichgesinnte hatten: »Die Rollen sind hauptsächlich aus weißem Papier gemacht. Die Schachteln sind wie ein Schneefeld. Die Wände erheben sich weiß und glatt [...] ich teile mit vielen anderen Leuten im Raum den Impuls: wir wollen dieses Weiß verdrecken, entweihen, darauf scheißen, dieses Zerbrechliche zerquetschen, diese Stille zerschlagen [...] Aber trotzdem ist es so, dass ICH DIES NICHT TUN MUSS. Ich entscheide mich, alles, all dieses Geschlage und Geschmiere nicht zu tun. Ich entscheide mich, das Spiel auf seine Art mitzuspielen, und durch diese Entscheidung bin ich befreit von dem

published in her first book, *Work 1961–73*. Her essay was also recorded on tape and played back during an improvised solo Rainer performed with a spool of white thread at Once Festival in Ann Arbor, Michigan, in 1964. Rainer's essay not only contains the first formal theoretical ideas on improvised dance but describes thoroughly the complex effect Byars's actions and works had at the time on his audience and peers: "The scrolls are made of white paper mostly. The boxes are a snowy field. The walls rise white and flat . . . I share a common impulse with many people in the room: We want to defile, to desecrate, to shit on the whiteness, to crush this fragility, to smash the silence . . . Anyway, the thing is that I DON'T HAVE TO DO IT. Any of it: all that smash and smudge, I choose not to do it. I choose to play the game his way and in so choosing I am freed from wanting to destroy his image. I become powerful and happy. I become knowledgeable. I know what is appropriate to do. I find his image beautiful."[22]

In 1965, during the Pittsburgh International Exhibition of Contemporary Painting and Sculpture at the Carnegie Museum of Art, Judson Group member Lucinda Childs, dressed in a full-length, white ostrich-feather gown and headdress (most likely the same costume Taki Sachiko was wearing during her performance for Lindley Hubell in Kyoto in 1967), performed Byars's *A Mile-Long Paper Walk* (1962–64), a long strip of handmade Japanese white flax paper in seventy-five sections, joined with rivets. Crouching at the beginning of the mile-long paper object, Childs executed a small circle with her body like the hands of a clock, in a clockwise direction, rose and tiptoed

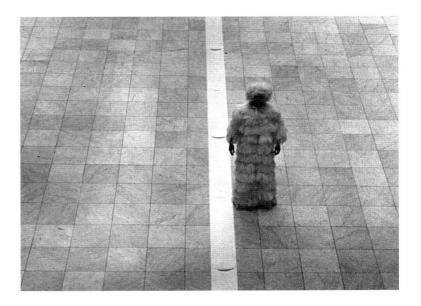

UNTITLED OBJECT (A MILE-LONG PAPER WALK) **OBJEKT OHNE TITEL (EIN MEILENLANGER PAPIERGANG)**
1962–64
PERFORMANCE CARNEGIE MUSEUM OF ART, PITTSBURGH 1965

Wunsch, seine Vision zu zerstören. Ich werde stark und glücklich. Ich werde wissend. Ich weiß, welches Handeln angemessen ist. Ich finde seine Vision schön.«[23]

Auf der Internationalen Ausstellung für zeitgenössische Malerei und Skulptur im Carnegie Museum of Art in Pittsburgh im Jahr 1965 führte Lucinda Childs Byars' Stück *A Mile-Long Paper Walk* (1962–1964) auf. Sie trug eine lange Robe und Kopfschmuck aus weißen Straußenfedern (wahrscheinlich handelte es sich dabei um dasselbe Kostüm, das Taki Sachiko später, 1967, bei der Performance im Zusammenhang mit Lindley Hubbell in Kyoto trug) und kauerte an einem Ende des Papierobjekts, einem Streifen von einer Meile Länge, der aus 75 Abschnitten handgeschöpftem japanischem Flachspapier bestand, die mit Nieten zusammengefügt waren. Childs vollführte mit ihrem Körper eine kleine Kreisbewegung, die, im Uhrzeigersinn ausgeführt, der Bewegung des Uhrzeigers entsprach. Sie erhob sich und lief graziös auf den Zehenspitzen bis zum anderen Ende des Papierobjekts, um dort eine weitere Kreisbewegung, diesmal entgegen dem Uhrzeigersinn auszuführen. Byars erklärte die Bedeutung dieser Bewegungen als ein Plus an dem einen und ein Minus an dem anderen Ende.

Stühle spielten bei Byars bereits seit den späten fünfziger Jahren eine große Rolle. Stühle stellten für ihn sowohl eine Ausweitung als auch einen Platzhalter des menschlichen Körpers dar. Eine seiner ersten Skulpturen, *The Black Figure* (um 1959), eine minimalistische Skulptur aus rohen, schwarz gestrichenen Holzbrettern, die an eine Leiter oder an eine leere Bahre denken lässt, betont die Abwesenheit des menschlichen Körpers und hat in ihrer Abstraktion auch Ähnlichkeit mit einem Stuhl. Eine andere Aktion von Byars aus den frühen siebziger Jahren steht in einem engeren Zusammenhang mit dem Judson Dance Theater. Eine Reihe farbiger Schnappschüsse (die im Nachlass des Künstlers gefunden wurden) dokumentieren diesen Auftritt: Byars, in rotem Anzug und mit schwarzem Hut, sitzt an verschiedenen Plätzen gegenüber dem Pierre Hotel in der Nähe des Central Parks in New York. Er sitzt bewegungslos und eine starke Präsenz ausstrahlend auf einem Stuhl und verkörpert so den »öffentlichen Denker«. Stühle tauchen auch in späteren Installationen als Objekte auf, oft vergoldet. Sie symbolisieren Throne, Orakel und Sitze der Weisheit und Macht, wie beispielsweise *The Philosophical Chair (Hear the First Totally Interrogative Philosophy around this Chair)* von 1978. Die Skulpturen der achtziger und neunziger Jahre zeichnen sich durch eine größere Autonomie des performativen Charakters aus, der Byars' Anwesenheit immer weniger erforderlich machte. Während sich Byars' frühere, stärker performative Werke am japanischen No-Spiel orientierten und mithilfe von Aktionen und Performances eine Dematerialisation der Kunst anstrebten, objek-

gracefully along the length of the paper object, and ended by performing another circle motion, this time counterclockwise. Byars explained this movement as signifying a plus on one end and a minus at the other.

Chairs played an important role in Byars's work as early as the late fifties. For Byars chairs served both as extensions of and stand-ins for the human body. One of his earliest sculptures, *The Black Figure* (ca. 1959), a Minimalist sculpture made from rough wooden planks painted black, which suggests both a ladder and an empty stretcher and emphasizes the absence of the human body, is chair-like in its abstraction. More closely related to the Judson Dance Theater is an action by Byars performed in the early seventies, documented in a series of color snapshots (found in the artist's estate), which show Byars, sitting still on a chair in various locations across from the Pierre Hotel near Central Park in New York, very much present in a red suit and

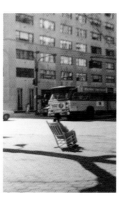

THE PUBLIC THINKER **DER ÖFFENTLICHE DENKER**
PERFORMANCE NEW YORK CA. 1970

black hat, as *The Public Thinker*. Chairs also appear in Byars's later installations of objects, often gilded, symbolizing thrones, oracles, and other seats of knowledge and power, such as *The Philosophical Chair (Hear the First Totally Interrogative Philosophy around this Chair)* of 1978.

As was typical of Byars's sculptures made during the eighties and nineties, the performative character of his work began to become more autonomous, requiring less and less of his presence. While Byars's earlier, dominantly performative works were guided by the model of Japanese Noh theater and sought to dematerialize art through actions and performances, his later works re-objectify his actions by transforming the material of the objects into performers who raise philosophical questions. Byars's familiarity with Japanese Noh theater—its demands for elegance and grace, its use of ceremonial dress and symbolic number systems, and

tivieren seine späteren Arbeiten die Aktionen wieder, indem sie das Material der Objekte selbst in Akteure verwandeln, die philosophische Fragen aufwerfen. Byars' Vertrautheit mit dem japanischen No-Spiel, mit all seiner Eleganz und Grazie, dem Gebrauch zeremonieller Kleidung und einem symbolischen Zahlensystem und seinem Frage- und Antwortschema, hat sein künstlerisches Schaffen zutiefst beeinflusst. No ist eine sehr alte Kunst und war im Gegensatz zu Kabuki, das dem einfachen Volk zur Unterhaltung diente, eine Kunstform für die Klasse der Krieger und Samurai. Die Schauspieler tragen Masken, und die dramatischen Elemente werden sparsam eingesetzt, Bewegungen werden sehr langsam zur begleitenden Musik ausgeführt. Tanz ist ein wesentlicher Bestandteil vieler No-Stücke. Die ineinander fließenden Bewegungen (Kata) sind durch den Rhythmus (Ma) strukturiert. Die vom Rhythmus der Tänzer bestimmten Übergänge müssen subtil und lebendig sein. In einem Brief an Dorothy Miller erklärte Byars es so:

»Das ›MA‹ im No-Drama ist die Pause zwischen den Wörtern, eine scheue Abwesenheit, die dem Laut die Möglichkeit des Werdens einräumt. Schöne Augenblicke der Ruhe, alles beinhaltend, isolierte reine Laute, hohe Klarheit, erfüllt von Kummer und Schönheit.«[24]

Byars war vor allem ein Bildhauer, der seine Objekte »aufführte« oder es den Materialien und Objekten gewährte, wie ein Schauspieler in einem Stück zu agieren. Diese Vorstellung teilte er mit Mark Rothko, dem Maler, den er am meisten bewunderte. Rothko betrachtete seine gemalten, fließenden Rechtecke als »Objekte« und »Akteure« in einem emotionalen Drama, die universale Fragen der menschlichen Spannungen auf der Leinwand aufspielten. Die Thematik in Byars' Skulpturen waren nicht Emotionen, sondern rituelle Akte der Körperlichkeit, des Sprechens und des Verstandes. Diese Affinität zu Rothko, dessen Sensibilität er über die Maßen bewunderte, mag Dorothy Miller in ihrem Interesse an Byars ermutigt haben, da auch sie eine frühe und leidenschaftliche Verfechterin von Rothkos Werk war.

Zu den ersten dauerhaften Skulpturen von Byars gehört eine Reihe *Tantrischer Figuren (Ohne Titel),* um 1960, die sich formal am Werk Constantin Brancusis orientieren. Jede Figur besteht aus zwei Granitblöcken, deren oberer mit zwei augenähnlichen Löchern versehen ist. Andere frühe anthropomorphe Holzskulpturen und Keramikgefäße, die Byars nach der Rückkehr von seinem ersten Japanaufenthalt geschaffen hatte, weisen neben Augenlöchern auch Nasen auf und erinnern damit an die hochstilisierten prähistorischen Figurinen der Kykladen. Wie seine spätere, aus einem Basaltblock gefertigte *Figure of Death* und die *Figure of Questions* aus einer vergoldeten Marmorsäule

its practice of articulating answers as questions—profoundly influenced his art. Noh goes back to ancient times. Whereas Kabuki was for the common people, Noh was a performance for the samurai or warrior class. The actors wear masks and dramatic elements are minimal, movements are performed very slowly to the accompaniment of music. Dances are an intrinsic part of many Noh plays. The rhythm *(ma)* structures the movements *(kata)* as they meld into each other. The transitions have to be subtle and alive, pulsed by the dancer's rhythm. As Byars explained in a letter to Dorothy Miller,

The 'MA' in Noh Drama is the interval between words, a scared absence, giving the sound its chance to become. Beautiful quiets, full of everything, isolated pure sounds, high clear, full of sorrow and joy.[23]

Byars was essentially a sculptor who either "performed" his objects or allowed the materials and objects to perform like actors in a play—a notion he shared with the painter he admired most, Mark Rothko. Rothko perceived his painted floating rectangles as "objects" and as "actors" in an emotional drama playing out universal human tensions on his canvases. In Byars's sculptures, what was played out were not emotions but ritual acts of body, speech, and mind. This affinity to Rothko, whose sensibility Byars greatly admired, may have played a role in Dorothy Miller's interest in Byars (she had been an early and ardent champion of Rothko's work). One of Byars's earliest series of permanent sculptures consisted of a series of untitled *Tantric Figures* (ca. 1960). Borrowing formally from Brancusi, each consists of two blocks of granite, the top one featuring two eyelike holes. Other early anthropomorphous wooden sculptures and ceramic vessels, made by Byars after his return from Japan in 1958, also feature noses and are reminiscent of the highly stylized prehistoric figurines found on the Cycladic islands. Like his later *Figure of Death,* constructed from basalt blocks, and *Figure of Questions,* a gilded marble column (both 1986), the tantric figures refer to a philosophical and religious system of practices in Hindu and Buddhist religion that revolve around concepts of time and the conjunctions of the planets. There are two classes of Buddha's teaching—sutras and tantras. While sutras are communicated publicly, tantras are taught individually, but only if the student is ready for them, and their content is kept between the teacher and the student. Thus early sculptures already point to the pedagogical/participatory and meditative aspects of Byars's later works.

Another idea that greatly influenced Byars's art of the sixties was the emergence of speech act theory. The theory of performative speech acts (also referred to simply as "performatives") was introduced by the eminent Oxford analytical philosopher J. L. Austin in a series of lectures given at Harvard University in 1955, and later published under the title *How to Do Things with Words.* The basic question posed by speech act theory was, as John Searle

(beide 1986) stellen die tantrischen Figuren religiös-philosophische Systeme dar, die sich auf Praktiken der hinduistischen und buddhistischen Religion beziehen. Das Denken kreist um Konzepte der Zeit und die Verbindungen der Planeten untereinander. Es gibt zwei Gattungen der buddhistischen Lehre – Sutras und Tantras. Während die Sutras Gegenstand einer öffentlichen Verbreitung sind, werden die Tantras nur individuell gelehrt. Der Lernende muss hierfür bereit sein, und der Inhalt der Lehre dringt nicht aus der Verbindung zwischen Lehrer und Schüler heraus. Auf diese Art weisen diese frühen Skulpturen bereits auf die pädagogisch-partizipatorischen und meditativen Aspekte der späteren Arbeiten Byars' hin.

Eine weitere Idee, die großen Einfluss auf die Kunst der sechziger Jahre hatte, war die neu entstandene Sprechakttheorie. Die Theorie der performativen Sprechakte (auch als »Performative« bezeichnet) war von dem in Oxford tätigen, analytischen Philosophen J. L. Austin in einer Vorlesungsreihe entwickelt worden, die er 1955 in Harvard gehalten hatte. Diese Vorlesungen wurden später unter dem Titel *How to Do Things with Words* veröffentlicht. Die grundlegende Frage dieser Theorie der Sprechakte war, wie der amerikanische Philosoph John Searle formulierte: »Worin besteht die Beziehung von Wörtern zur Welt? Wie kommt es in einer Situation, in der ein Sprecher einem Zuhörer gegenübersteht und ein akustisches Signal aussendet, zu so bemerkenswerten Dingen wie den folgenden: Der Sprecher meint etwas; die Laute, die er von sich gibt, bedeuten etwas; der Zuhörer versteht, was gemeint ist; der Sprecher behauptet etwas, stellt eine Frage oder gibt einen Befehl.«[25] Im Sinne Austins sind performative Äußerungen jene, die Handlungscharakter haben, im Gegensatz zu bloßen Aussagen, wie beispielsweise »ich glaube«, »ich mache«, »ich erkläre«, »ich wette.« So wie sie von Austin und Searle gesehen wird, gibt es in der angloamerikanischen Sprechakttheorie eine Bevorzugung der Funktion gegenüber der Bedeutung. Hierin besteht eine Gemeinsamkeit mit dem französischen Strukturalismus, einer weiteren linguistischen Theorie, die in den sechziger Jahren populär wurde. Beide Theorien beschäftigten sich mehr mit dem Hervorbringen von Bedeutung – dem Akt der Kommunikation – als mit dem Sinngehalt an sich. »Der Grund für die Konzentration auf die Untersuchung von Sprechakten besteht einfach darin, dass zu jeder sprachlichen Kommunikation sprachliche Akte gehören. Die Grundeinheit der sprachlichen Kommunikation ist nicht, wie allgemein angenommen wurde, das Symbol, das Wort oder der Satz, oder auch das Symbol-, Wort- oder Satzzeichen, sondern die Produktion oder Hervorbringung des Symbols oder Wortes oder Satzes im Vollzug des Sprechaktes.«[26] Byars' Aktionen und Skulpturen führen das aus, was Austin »illokutive« Akte nennt: Feststellungen machen, Fragen stellen,

writes, "How do words relate to the world? How is it possible that when a speaker stands before a hearer and emits an acoustic blast such remarkable things occur as: the speaker means something; the sounds he emits mean something; the hearer understands what is meant; the speaker makes a statement, asks a question, or gives an order?"[24] According to Austin, performatives are utterances that perform an action as opposed to simply saying something, for example, "I believe," "I do," "I declare," "I bet." As defined by Austin and Searle, speech act theory shares with French structuralism (another linguistic theory that gained popularity in the sixties) a predilection for function rather than meaning. Both theories are concerned more with the production of meaning—the act of communicating—than with meaning itself: "All linguistic communication involves linguistic acts. The unit of linguistic communication is not, as has generally been supposed, the symbol, word, or sentence, or even the token of the symbol, word, or sentence, but rather the production or issuance of the symbol or word or sentence in the performance of the speech act."[25] Byars's actions and sculptures, including *The Philosophical Chair* (1978), *Figure of Question* (1986), and *The Book of Question* (1987), carry out what Austin called "illocutionary" acts, such as stating, questioning, commanding, promising. What distinguishes speech acts from random noise or gestures is *intention*. Even the arrangement of furniture can be understood as a performative speech act as long as it is the result of intentional behavior. As Searle remarks, "The attitude one would have to such an arrangement of furniture, if one 'understood' it, would be quite different from the attitude I have, say, to the arrangement of furniture in this room, even though in both cases I might regard the arrangement as resulting from intentional behavior."[26] Theater by virtue of its representational function is as much about presence as it is about absence. The actors, costumes, and stage props are as much themselves as they are standing in for someone or something not present; they are present by representing. Thus the epistemologist distrust of theater expressed in Austin's remark that "a performative utterance will . . . be in *a peculiar way* hollow and void if said by an actor on the stage, or if introduced in a poem, or spoken in soliloquy."[27]

According to Samuel Weber, professor of humanities at Northwestern University, the publication of Kierkegaard's book on repetition in 1843, in which Kierkegaard constructs his criticism of Hegel's dialectical philosophy and renounces traditional theater in favor of the farces of popular street theater, should be seen as a watershed at the transition from theater to *theatricality* without theater: "The result is the emergence of a notion of theatricality that exceeds any determinate institutional location while still remaining inseparable from it. In short, no theatricality *without* theater, but also no theatricality that would fit comfortably *within* the fixed dimensions of any existing theater."[28] Weber sees a direct influence of Kierkegaard's distinction of theater and theatricality in many modern

Befehle und Versprechen geben, in Werken wie *The Philosophical Chair* (1978), *Figure of Question* (1986) und *The Book of Question* (1987). Was Sprechakte von willkürlichen Geräuschen oder Gesten unterscheidet, ist die Intention. Selbst die Art und Weise, wie Möbel gestellt werden, kann als performativer Sprechakt verstanden werden, wenn es die Folge eines absichtsvollen Handelns ist. Searle bemerkt hierzu: »Eine solche Anordnung von Möbelstücken würde man, wenn man sie ›verstünde‹, ganz anders auffassen, als ich zum Beispiel die Anordnung der Möbelstücke in diesem Raum, in dem ich gerade schreibe, auffasse, obwohl die Anordnung in beiden Fällen als das Ergebnis intentionalen Verhaltens angesehen werden kann.«[27] Das Theater hat kraft seiner darstellenden Fähigkeiten die Möglichkeit, sowohl auf eine Anwesenheit als auch auf eine Abwesenheit hinzuweisen. Die Schauspieler, Kostüme und Bühnendekorationen sind ebenso sehr sie selbst, wie sie auch eine Vertretung für jemanden oder etwas sind, was nicht da ist; sie sind da, indem sie dargestellt werden. Hieraus folgt das epistemologische Misstrauen dem Theater gegenüber, das Austin so formuliert: »In einer ganz besonderen Weise sind performative Äußerungen unernst oder nichtig, wenn ein Schauspieler sie auf einer Bühne tut oder wenn sie in einem Gedicht vorkommen oder wenn jemand sie zu sich selbst sagt.«[28]

Nach Samuel Weber, Professor für Geisteswissenschaften an der Northwestern University in Chicago, stellt Kierkegaards Buch *Die Wiederholung* aus dem Jahr 1843, in dem er die Kritik an Hegels dialektischer Philosophie formuliert und in dem er die Farcen des beliebten Straßentheaters über das traditionelle Theater stellt, eine Wegscheide auf dem Übergang vom Theater zum Theatralischen ohne Theater dar: »Das Resultat ist das Aufkommen einer Vorstellung des Theatralischen, die jede begrenzte institutionalisierte Örtlichkeit übersteigt, obschon ihr untrennbar verbunden bleibend. Also: Es gibt das Theatralische nicht *ohne* das Theater, aber es gibt das Theatralische auch nicht bequem *innerhalb* der klaren Begrenzungen eines existierenden Theaters verharrend.«[29] Weber sieht einen direkten Einfluss von der Kierkegaardschen Unterscheidung zwischen Theater und Theatralischem auf viele moderne Denker, die das Theatralische in ihre Theorie einführten, unter anderem bei Marx, Nietzsche, Freud, Heidegger und Derrida, deren Schreibstil sowohl dem Theatralischen wie dem Theoretischen verbunden ist. Folglich hat man sich Byars' partizipatorische Spiele, (Ein-Mann-)Performances und Installationen nicht als theatralische Unterhaltung vorzustellen. Auch wenn es öffentliche Ereignisse sind, erfordern sie nicht unbedingt ein Publikum oder Zeugen, zumindest kein »Kunstpublikum«. Lindley Hubbell erinnert sich diesbezüglich an Byars' Vorstellungen: »All die Zeit und der Aufwand (und die Kosten!) stecken in etwas, das nur für einen kurzen Moment und nur von einer

thinkers who introduced theatricality into theory, including Marx, Nietzsche, Freud, Heidegger, and Derrida, creating a style of writing that is as *theatrical* as it is *theoretical.* Thus one must not think of Byars's (participatory) plays, (one-man) performances, and installations as theatrical entertainment. While they are public events, they do not necessarily require an audience or witness, at least not an "art" audience. Lindley Hubbell recalls this about Byars's "presentations": "All that time and effort (and expense!) go into something to be seen for only a moment and by only one person. Sometimes not even one person. Once he wrote asking me to come and see one of his 'presentations' which was to take place at 5 a.m. in the grounds of the Imperial Palace [in Kyoto]. I refused to get up so early. Afterwards he wrote to me, 'It was quite nice. It was witnessed by a policeman and a dog.'"[29]

Byars never worked completely on his own, however. He was often assisted by his female companions: in Japan, by Taki Sachiko; in Europe in the seventies, by B. B. Grögel, his German companion to whom many referred as "Byars's double," since both usually wore matching outfits; and in his later years, by his wife, Gwendolyn (Wendy) Dunaway. (A reunion between Taki, who now lives in Los Angeles, and Byars was arranged by Kiochi Toyama, the curator of the Toyama Memorial Museum near Tokyo, which Byars visited in 1997, during his last visit to Japan. The reunion took place in Santa Fe six months before Byars's death.)

In an interview, Yvonne Rainer once described performance as "an epiphany of beauty and power."[30] Byars's works should be thought of as epiphanies of beauty and knowledge.

The Art of Happenstance

In the romantic comedy *Le Battement d'aile du papillon* by the French film director Laurent Firode (released in the U. S. under the title *Happenstance*), a group of strangers become connected during the course of a single day by random events (a thrown pebble, lettuce falling off a truck, grains of sand blowing out of an open window) that in the end fulfill the predestined fates of two of them, who happen to share the same birthday, as predicted by their horoscopes. The French title refers to the so-called "butterfly effect," ascribed to the MIT meteorologist Edward N. Lorenz, who first explored the existence of "chaotic attractors." Attractors are geometric forms that result from the long-term behavior of a chaotic system, proving that even random systems can be "predictable." In a paper delivered in 1963 at the New York Academy of Sciences, Lorenz remarked that one flap of a seagulls' wing could alter the weather. A decade later, the seagull had evolved into the more poetic butterfly in the title of a talk given in 1972: "Does the Flap of a Butterfly's Wings in Brazil Set off a Tornado in Texas?"

Person zu sehen ist. Manchmal sogar von niemandem. Er bat mich ein-mal schriftlich, eine seiner ›Darstellungen‹ anzuschauen, die um fünf Uhr morgens auf dem Gelände des kaiserlichen Palastes [in Kyoto] stattfin-den sollte. Ich wollte aber nicht so früh aufstehen. Später schrieb er mir: ›Es war ganz nett. Ein Polizist und ein Hund haben es beobachtet.‹«[30]

Byars arbeitete niemals völlig allein. Oft waren es seine weiblichen Begleiterinnen, die ihm halfen: In Japan war es Taki Sachiko; in Europa in den siebziger Jahren seine deutsche Gefährtin B. B. Grögel, die von vielen »Byars' Double« genannt wurde, da beide meistens die glei-che Kleidung trugen; schließlich in seinen späteren Jahren seine Frau Gwendolyn (Wendy) Dunaway. (Ein Wiedersehen zwischen Taki, die jetzt in Los Angeles lebt, und Byars wurde von Kiochi Toyama arran-giert. Kiochi Toyama ist Kurator des Toyama Memorial Museum in der Nähe von Tokio, das Byars 1997, bei seinem letzten Aufenthalt in Japan, besuchte. Das Treffen fand 1996 in Santa Fe statt.)

In einem Interview bezeichnete Yvonne Rainer Performance als »eine Epiphanie von Schönheit und Macht«.[31] Byars' Arbeiten können als Epiphanien der Schönheit und des Wissens verstanden werden.

Die Kunst des Zufalls

In der romantischen Komödie *Le battlement d'aile du papillon* des franzö-sischen Regisseurs Laurent Firode kommt eine Gruppe von bis dahin un-tereinander unbekannten Personen durch eine Reihe zufälliger Ereignisse im Laufe eines Tages (wie das Werfen eines Kieselsteins, das Fallen eines Salatkopfs von einem Lastwagen, den Flug von Sandkörnern durch ein offenes Fenster) miteinander in Kontakt. Zum Schluss erfüllt sich das vor-herbestimmte Schicksal zweier Protagonisten, die zufällig am gleichen Tag Geburtstag haben, auf die ihnen in ihrem Horoskop vorhergesagte Weise. Der Titel bezieht sich auf den so genannten »Schmetterlingseffekt«, einen Begriff, den Edward N. Lorenz, Meteorologe am Massachusetts Institute of Technology (MIT) eingeführt hatte, nachdem er erstmals die Existenz »chaotischer Attraktoren« bemerkte. Attraktoren sind geometri-sche Formen, die aus dem Langzeitverhalten eines chaotischen Systems resultieren. Hierin zeigte sich, dass selbst Zufallssysteme »vorhersag-bar« sind. In einem Vortrag an der New York Academy of Science merk-te Lorenz 1963 an, dass der Flügelschlag einer Möwe den Verlauf des Wetters ändern könne. Ein Jahrzehnt später, bei einem Vortrag im Jahr 1972, hatte sich die Möwe in den poetischeren Schmetterling verwandelt. Der Titel lautete: »Löst der Flügelschlag eines Schmetterlings in Brasilien einen Tornado in Texas aus?«

The "Great James Lee Byars" (as he often signed his letters and post-cards) was attracted to great minds of his time. Byars believed that to ac-complish the extraordinary, one must seek out extraordinary minds. In 1969 he conceived the idea of the World Question Center, a synthesis of the one hundred most brilliant minds, who would be locked together in a room to ask each other questions. He visited the Brain Research Institute in Berkeley, the Hudson Institute (where he met with the mathematician and nuclear strate-gist Herman Kahn), and traveled to Oxford University to meet the philoso-pher and Wittgenstein translator Elizabeth (G. E. M.) Anscombe to discover which questions existed in the faculty of philosophy. There he spoke to two doctoral candidates who were studying event identity about the difference between extraordinary events and miracles. Other great minds that crossed his path include the Nobel laureate and discoverer of the quark particle, Murray Gell-Mann; the physicist and science writer, Heinz R. Pagels (who once brought the MIT professor Seth Lloyd to a Byars opening and pro-ceeded to heckle and insult Byars until he got some entertaining responses); and author and internet entrepreneur John Brockman. Inspired by Byars's World Question Center and by their long friendship dating back to the sev-enties, Brockman, in 1981, founded the Reality Club, an intellectual forum, now online. In a 1964 letter to Wernher von Braun at NASA, Byars inquired whether it would be possible "to employ a government rocket or satellite" to send a folded piece of white paper measuring eight miles by four inches into space "to be dropped to fall on our beautiful prairie at its flattest point using international instantaneous Tel-Star announcements." Later he proposed a similar idea to Alicia Legg, associate curator at the Museum of Modern Art, a "Global Spontaneity" event or "Galaxy Show" to consist of one-minute presentations of all means of expression—painting, sculpture, poetry, mu-sic—and employing Wernher von Braun's Tel-star communications satellite for a "global-visual announcement."[31]

For Byars, communication was asking questions. In a 1995 conversation with Joachim Sartorius he said:

> By attaching a question mark to any statement I fill that statement with life and move it into the realm of art or poetry . . . The symbol for the in-terrogative philosophy is the point, from which arises the perfectly round O and then the Q—for QUESTION . . . One could imagine a philosophy that is rooted in the idea that every philosopher makes of 'the question.' . . . When the question arises, it contains information which is applicable to the highest intellectual level.[32]

As architect Robert Landsman, who had met Byars in Kyoto and later in-vited him to stay in his Central Park West apartment in New York, remarked,

Der »große James Lee Byars« (wie er oft seine Briefe und Postkarten unterschrieb) fühlte sich von den großen Denkern seiner Zeit angezogen. Er war der Ansicht, dass man die außergewöhnlichen Denker aufspüren müsse, wolle man das Außergewöhnliche erreichen. 1969 entwickelte er die Idee des »World Question Center«, eines Zusammentreffens der 100 fähigsten Denker, die in einem Raum eingeschlossen werden sollten, um sich gegenseitig Fragen zu stellen. Er besuchte das Institut für Hirnforschung in Berkeley, das Hudson Institute (wo er den Mathematiker und Nuklearstrategen Herman Kahn traf) und reiste nach Oxford, um dort die Philosophin und Wittgenstein-Übersetzerin Elizabeth (G. E. M.) Anscombe zu treffen und von ihr zu hören, welche Fragen in der Philosophischen Fakultät derzeit anstünden. Hier sprach er auch mit zwei Doktoranden, die sich mit der Identität von Ereignissen befassten, über den Unterschied zwischen außergewöhnlichen Ereignissen und Wundern. Unter weiteren großen Denkern, denen er begegnete, befanden sich der Nobelpreisträger und Entdecker der Quarks, Murray Gell-Mann, der Physiker und Wissenschaftsautor Heinz R. Pagels (der einmal den MIT-Professor Seth Lloyd zu einer Veranstaltung von Byars mitnahm und Byars so lange mit Fragen auf die Nerven ging und beleidigte, bis dieser ihm einige unterhaltsame Antworten gab) sowie der Autor und Internetunternehmer John Brockman. Angeregt durch die lange, bis in die siebziger Jahre zurückgehende Freundschaft mit Byars und dessen Idee eines World Question Centers, gründete Brockman 1981 den »Reality Club«, ein intellektuelles Forum, das jetzt über das Internet zugänglich ist.

Bereits 1964 hatte Byars in einem Brief an Wernher von Braun bei der NASA angefragt, ob es möglich wäre, »eine Rakete oder einen Satelliten der Regierung zu verwenden«, um ein gefaltetes weißes Papier von der Größe 8 Meilen x 4 Zoll (ca. 13 km x 10 cm) in den Weltraum zu schicken, »um es über unserer schönen Prärie an ihrem flachsten Punkt fallen zu lassen und dabei augenblickliche, internationale Telstar-Satellitenankündigungen zu benutzen.« Später richtete er eine ähnliche Anfrage an Alicia Legg, Kuratorin am Museum of Modern Art, der er ein »Globales Spontaneitäts-Event« oder eine »Galaxieausstellung« vorschlug, die aus einminütigen Präsentationen aus allen Kunstrichtungen – Malerei, Bildhauerei, Dichtung, Musik – bestehen und Wernher von Brauns Telstar-Satelliten für eine »global-visuelle Verbreitung« mit einbeziehen sollte.[32]

Für Byars war Kommunikation das Stellen von Fragen. In einem Gespräch mit dem Publizisten Joachim Sartorius erklärte er 1995:

»Ich denke, dass ich durch das Anhängen eines Fragezeichens an eine Aussage diese Aussage mit Leben fülle und sie in den Bereich

"The three people [Byars] admired most were Stein, Einstein, and Wittgenstein."[33] With the writer and poet Gertrude Stein he shared a fondness for word play; with the analytical philosopher Ludwig Wittgenstein, an obsession with questions; and with Albert Einstein, a fixation on time. Byars's art and life seem to have been affected by Einstein's time dilation: the phenomenon of time as it appears to almost come to a full stop as particles approach the speed of light. Like the theoretical physicist Stephen Hawking, who suffers from incurable amyotrophic lateral sclerosis, Byars, a master thief of time, was in a state of compressed acceleration, which intensified towards the end of his life as he was fighting cancer. It brought his sculptures close to Hawking's "event horizon," which defines the edge of black holes, beyond which there is no difference between extraordinary events and miracles. Just as, in quantum theory, particle waves are not in real time but take place in *imaginary* time, so Byars's art takes place in imagined time and can be observed in real time only *after* it has occurred—in the form of installations, photographs, postcards, telegrams, phone calls, and other ephemeral souvenirs. Byars's art is essentially immaterial. Its presence lasts often only for a second. It is the art of *absence.* For Byars the perfect presence was the perfect absence or death.

In Japan Byars supported himself by teaching English at Doshisha University in Kyoto, an activity which he occasionally turned into performance. Robert Landsman recalls one particular lesson on a late-spring evening. That day Byars instructed his class not to speak and to follow him out of the school to his apartment, where he had laid a ten by ten foot piece of white paper on the floor. He then asked his students to lie face down on the paper forming a circle with their heads meeting at its center, while in the backroom Landsman played the *shakuhachi,* a Japanese bamboo flute, traditionally performed in Shinto ceremonies by monks. Later, as Landsman joined the students on the floor, a large insect suddenly flew through the open window into the room and began to dance inside the circle on the paper, before dropping dead. Byars put his finger on his lips, then gestured his class to get up and leave. His "English" lesson had ended. Byars had already mastered the art of happenstance.

In Byars's works, as in Laurent Firode's film, nothing and everything happens by chance. Even Byars's first "exhibition" in New York in 1958, at the Museum of Modern Art, occurred as a result of happenstance. Impressed by a Rothko painting he had seen exhibited at the Cranbrook Academy outside of Detroit, Byars hitchhiked to New York with some drawings, walked to the Museum of Modern Art, and asked the receptionist for Mark Rothko's address so he could show him his paintings on paper, which he had brought from Japan. The staff at the museum was so impressed by Byars's appearance that, after explaining that the museum's policy does not allow giving out the addresses of artists, the receptionist called the museum's curator, Dorothy Miller, to come down and meet this strange young man. Byars visited Miller

der Kunst oder Poesie rücke [...] Das Urzeichen [...] für die fragende Philosophie ist der Punkt, aus dem sich dann das vollkommen runde O und dann das Q – für Question – ergibt [...] Man könnte sich eine Philosophie vorstellen, die in der Vorstellung wurzelt, die sich jeder Philosoph von ›der Frage‹ macht [...] Wenn die Frage auftaucht, enthält sie die Information, die auf die höchste geistige Wahrnehmung anwendbar ist.«[33]

Wie der Architekt Robert Landsman berichtete, der Byars in Kyoto getroffen hatte und ihn später einlud, in seinem Apartment am Central Park West in New York zu wohnen, waren die »drei Personen, die Byars am meisten bewunderte, Stein, Einstein und Wittgenstein.«[34] Mit der Dichterin und Schriftstellerin Gertrude Stein teilte er die Begeisterung für Wortspiele, mit dem sprachanalytischen Philosophen Ludwig Wittgenstein das leidenschaftliche Interesse an Fragen und mit Albert Einstein die fortwährende Beschäftigung mit dem Thema Zeit. Der Einsteinsche Effekt der »Zeitdehnung« scheint sich auf Byars' Kunst und Leben ausgewirkt zu haben: Das Phänomen der Zeit nähert sich in dem Maße dem Stillstand, in dem sich Partikel der Lichtgeschwindigkeit annähern. Wie der an unheilbarer amyotropher Lateralsklerose leidende theoretische Physiker Stephen Hawking befand sich auch Byars, ein meisterhafter Zeitdieb, in einem Zustand der komprimierten Beschleunigung. Dies verstärkte sich gegen Ende seines Lebens, als er gegen den Krebs kämpfte. Seine Skulpturen rückten so in die Nähe von Hawkings »Ereignishorizont«, der die Begrenzung der Schwarzen Löcher bildet und jenseits dessen es keine Unterschiede zwischen außergewöhnlichen Ereignissen und Wundern gibt. Genau wie in der Quantentheorie die Bewegungen der Partikel nicht in der realen Zeit,

frequently thereafter or sent sketches of his new paintings. During that time, Miller bought one of his paintings for herself, helped him apply for a grant at the Guggenheim Foundation, introduced him to a young dealer, Marion Willard, who gave him his first show in her New York gallery, and even lent him money and temporarily stored his work in her office. At their first meeting Miller agreed to let Byars hang some of his paper paintings in the emergency stairwell for one evening. Several were sold, including one to the architect Philip Johnson. The exhibition apparently lasted only several hours, and Byars delivered the sold pieces personally that night to the collectors' homes. Byars returned to Detroit and Wayne University, where he began to experiment with ceramics and wooden sculptures, having been unable to raise enough money to return to the Orient, "to Japan, where I belong." "My Life and paintings both seem to belong there," he wrote to Miller in 1960, "where the simple essence of existence has a daily meaning."[34]

Miller continued to be supportive for many years, meeting with him, if her schedule allowed it, during his frequent visits to New York. Each time Byars begged Miller to introduce him to Rothko and the Japanese-American sculptor Isamu Noguchi. Once Byars hauled paintings, pottery, sculptures, forms, wooden, bronze, and clay sculptures in a brand-new Cadillac, which he drove from Detroit to New York for the owner. There is a wry reference to his first exhibition with Miller in a note he sent her in 1965, after a proposal to do a collaborative project with the Guggenheim and MoMA had failed:

Dear Miss Miller
I want to thank you
for helping my 'GUGGTRY.'
My dilemma is painfully difficult
please let me know

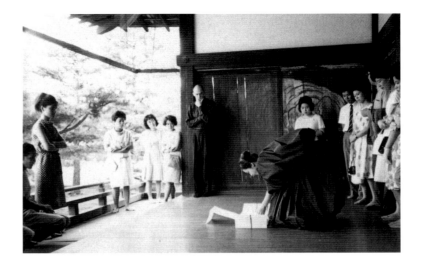

UNTITLED OBJECT (1 x 200 FOOT PAPER) OBJEKT OHNE TITEL (1 x 200 FUSS PAPIER) 1962–64
PROCESSIONAL PROZESSION SHOKOKU-JI HOJO, KYOTO 1964

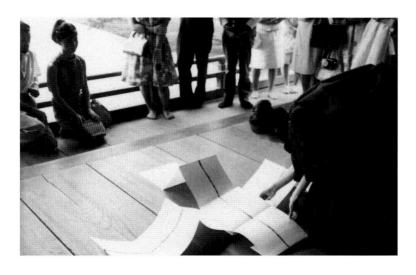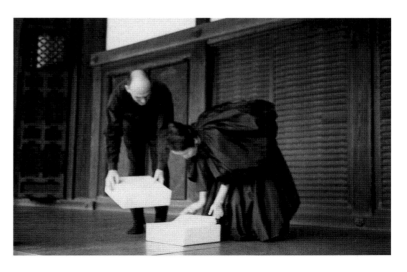
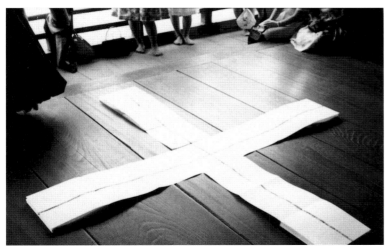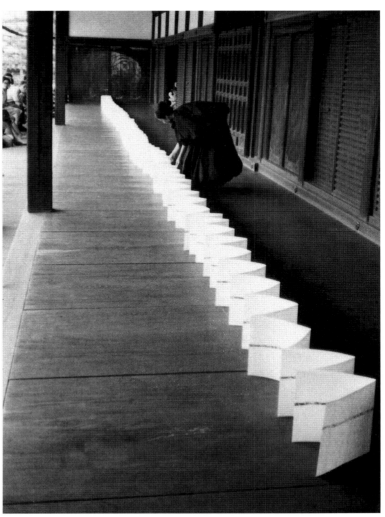
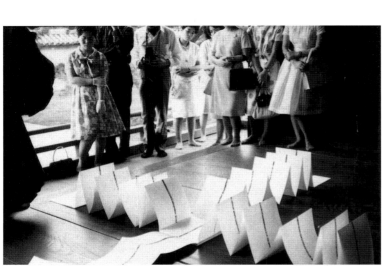

sondern in der imaginären Zeit stattfinden, ereignet sich Byars' Kunst in der imaginierten Zeit und kann in der realen Zeit – in Form von Installationen, Fotografien, Postkarten, Telegrammen, Anrufen und anderen vergänglichen Souvenirs – erst dann beobachtet werden, wenn sie schon stattgefunden hat. Byars' Kunst ist dem Wesen nach immateriell, sie ist oft nur für die Dauer einer Sekunde anwesend. Es ist eine Kunst der Abwesenheit. Für Byars war die vollkommene Anwesenheit die vollkommene Abwesenheit oder der Tod.

In Japan verdiente Byars sich seinen Lebensunterhalt mit Englischunterricht an der Doshisha Universität in Kyoto, den er gelegentlich in eine Performance verwandelte. Robert Landsman erinnert sich besonders an eine abendliche Unterrichtsstunde im Spätfrühling. Byars hatte seine Klasse angewiesen, nicht zu sprechen und ihm aus der Schule zu seinem Apartment zu folgen. Dort hatte er ein 3 x 3 Meter großes Stück weißes Papier auf den Boden gelegt. Er bat seine Studenten, sich mit dem Gesicht nach unten auf das Papier zu legen, wobei die Körper eine Art Stern mit den Köpfen im Zentrum bildeten. Im Nebenraum spielte Landsman auf der Shakuhachi, einer japanischen Bambusflöte, die traditionell bei Shinto-Ritualen von Mönchen gespielt wird. Später, als Landsman sich zu den Studenten auf den Boden gelegt hatte, kam plötzlich ein großes Insekt durch das Fenster hereingeflogen und tanzte in der Mitte des Kreises auf dem Papier, bis es tot zu Boden fiel. Byars legte den Finger an die Lippen und bedeutete seiner Klasse durch Gesten, sich zu erheben und den Raum zu verlassen. Seine »Englischstunde« war beendet. Er war bereits damals ein Meister der Kunst des Zufalls.

Wie in dem Film von Laurent Firode ist auch in den Werken von Byars alles und nichts vom Zufall abhängig. Selbst seine erste »Ausstellung«, die 1958 im Museum of Modern Art in New York stattfand, erscheint als Resultat solcher Zufälligkeiten: Byars war so beeindruckt von einem Bild von Mark Rothko, das er in der Cranbrook Academy of Art in der Nähe von Detroit gesehen hatte, dass er mit einigen seiner Papierbilder, die er aus Japan mitgebracht hatte, nach New York trampte. Er ging in das Museum of Modern Art und fragte am Empfang nach Rothkos Adresse, weil er ihm seine Bilder zeigen wollte. Das Personal erklärte ihm, dass es gegen die Richtlinien des Museums verstoße, die Adressen der Künstler herauszugeben, man war aber so beeindruckt von Byars' Erscheinung, dass Dorothy Miller, Kuratorin des Museums, gebeten wurde, zum Empfang zu kommen und diesen merkwürdigen jungen Mann in Augenschein zu nehmen. Byars besuchte Miller daraufhin häufig oder schickte ihr Skizzen seiner neuen Bilder. Sie kaufte eines seiner Bilder für sich selbst, half ihm in dieser Zeit bei der Bewerbung für das Stipendium der Guggenheim Foundation und stellte ihn der jungen

if I can use your
fire escape?[35]

And another reference in a letter from December 1967:

Do you have new technologies that I don't know about in the museum? Instant changing rooms? Always ready space . . . what's in the fire escape?[36]

Paradoxically, Byars always counted on coincidences, accidents, happenstances, "circumstances," and miracles. This certitude was reenforced by his extremely charismatic personality and a certain attractive naiveté and unwordliness. His participation in the Carnegie International exhibition in 1965, for instance, was the result of a chance meeting of Byars with the director of the Carnegie, Gordon Bailey Washburn, in Central Park.

Several miracles have come—At the Carnegie Institute Parthenon. Unknown noon Nov. 6 a Benedictine nun quietly performed one of my works. It was by accident or surprise that I went there.[37]

During the Carnegie International, Sister M. Germaine, O. S. B., performed two paper object by Byars: *1 x 50-Foot Drawing* and *A 1,000-Foot Chinese Paper,* both times in the sculpture court of the Carnegie Institute.

In 1966 Byars rented Marcel Duchamp's old New York studio on the top floor of 210 West Fourteenth Street, which Duchamp vacated at the end of 1965 after having worked there since 1943.

Curiously, I walked by
Duchamp's old studio and
it was just being made to
let. I have it all white with
floor, too, and a west bank
of opaque gray glass. Mysterious
circumstances, again![38]

And to Sam Wagstaff he wrote:

By luck I walked by Duchamp's old place and it was being put to let, I'm there at 210 west 14 top floor, if you are free sometime I would enjoy seeing you . . . PS Sorry no phone.[39]

(Duchamp was notorious for never having a phone in his studio.)

Galeristin Marion Willard vor. Sie arrangierte seine erste Ausstellung in deren New Yorker Galerie, lieh ihm sogar Geld und hob zeitweise seine Arbeiten in ihrem Büro auf. Dorothy Miller hatte Byars bei ihrem ersten Treffen gestattet, seine Bilder für einen Abend im Nottreppenhaus des Museums aufzuhängen. Er behängte die gesamte Feuertreppe und verkaufte einige Bilder, unter anderem eines an den Architekten Philip Johnson. Die Ausstellung dauerte angeblich nur einige Stunden, und die verkauften Bilder wurden noch in derselben Nacht von Byars bei ihren neuen Besitzern abgeliefert. Byars kehrte nach Detroit und an die Wayne University zurück, wo er an Keramiken und Holzskulpturen zu arbeiten begann. Er hatte nicht genügend Geld, um in den Orient zurückzukehren, und sehnte sich doch »nach Japan, wohin ich gehöre«. An Dorothy Miller schrieb er im Jahr 1960: »Mein Leben und meine Bilder scheinen dorthin zu gehören, wo das einfache Wesen der Existenz eine tägliche Bedeutung hat«.[35]

Miller unterstützte Byars über viele weitere Jahre und traf sich mit ihm, wenn es ihr Terminkalender zuließ, während seiner häufigen Besuche in New York. Er bat Miller bei jeder Gelegenheit, ihn mit Rothko und dem japanisch-amerikanischen Bildhauer Isamu Noguchi bekannt zu machen. Einmal transportierte Byars Bilder, Keramiken, skulpturale Formen, Skulpturen aus Holz, Bronze und Ton in einem nagelneuen Cadillac, den er im Auftrag des Eigentümers von Detroit nach New York überführte. In einer Nachricht, die er 1965 an Dorothy Miller geschickt hatte, nachdem sich die Möglichkeit eines gemeinsamen Projektes von Guggenheim und MoMA zerschlagen hatte, befindet sich ein ironischer Hinweis auf seine erste Ausstellung mit ihr:

»Liebe Miss Miller,
ich möchte Ihnen danken
für die Hilfe bei meinem ›GUGGVERSUCH‹.
Mein Dilemma ist von schmerzhafter Schwierigkeit,
bitte sagen Sie mir,
ob ich Ihre Feuertreppe
benutzen kann?«[36]

Ein weiterer Hinweis befindet sich in einem Brief vom Dezember 1967:

»Gibt es neue technische Dinge im Museum, die ich noch nicht kenne? Neue Umkleideräume? Zur Verfügung stehender Platz [...] Befindet sich etwas in dem Nottreppenhaus?«[37]

Paradoxerweise verließ Byars sich immer wieder auf Fügungen, Zufälle, Unfälle, »Begleitumstände« aller Art und Wunder. Diese Gewissheit wurde

What made Byars's work and life most remarkable was the near hypnotic effect they had on others. He was able to enact seemingly random events by some form of "psychic magnetism." He was a conjurer who bet the fate of his art on random events supervised by carefully orchestrated rituals. His performances were chaotic attractors: a combination of control and random intervention. He was alternately a sleight-of-hand artist and a truth-seeking philosopher—two roles that for him were not contradictory. In his performative works, the extraordinary and the miraculous often became one. In her recommendation letter in support of Byars's application for a Guggenheim Foundation grant, written in 1961, Miller recalls, "When James Byars appeared in 1959 [sic] at the museum . . . several members of the staff talked to him and became interested in his unusual personality. He seemed quite unworldly and though he was living with his family in Detroit he appeared to be isolated from any appreciation or understanding of what he was trying to do in his art . . . Both his sculptures and his 'paintings' have an immediate appeal to a number of people (I observed this myself)."[40]

Kierkegaard famously distinguished between "genius" and "apostle" —two exclusionary figures, one standing for absolute knowledge, the other for absolute faith. Byars managed to wear both hats (in fact, he would literally alternate between a red hat and a black hat), at times playing the role of the analytical philosopher and founder of the World Question Center and at other times, the spiritual artist/apostle, who rejoiced in the paradoxes of faith.

Byars's works of the late fifties and early sixties consisted primarily of large-scale black-ink drawings on paper that predated Richard Serra's black-and-white drawings by at least a decade, and performative sculptures made of hundreds of sheets of hinged traditional Japanese flax or *kozo* (mulberry) paper folded into solid geometric shapes. Byars was one of a number of artists (such as Richard Tuttle and Serra; with the latter, Byars shared an admiration for Brancusi's 1908 sculpture, *The Kiss*) who, in the sixties and seventies, expanded the medium of drawing into sculpture. At the opening of the 1967 Kyoto Independents exhibition held by the National Museum of Modern Art in Kyoto, Byars and a friend, Rem Stone, "performed" a paper scroll, two feet wide and one hundred feet long, which was attached to a pole, forty feet high. The audience was held in suspense as foot after foot of blank paper was unrolled until finally a drawn shape was revealed, followed by an equal amount of blank paper. Both then stood for three hours without moving and, according to Lindley Hubbell, were almost paralyzed afterwards. In Kyoto, many of Byars's paper works were "performed" by Taki Sachiko dressed in black ceremonial garb. She is seen in several photographs taken at the Shokoku-ji temple near Doshisha University, which Byars rented for two hours on June 21, 1964, performing a "processional" or "single object presentation" of an untitled accordion-folded paper object

noch verstärkt durch seine sehr charismatische Persönlichkeit, eine anziehende Naivität und Weltfremdheit. Byars' Mitwirkung an der Carnegie-International-Ausstellung im Jahr 1965 war beispielsweise seinem zufälligen Zusammentreffen mit dem Direktor des Carnegie Museums, Gordon Bailey Washburn, im Central Park 1964 zu verdanken.

> »Einige Wunder sind geschehen – Im Carnegie Institut Parthenon.
> Unbekannterweise am 6. November mittags hat eine
> Benediktinernonne ganz leise eines meiner Werke aufgeführt.
> Zufall oder Überraschung, dass ich dort vorbei kam.«[38]

Bei dieser Ausstellung hatte Schwester M. Germaine zwei von Byars' Papierarbeiten aufgeführt, *1 x 50 Foot/50-Foot Drawing* und *A 1,000-Foot Chinese Paper*, beide im Skulpturenhof des Carnegie Instituts in Pittsburgh.

1966 mietete Byars das frühere Atelier von Marcel Duchamp im obersten Stockwerk des Hauses Nummer 210 in der 14. Straße in New York. Duchamp hatte das Atelier Ende 1965 verlassen, nachdem er dort von 1943 an gearbeitet hatte.

> »Eigenartigerweise lief ich
> an Duchamps altem Studio vorbei
> und es wurde gerade zum Vermieten hergerichtet.
> Ich nehme es, alles weiß, der Boden auch,
> und eine Fensterbank nach Westen aus opakem, grauem Glas,
> abermals geheimnisvolle Umstände!«[39]

An Sam Wagstaff schrieb er:

> »Per Zufall lief ich an Duchamps altem Atelier vorbei und es war
> zu vermieten, ich bin jetzt 210 West 14, oberstes Stockwerk,
> wenn du Zeit hast, würde ich dich sehr gerne sehen ...
> P. S. Tut mir Leid, kein Telefon.«[40]

(Duchamp war bekannt dafür, dass er nie ein Telefon in seinem Atelier hatte.)

Was das Leben und Werk von Byars so besonders machte, war die beinahe hypnotische Wirkung, die er auf andere ausübte. Seine Fähigkeit, scheinbar zufällige Ereignisse heraufzubeschwören, könnte man fast als »psychischen Magnetismus« bezeichnen. Er war ein Zauberer, der das Schicksal seiner Kunst von Zufälligkeiten abhängig machte, die aber von fein abgestimmten Ritualen gelenkt wurden. Seine Performances waren chaotische Attraktoren: eine Kombination aus Kontrolle und

(1 x 1 x 211 feet), which he later gave to the collection of the Museum of Modern Art, New York.

One of his best-known performative sculptures from the period is *Untitled Object (Runcible)* (1962–64), also known as *Performable Square,* an eighteen-by-eighteen-by-eighteen-inch cube consisting of one thousand sheets of white flax paper that unfold into a fifty-by-fifty-foot white plane divided by thirty-two parallel strips connected at the top with paper hinges. It was first exhibited at the National Museum of Modern Art, Kyoto, in 1964, in the center of the museum floor, placed on a sheet of glass but not performed until fourteen years later, in March 1978, during Byars's exhibition at the University Art Museum in Berkeley, California. There it was unfolded by the exhibition's curator, James Elliott, with the assistance of David Ross, Mark Rosenthal, and Earl Michaelson. In 1966 it was given to the Museum of Modern Art, New York, "in total anonymity" by Byars, together with two other paper objects, *Untitled Object (A Mile-Long Paper Walk)* and *Untitled Object (Rivet Continuity)* (both 1962–64, the latter can be arranged as a halo or as a star or it can be hung on a wall by means of hollow eye rivets). *Runcible* has not been performed since. In his instructions to Dorothy Miller, Byars wrote: "Any portion of plane may be reduced by simply closing it up. The entire object is performable or may be used as a put out . . . All pieces kept in visual sequence both within the paper making process and in the construction of the object (All left to right beginnings)."[41] The title *Runcible,* meaning "gigantic," was later given to the work by Byars. The word had been coined by Edward Lear, the British nineteenth-century nonsense poet and author of *The Owl & The Pussy-Cat.* (Lear once wrote the remarkable sentence, "His body is perfectly spherical/He weareth a runcible hat.")

Byars's best-known and most spectacular performative sculpture was *The Giant Soluble Man (500' Dissolvo-Man)* which was presented on Fifty-third Street between Fifth and Sixth Avenue in New York on November 16, 1967, during the opening of the "Made With Paper" exhibition held simultaneously at the Museum of Contemporary Crafts and at the Time-Life Exhibition Center, and sponsored by the Container Corporation of America. The large silhouette of a man glued together from five-hundred feet of white Dissolvo paper—a water-soluble paper donated by the Gilbreth paper company—covered all of Fifty-third Street between Fifth and Sixth Avenue from curb to curb. It was performed with the help of the New York City Police Department, which stopped the traffic and removed all cars from the block. On Byars's signal, two street-cleaning trucks from the Department of Sanitation drove over the paper, spraying it with water, which caused the paper to dissolve.

Zufälligkeiten. Er war abwechselnd ein taschenspielender Künstler und ein Wahrheit suchender Philosoph – für ihn lag in diesen beiden Rollen kein Widerspruch. In seinen performativen Arbeiten verschmolzen oft das Außergewöhnliche und das Wundersame zu einer Einheit. In einem Brief, den Dorothy Miller 1961 geschrieben hatte, um Byars' Bewerbung für das Stipendium der Guggenheim Foundation zu unterstützen, erinnert sie sich: »Als James Byars 1959 [sic] im Museum [...] erschien, unterhielten sich einige Mitarbeiter mit ihm, da ihr Interesse durch seine ungewöhnliche Persönlichkeit geweckt worden war. Er schien nicht ganz von dieser Welt zu sein, und auch wenn er mit seiner Familie in Detroit lebte, machte er doch den Eindruck, als ob niemand ihm Verständnis oder Anerkennung für das, was er mit seiner Kunst versuchte, entgegenbrächte [...] Sowohl seine Skulpturen als auch seine ›Gemälde‹ üben (wie ich selbst beobachtet habe) eine ganz unmittelbare Anziehungskraft auf etliche Menschen aus.«[41]

Von Kierkegaard stammt die berühmte Unterscheidung zwischen »Genie« und »Apostel« – zwei sich einander ausschließenden Figuren, von denen die eine das absolute Wissen, die andere den absoluten Glauben verkörpert. Byars füllte beide Rollen aus und trug sogar die zur jeweiligen Rolle passende Kopfbedeckung, einen roten beziehungsweise einen schwarzen Hut. Zeitweise spielte er die Rolle des analytischen Philosophen und Gründers des World Question Centers, ein anderes Mal war er der spirituelle Künstler und Apostel, der sich für das Paradox des Glaubens begeisterte.

Die Arbeiten von Byars in den späten fünfziger und frühen sechziger Jahren waren zumeist großformatige, schwarze Tuschzeichnungen auf Papier; sie waren damit mindestens ein Jahrzehnt vor den Zeichnungen Richard Serras entstanden. Zum anderen schuf er performative Skulpturen aus Hunderten Blättern von gefalztem, traditionellem japanischem Flachs- oder Kozopapier (das aus Maulbeerbäumen hergestellt wird), die er zu geometrischen Körpern faltete. Byars gehörte, neben Richard Tuttle und Serra, mit dem er die Begeisterung für Brancusis 1908 entstandene Skulptur *Der Kuss* teilte, zu einer Gruppe von Künstlern, die in den sechziger und siebziger Jahren das Medium der Zeichnung zur Skulptur hin erweiterten. Bei der Eröffnung der Ausstellung der Kyoto Independents 1967 im National Museum of Modern Art in Kyoto zeigte Byars gemeinsam mit einem Freund, Rem Stone, die »Aufführung« einer Papierrolle. Das Papier mit einer Breite von ca. 60 Zentimetern und einer Länge von ca. 30 Metern war an einer etwa 12 Meter hohen Stange befestigt. Das Publikum beobachtete mit Spannung, wie viele Meter weißes Papier entrollt wurden, bis schließlich eine gezeichnete Form zum Vorschein kam, der wiederum genauso viel weißes Papier folgte. Byars und Stone standen anschließend drei

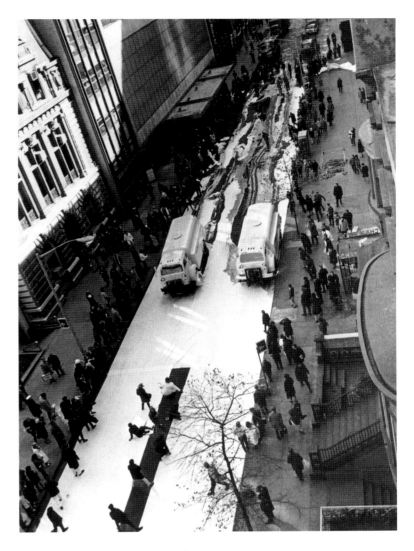

THE GIANT SOLUBLE MAN **DER GIGANTISCHE LÖSLICHE MANN**
NEW YORK 1967

Stones for Speech: "Announcing Perfect until It Disappears"

"The processes of naming the stones . . . might also be called language-games. Think of much of the use of words in games like ring-a-ring-a-roses."
Ludwig Wittgenstein, *Philosophical Investigations* (1953)

There are a number of references to T. S. Eliot's poem "The Dry Salvages" (from *Four Quartets*) in Byars's correspondence, including xeroxed copies

Stunden regungslos da und waren, nach Aussage von Lindley Hubbell, nach dieser Performance beinahe paralysiert.

In Kyoto wurden viele von Byars' Papierarbeiten von Taki Sachiko in einem schwarzen zeremoniellen Gewand »aufgeführt«. Einige Fotos zeigen sie im Shokoku-ji Tempel nahe der Doshisha Universität. Byars hatte ihn am 21. Juni 1964 für zwei Stunden gemietet, um dort von ihr eine »Prozession« oder »Einzelobjekts-Präsentation« einer faltbaren Papierarbeit ohne Titel, die Byars später dem Museum of Modern Art in New York schenkte, aufführen zu lassen. Eine der bekanntesten performativen Skulpturen aus dieser Periode ist *Untitled Object (Runcible)* (1962–1964), auch als *Performable Square* bezeichnet, ein Würfel mit der Kantenlänge von ca. 46 Zentimetern, bestehend aus 1000 Blättern weißem Flachspapier. Er ließ sich zu einer ca. 15 x 15 Meter großen Fläche entfalten, die von 32 parallel laufenden Streifen unterteilt wurde, die wiederum am oberen Ende durch Falze miteinander verbunden waren. Diese Skulptur wurde erstmals 1964 in Kyoto im Museum of Modern Art ausgestellt. Sie wurde gefaltet auf einer Glasplatte präsentiert, die sich auf dem Fußboden in der Mitte des Museums befand. Bis zur ersten und einzigen Aufführung im März 1978 im University Art Museum in Berkeley in Kalifornien sollte es 14 Jahre dauern. Hier wurde die Skulptur von James Elliott, dem Kurator der Ausstellung, und unter Mithilfe von David Ross, Mark Rosenthal und Earl Michaelson entfaltet. 1966 schenkte Byars die Skulptur unter Wahrung »völliger Anonymität« dem Museum of Modern Art in New York zusammen mit zwei weiteren Papierobjekten, *Untitled Object (A Mile-Long Paper Walk)* und *Untitled Object (Rivet Continuity)* (beide 1962–1964), das Letztere kann sowohl sternförmig als auch als Ring gezeigt oder mittels Hohlnieten aufgehängt werden). In seinen Anweisungen an Dorothy Miller schrieb Byars: »Jeder Teil der Fläche kann durch einfaches Hochklappen zum Verschwinden gebracht werden. Das ganze Objekt kann vorgeführt oder einfach ausgestellt werden. Alle Teile sind in visueller Folge sowohl in Bezug auf Papierherstellung als auch Konstruktion des Objekts gehalten. (Alles von links nach rechts.)«[42] Den Titel *Runcible* in der Bedeutung von »Riesig« hatte Byars dem Objekt später in Anlehnung an den britischen Nonsensdichter des 19. Jahrhunderts und Autor von *The Owl and the Pussy-Cat,* Edward Lear, gegeben. (Von Lear stammt auch der bemerkenswerte Satz: »Sein Körper ist vollkommen kugelig, er trägt einen riesigen Hut.«)

Die bekannteste und spektakulärste von Byars' performativen Skulpturen war *The Giant Soluble Man (500' Dissolvo-Man),* die am 16. November 1967 in New York auf der 53. Straße zwischen Fifth und Sixth Avenue aufgeführt wurde. Diese Performance war eine Auftaktveranstaltung für die »Made-With-Paper«-Ausstellung, die zur

of Eliot's poem and magazine articles related to Eliot, going as far back as 1958, in his correspondence with Sam Wagstaff. Considering Byars's lifelong reverence for and reference to stones, his fondness for the poem may in part be explained by its title, which refers to a small group of rocks off the coast of Cape Ann, Massachusetts.

Byars liked to play with names, in particular names that connote both books and stones, either literally or metaphorically: Wittgenstein, Einstein, and Gertrude Stein (the German *Stein* meaning "stone"). Soon Byars associated all stones with books, and vice versa. Books are a recurring element in the artist's visual lexicon. Reduced to simple geometric shapes such as spheres, squares, and triangles, and often made of stone, Byars's textless books symbolize perfect meaning: *The Hollow Sphere Book* (1978), *The Cube Book* (1983), *The Moon Books (Phases of the Moon)* (1989), among others. Arguably Byars's most important book work is *The Book of 100 Perfects* (1985), an installation of four black-velvet daybeds with gilded legs and one

UNTITLED **OHNE TITEL** CA. 1960

cube-shaped book, which expresses the artist's obsession with the concept of the book and the philosophical idea of perfection. Byars was never tired of thinking of new ways to "write" a book. Once Byars sent Sam Wagstaff the following note on silk tissue,

Sam this is a silk tissue I've always wanted to wear a book in my sleeve.[42]

Byars's fascination with stones was as phenomenological as it was spiritual, and his stone works may have been affected by Chinese scholar rocks *(gongshi)* and by visits to the ancient Ryoanji rock garden in Kyoto, which had already inspired John Cage's music and art. The Chinese began collecting rocks for religious

gleichen Zeit im Museum of Contemporary Crafts, New York, und im Time-Life Exhibition Center stattfand und die von der Container Corporation of America gesponsert wurde. Die riesige Silhouette eines Mannes war aus 150 Meter weißem »Dissolvo«-Papier zusammengeklebt. Dieses Papier, das sich bei Kontakt mit Wasser auflöst, war eine Spende der Papierfabrik Gilbreth und bedeckte den gesamten Straßenabschnitt von Bordsteinkante zu Bordsteinkante. Bei der Durchführung half die New Yorker Polizei mit, indem sie diesen Abschnitt vom Autoverkehr frei hielt. Auf Byars' Kommando hin setzten sich zwei Lastwagen der Stadtreinigung in Bewegung, fuhren über das Papier und besprühten es mit Wasser, wodurch sich das Papier auflöste.

Steine für die Rede: »Das Vollkommene ansagen, bis es verschwindet«

»Man könnte die Vorgänge des Benennens der Steine [...] auch Sprachspiele nennen. Denke an manchen Gebrauch, der von Worten in Reigenspielen gemacht wird.«
Ludwig Wittgenstein, *Philosophische Untersuchungen* (1953)

In der Korrespondenz von Byars gibt es mehrere Hinweise auf T. S. Eliots Gedicht »The Dry Salvages« (aus *Four Quartets),* unter anderem das fotokopierte Gedicht selbst sowie Artikel aus Zeitschriften über Eliot, die bis in das Jahr 1958 zurückreichen und den Briefen an Sam Wagstaff beilagen. Wenn man die Ehrfurcht, die Byars vor Steinen empfand, und seine immer wiederkehrende Bezugnahme auf Steine, die sein ganzes Leben durchzog, betrachtet, lässt sich seine Begeisterung für dieses Gedicht zum Teil durch den Titel erklären. Gemeint ist hierbei eine kleine Felsgruppe vor der Küste von Cape Ann in Massachusetts. Byars liebte das Spiel mit Namen, besonders mit solchen, die in wörtlichem oder übertragenem Sinn eine Verbindung zwischen Büchern und Steinen herstellten, wie bei Wittgenstein, Einstein und Gertrude Stein. Byars assoziierte sämtliche Steine mit Büchern und umgekehrt. Bücher sind ein ständig wieder auftauchendes Element im visuellen Lexikon des Künstlers. Auf einfache geometrische Grundformen – wie Kugeln, Quadrate und Dreiecke – reduziert und oft aus Stein gefertigt, symbolisieren Byars' »textlose« Bücher die vollkommene Bedeutung: *The Hollow Sphere Book* (1978), *The Cube Book* (1983), *The Moon Books (Phases of the Moon)* (1989) und andere. Das wichtigste Werk innerhalb dieser Werkgruppe dürfte *The Book of 100 Perfects* von 1985 sein, eine Installation von vier schwarzsamtenen Liegen mit vergoldeten Beinen und einem würfelförmi-

or aesthetic purposes in the Han dynasty (206 BC–AD 220). Scholars' rocks are smaller and more refined than garden rocks, their sizes varying from about one inch to four or five feet in height. Most were placed on desks and used for meditation on philosophical principles and contemplation prior to writing or painting. Their beauty was often enhanced by polishing, sanding, or submerging them in water to restore the natural patterns of wear.

Byars looked for stones and stones found him. He wrote to Dorothy Miller:

I look a lot for stones and I wonder a lot about
them, sometimes they find me, and how do they get
there, a head a body side and side, I wonder am
I right to touch them or do they say so, going here,
going here and finding, what does all of this mean, do
stones love me, do I love stones. I think so, how
is it everything knows, is consciousness, spirit;
is it possible to love chance, even its detachment.[43]

One of Byars's first "actions" was the removal of all the furniture, windows, and doors from his mother's house. Soon after he "re-arranged" their neighbor's garden (at his request) by removing all flowers and filling the garden with five tons of white sand, on which he placed several very large stones. His neighbor was of Greek descent, and, according to Byars, the objective was less to create a Japanese Zen garden than to express his interpretation of a "tactile garden" suited for Greek-style outdoor banquets. This project prompted another neighbor to ask for an installation in his garden and to give Byars a small stipend to travel to Japan. One year later, in 1958, Byars went to Japan for the first time. Like the Japanese art of Ikebana, Byars's installations distinguish themselves from other kinds of "arrangements" by the use of empty space as an essential feature of the composition, a characteristic of aesthetics that is shared by traditional Japanese paintings, gardens, and architecture.

Byars's books made out of stone or paper are *silent.* The idea of reading in silence is a relatively modern notion. Reading aloud was still common practice during the time of Saint Augustine, who was disturbed to see his master Saint Ambrose of Milan read silently. Not until the tenth century did silent reading become commonplace. However, Byars also performed books by *speaking* words aloud, calling names, asking questions— for Byars every utterance constituted a book. The constant repetition of his verbal or nonverbal performances belong to the concept of the perfect. There is a saying in Zen Buddhism that even the most mundane, dull, and boring words or activities become very interesting, if repeated long enough. As Viola Michely writes, "Constant repetition is another characteristic of the concept of

gen Buch; es zeigt sich die intensive Auseinandersetzung des Künstlers mit dem Thema »Buch« und der philosophischen Idee der Vollkommenheit. Byars wurde niemals müde, sich neue Arten des »Buchschreibens« auszudenken. An Sam Wagstaff schickte er folgende, auf ein Seidenpapier geschriebene Notiz:

> »Sam, dies ist Seidenpapier, ich wollte schon immer ein Buch in meinem Ärmel tragen.«[43]

Byars' Faszination für Steine war zugleich phänomenologisch und spirituell. Seine Steinarbeiten sind möglicherweise durch die chinesischen Gelehrtensteine *(Gongshi)* und durch Besuche in dem alten Ryoanji-Steingarten in Kyoto angeregt. Dieser Garten hatte auch John Cage zu Kompositionen und zur Kunst inspiriert. In China hat das Sammeln von Steinen für religiöse und ästhetische Zwecke seinen Ursprung in der Han-Dynastie (206 v. Chr. – 220 n. Chr.). Die Steine für Lehrzwecke sind kleiner als die Steine für Gärten, die Größe variiert zwischen ungefähr zwei Zentimetern bis zu ein oder anderthalb Metern in der Höhe. Meist wurden sie auf Tischen platziert und waren Hilfsmittel für Meditation, philosophisches Denken oder Kontemplation, die dem Schreiben oder Malen vorausgingen. Ihre Schönheit wurde oft durch Polieren, Schleifen oder das Eintauchen in Wasser hervorgehoben, was ihre Musterungen noch deutlicher zum Vorschein brachte.

Byars hielt nach Steinen Ausschau und Steine fanden ihn. An Dorothy Miller schrieb er:

> »Ich schaue viel nach Steinen aus und ich denke viel über sie
> nach, manchmal finden sie mich, aber wie kommen sie her,
> ein Kopf, ein Körper daneben, ich frage mich,
> darf ich sie berühren, oder sagen sie es mir, hier entlang,
> hier entlang, finden, was hat das alles zu bedeuten, lieben
> mich die Steine, liebe ich die Steine. Ich glaube schon, wie kann
> es nur jeder wissen, es ist Bewusstsein, Geist;
> ist es möglich, den Zufall zu lieben, und sogar seine Loslösung.«[44]

Eine der ersten »Aktionen« von Byars war das Entfernen sämtlicher Möbelstücke, Fenster und Türen aus dem Haus seiner Mutter gewesen. Kurz darauf widmete er sich der »Umgestaltung« des Gartens eines Nachbarn, auf dessen Wunsch hin er alle Blumen entfernte und den Garten mit fünf Tonnen weißem Sand auffüllte, auf dem er einige große Steine verteilte. Der Nachbar war griechischer Abstammung, und es war nach Byars' Aussage nicht beabsichtigt gewesen, einen japanischen

the 'perfect' . . . An artist [such as Byars] has no choice other than to repeat himself incessantly during his lifetime, to use any occasion in his quest for an all-embracing encounter."[44]

Some of Byars's last sculptures are made of white marble from the Greek Island of Thassos. While it is sought for its matchless whiteness, the marble's unusual large grain, which resembles that of rock salt, tends to have relatively large holes and thus is not as smooth as marble from Carrara or Macedonia. The holes are often patched, which leaves yellow flecks that can be quite visible on large surface. Several of Byars's late white marble sculptures display such visible yellow spots, such as *The Moon Column.* This raises the question whether the artist had indeed intended to show them that way. Michael Werner once told me that Byars would customarily cover impurities in marble with gold leaf. On the other hand Byars knew perfectly well that perfection always comes with a trade-off. For Byars the perfect is not found in material perfection but in the quest for it. For him, perfection is an impossibility, except for the auspicious moment *(kairos)* where life and death, happiness and tragedy, are one.

Kierkegaard's narrator in *Repetition* returns to Berlin in order to find out if repetition is possible. Like Byars's later, death performances, Kierkegaard's psychological experiment is a singular event. For Samuel Weber, this singular practice anticipates the contemporary art practices commonly described as happenings, performances, or installations. Theater is never an accomplished action or intention, it is *acting* rather than *action,* and as Weber emphasizes, it is never complete. For the Postmodern artist, who reenacts Kierkegaard's experiment, the world is created anew every day. Like Kierkegaard's "echo of irony," which repeats but not entirely reproduces, and his "rotation method" of "remembering and forgetting," the Postmodern artist repeats the creative act each time as if for the first time, his or her works are allegories of permanent childhood, the *Americanism* (an America where everything is new) of Postmodern art. Accordingly, Byars repeated his death each time anew. For the Postmodern artist, like for the protagonist in a new novel by Andrew Sean Greer, *The Confessions of Max Tivoli,* who was born as a seventy-year-old man and ages in reverse (regressing his existence year by year until he reaches his physiological infancy and, ultimately, death), death is always on his mind (because his life moves backwards, Max Tivoli knows the exact date of his death and thus is constantly faced with his day of death).

Garten zu kreieren, vielmehr ging es darum, einen »taktilen Garten« zu schaffen, der sich für »griechische« Gartenfeste eignete. Durch diese Aktion angeregt, bat ein weiterer Nachbar um eine Installation in seinem Garten und entlohnte Byars mit einem Stipendium für eine Japanreise. Ein Jahr später, 1958, ging er zum ersten Mal nach Japan. Genau wie die japanische Kunst des Ikebana unterscheiden sich die »Arrangements« von Byars von anderen Arrangements durch die Einbeziehung des leeren Raumes als wesentlichem Bestandteil der Komposition. Diese besondere Ästhetik ist auch ein Charakteristikum der traditionellen japanischen Malerei, Gartenkunst und Architektur.

Die aus Papier oder Stein bestehenden Bücher von Byars sind *still*. Die Idee des Lesens in der Stille ist eine relativ moderne Vorstellung. Zur Zeit des Augustinus, der sich noch dadurch gestört fühlte, dass sein Lehrer Ambrosius von Mailand leise las, war das laute Lesen die übliche Praxis. Erst im 10. Jahrhundert wurde das leise Lesen üblich. Byars führte Bücher aber auch auf, indem er Wörter laut sprach, Namen rief, Fragen stellte – für Byars stellte jede Äußerung ein Buch dar. Die ständigen Wiederholungen seiner verbalen und nonverbalen Performances gehören zu seiner Vorstellung des Vollkommenen, des Konzepts »Perfect«. Im Zen-Buddhismus gibt es einen Satz, der besagt, dass selbst die banalsten, langweiligsten und eintönigsten Wörter oder Handlungen interessant werden, wenn sie nur lange genug wiederholt werden. Oder wie Viola Michely schreibt: »Kennzeichen des Konzepts ›Perfect‹ ist auch das stetige Wiederholen [...] Ein solcher Künstler hat keine Wahl, als zu Lebzeiten in unaufhörlicher Penetranz zu wiederholen, jeden Anlass zu nutzen, auf der Suche nach einer umfassenden Berührung.«[45]

Einige der letzten Skulpturen von Byars bestehen aus weißem Marmor, der von der griechischen Insel Thassos stammt. Dieser Marmor ist wegen seiner unvergleichlich weißen Farbe sehr begehrt, hat aber eine grobe, an Steinsalz erinnernde Körnung und oft große Löcher, daher ist er nicht so glatt wie der Marmor aus Carrara oder Mazedonien. Die Löcher werden oft geflickt, was gelbliche, auf der Oberfläche sichtbare Flecken hinterlässt. Mehrere dieser späten Marmorskulpturen weisen derartige gelbe Flecken auf, so auch *The Moon Column,* was zu der Frage führt, ob es tatsächlich in der Absicht des Künstlers lag, diese Flecken auf diese Weise sichtbar werden zu lassen. Von Michael Werner, seinem langjährigen Galeristen, weiß ich, dass Byars Unreinheiten im Marmor normalerweise mit Blattgold abdeckte. Andererseits war sich Byars nur zu gut bewusst, dass es zum Vollkommenen immer auch gehört, Abstriche zu machen. Für Byars findet sich das Vollkommene nicht in der materiellen Vollkommenheit, sondern in der Suche danach. Vollkommenheit ist eine Unmöglichkeit und nur in dem einen, verheißungsvollen Moment *(kairos)* gegenwärtig, in dem Leben und Tod, Glück und Tragik zusammenfallen.

"Death Is the Question"

"The six most important necessities which the Creator has imposed on mankind are to be born, to move about, to eat, to sleep, to procreate, and to die . . . These aforementioned basic needs are all of them accompanied by and made more agreeable by various sensations of pleasure, and death itself is not without enjoyment."
Jean Anthelme Brillat-Savarin, *The Physiology of Taste* (1825)

In 1994 Byars installed *The Death of James Lee Byars* at Galerie Marie-Puck Broodthaers in Brussels: it consisted of a single room covered in gold leaf. At the opening Byars, dressed in gold lamé, lay down on the floor. Afterwards he replaced his corporeal presence with five diamonds (which were actually Swarovski crystals), which he placed in the form of a star on a thirty-centimeter-high and one-hundred-eighty-centimeter-long sarcophagus-shaped pedestal, also covered with gold leaf, in the center of the room. Asked by Joachim Sartorius about the meaning of the work, Byars said that it was about practicing death, referring to Socrates who defined philosophy as a practice of death. The performance element of the work was repeated later that year in Venice in front of the Punta della Dogana, the famous seventeenth-century customs house, whose tower is crowned by a large, golden ball. In the presence of his wife, Wendy Dunaway, and a friend, Heinrich Heil, Byars lay down on the ground wearing a gold-lamé suit while Heil shouted, "The death of James Lee Byars—five points make a man." Afterwards, Dunaway marked the spot on the ground with five drops of water. (In Brussels Byars had suggested that the piece be repeated at different locations using five drops of water instead of diamonds.) And in 1995 he installed *The Diamond Floor* at the Cartier Foundation in Paris, using again five Swarovski crystals arranged in the form of a five-point star on a black lacquer floor. Death was an omnipresent force in Byars's life and work. "For me death is omnipresent," he told Joachim Sartorius in 1996, "Life and Love and Death are gigantic historic themes."[45]

The path of gold, like all the paths trodden by Byars, leads to death. Gold and money have their origin in the sacrificial cult. In Greece a common monetary unit is the *obolos,* originally the skewer on which each participant of a sacrificial feast put the part of the meat that is allotted to him. In Egypt the seals which were used to mark the sacrificial animals depicted a kneeling man who was bound to a pale with a knife pointing to his throat—the original sacrifice. The seals represent the idea of the sacrificial substitution which became the base of the monetary system. The oldest coins symbolize sacrificial animals or implements, like the axe or the tripod, which they depict.

Kierkegaards Erzähler in *Die Wiederholung* kehrt nach Berlin zurück, um dort herauszufinden, ob eine Wiederholung möglich ist. Wie die späten Todes-Vorführungen von Byars ist auch Kierkegaards psychologisches Experiment ein singuläres Ereignis. Für Samuel Weber antizipiert diese singuläre Praxis die zeitgenössischen Praktiken von Happening, Performance oder Installation. Theater ist niemals eine vollendete Handlung oder Absicht, es ist vielmehr ein Handeln als eine Handlung, und es wird nie, wie Weber betont, zu einem Abschluss kommen.

Für den postmodernen Künstler, der das Kierkegaardsche Experiment nachvollzieht, stellt sich die Welt jeden Tag als neue Schöpfung dar. Wie Kierkegaard durch sein »Echo der Ironie«, das zwar wiederholt, aber nicht komplett reproduziert, und seine »Rotationsmethode« des »Vergessens und Erinnerns«, so führt auch der postmoderne Künstler den kreativen Akt jedes Mal so aus, als sei es das erste Mal. Die Werke des Künstlers oder der Künstlerin sind Allegorien einer immer währenden Kindheit, des »Amerikanismus« (der Idee eines Amerika, in dem alles neu ist) in der postmodernen Kunst. Demnach wiederholte Byars seinen Tod jedes Mal neu. Für den postmodernen Künstler ist der Tod ständig präsent. Wie dem Protagonisten des Romans *The Confessions of Max Tivoli* von Andrew Sean Greer, der im Alter von 70 Jahren geboren wird und in entgegengesetzter Richtung altert (und sich in seiner Existenz von Jahr zu Jahr zurückentwickelt, bis er die physiologische Kindheit und schließlich seinen Tod erreicht), hat der postmoderne Künstler den Tod immer im Sinn. (Die Romanfigur Max Tivoli kennt, da sein Leben rückwärts abläuft, seinen genauen Todeszeitpunkt und hat daher ständig seinen Todestag vor Augen.)

»Tod ist die Frage«

»Der Schöpfer hat dem Menschen sechs große und wesentliche Notwendigkeiten auferlegt, nämlich die Geburt, die Arbeit, das Essen, den Schlaf, die Fortpflanzung und den Tod [...] All diese verschiedenen Notwendigkeiten sind von irgendeinem Lustgefühl begleitet und gemildert. Selbst der Tod ist nicht ganz ohne Reiz.«
Jean Anthelme Brillat-Savarin, *Physiologie des Geschmacks* (1825)

Im Jahr 1994 installierte Byars *The Death of James Lee Byars* in der Galerie Marie-Puck Broodthaers in Brüssel. Die Installation bestand aus einem einzigen, mit Blattgold ausgekleideten Raum. Bei der Eröffnung lag Byars in der Mitte des Raumes, in Goldlamé gekleidet, auf dem

The pictorial representation has always been connected to sacrifice, and since Prometheus, sacrifice has been accompanied by fraud: the profit (only an inferior part is for the gods) which leads to the accumulation of capital and the beginnings of trade and exchange. This sacrificial context of art is still present in the Renaissance when, in the association of art and money, painting undergoes a second substitution and becomes a commodity. In Fra Angelico's *The Martyrdom of Saints Cosmas and Damian,* the beheaded halos are like gold coins attached to the heads of the saints who were called "enemies of money" because they practiced medicine without charging a fee. Furthermore the scene contains both *original* (the decapitation) and *substituted* sacrifice (the offertory). Postmodern art uses gold to emphasize the sacrificial context of representation, which modern art denies, and reveals its fraudulent character, the gilding. Byars's *Halo* is golden only on the outside—the inside is made

THE DEATH OF JAMES LEE BYARS **DER TOD DES JAMES LEE BYARS** 1994
GALERIE MARIE-PUCK BROODTHAERS, BRUSSELS **BRÜSSEL**

Boden. Hinterher ersetzte Byars seinen Körper durch fünf Diamanten (eigentlich waren es Swarovski-Kristalle), die er auf einem 30 Zentimeter hohen und 180 Zentimeter langen Podest, das die Form eines Sarkophages hatte und ebenfalls mit Blattgold belegt war, sternförmig platzierte. Von Joachim Sartorius nach der Bedeutung dieser Arbeit gefragt, erklärte er, dass es sich um ein Üben des Todes handele, in Anlehnung an Sokrates, der Philosophie als ein Einüben des Todes definiert habe. Das performative Element dieser Arbeit wurde im gleichen Jahr noch einmal in Venedig aufgeführt, vor der Punta della Dogana, dem Zollhaus aus dem 17. Jahrhundert, dessen Turm von einem großen, goldenen Ball gekrönt ist. Im Beisein seiner Ehefrau Wendy Dunaway und seines Freundes Heinrich Heil legte sich Byars in seinem Goldlamé-Anzug auf den Boden, während Heil rief: »Der Tod des James Lee Byars – Fünf Punkte machen den Mann.« Anschließend markierte Dunaway die fünf Punkte mit fünf Tropfen Wasser. (Schon in Brüssel hatte Byars vorgeschlagen, dass bei Wiederholungen an anderen Orten fünf Wassertropfen anstelle der »Diamanten« verwendet werden könnten.) Im Jahr 1995 installierte er *The Diamond Floor* in der Fondation Cartier pour l'art contemporain in Paris und arrangierte hier fünf Swarovski-Kristalle in der Form eines fünfzackigen Sternes auf dem schwarzen Lackfußboden. Der Tod war eine stets anwesende Kraft in Byars' Leben und Arbeit. Gegenüber Joachim Sartorius äußerte er sich 1996: »Für mich ist der Tod allgegenwärtig [...] Leben und Liebe und Tod [sind] gigantische historische Themen.«[46]

Der Pfad des Goldes führt, wie alle von Byars beschrittenen Wege, zum Tod. Gold und Geld haben ihren Ursprung im Opferkult. In Griechenland war eine gängige Währungseinheit der *obolos,* ursprünglich der Spieß, auf den jeder Teilnehmer eines Opferfestes das ihm zugewiesene Fleisch steckte. In Ägypten zeigten die Siegel, mit denen Opfertiere gekennzeichnet wurden, das Bild eines knienden, an einen Pfahl gebundenen Mannes, auf dessen Kehle ein Messer gerichtet ist – das ursprüngliche Opfer. Die Siegel stehen für die Idee einer Substitution des Opfers, aus dieser Idee ging die Geldwirtschaft hervor. Die bildliche Darstellung stand von jeher mit Opfergaben in Verbindung, und seit Prometheus gehört auch der Betrug zum Opfer: Der Erlös (von dem nur ein kleiner Teil für die Götter bestimmt ist) führt zur Anhäufung von Kapital und zu beginnendem Tausch und Handel. Dieser Kontext, die Verbindung von Kunst und Opferkult, bestand noch in der Renaissance, als im Zusammenspiel von Kunst und Geld die Malerei ein zweites Mal einen Bedeutungswandel erfuhr und zur Ware wurde. Die Heiligenscheine auf der Predella-Darstellung des *Martyriums der Heiligen Cosmas und Damian* von Fra Angelico wirken auf den Köpfen der enthaupteten Heiligen wie Goldmünzen. Diese Heiligen wurden »Feinde des Geldes« genannt, weil sie Kranke

of brass. Kiochi Toyama mentioned to me that while gold is a common ornament in Japanese art and particularly prevalent in Kyoto, Taki Sachiko recalls that for Byars gold meant primarily "light," which suggests that Byars's use of gold may be a synthesis of Eastern and Western concepts.

By far Byars's most ambitious work is the *Golden Tower.* Originally conceived in 1974, it was intended to be a 333-meter-high golden cylinder at the Steinplatz in the center of Berlin that was to "rattle the sky." It was first executed, on a much-reduced scale (four meters high), in 1982 during "documenta 7" as *The Golden Tower with Changing Tops,* and again in 1990 at the exhibition "Gegenwart Ewigkeit (Presence Eternity)" at the Martin-Gropius-Bau in Berlin with a height of twenty-five meters.

Byars was not the only artist and certainly not the first artist to be fascinated by death. By 1963 Andy Warhol, another artist who tried to erase his persona as artist through distancing, had amassed a large collection of UPI photographs of suicides, which he titled *Death in America,* and which became the basis of his 1963 *Death and Disaster* series of plane crashes, accidents, and electric chairs. Kafka introduces the practice of writing as practice of death in his story *The Penal Colony,* with the metaphor of a writing-apparatus that is designed to inscribe the judgment onto the skin of the condemned-to-death but ultimately fails to do so. The "writing" of the apparatus demands from the "reader" the ultimate sacrifice: death. Like Kafka's apparatus, the "star-writing" used by Byars in his letters and drawings, a highly ornamental script that for the uninitiated can be extremely difficult to read, engages those who fail to decipher it in an act of "deathly" complicity. In his performances and installations, Byars forced the viewer to confront mortality. In his 1976 performance, *The Play of Death,* Byars and twelve physicians, including the Cologne collector and urologist Reiner Speck, all dressed in black, appeared on the balconies of thirteen rooms of a Cologne Dom-Hotel facing onto the cathedral square. Byars aspired the sound "th" (for *thanatos,* "death"), after which all retreated back into their rooms. As in Kafka's story, for Byars, simply being an artist is a metaphor for death and failure.

Byars's star-writing is related to a series of works titled *Five Points Make the Man,* which in turn is derived from Leonard da Vinci's *Vitruvian Man:* the outstretched arms and legs and the head of the human figure form a five-pointed star. Both Byars's letters and postcards covered with star-writing and the miniscule pieces of paper bearing microscopic printed texts that he often hid in the envelopes and presented to others, were examples of his *gift-giving,* another important aspect of his art. They are an updated version of the "presentation drawings," which were common practice in the Renaissance. (Michelangelo made a large number of so-called "presentation drawings" which he frequently presented as gifts to his lovers.)

Death can take many shapes. For the minimalist American sculptor Tony Smith it was a six-cubic-foot piece of steel (*Die,* 1962). For Byars, it was

heilten, ohne dafür Geld zu verlangen. Darüber hinaus beinhaltet die Darstellung sowohl das ursprüngliche Opfer (die Enthauptung) als auch das übertragene Opfer (das Offertorium). In der postmodernen Kunst betont Gold den Opferkontext einer Darstellung, den die moderne Kunst bestreitet, und entlarvt ihren betrügerischen Charakter, die Vergoldung. Byars' *Halo* (1994) ist nur von außen aus Gold, innen ist er aus Messing.

Kiochi Toyama machte mich darauf aufmerksam, dass Gold eine in der japanischen Kunst und besonders in Kyoto gebräuchliche Verzierung ist. Äußerungen von Taki Sachiko legen den Schluss nahe, dass Gold für Byars vor allem die Bedeutung von »Licht« hatte, möglicherweise versuchte er durch seine Verwendung die Synthese eines östlichen und eines westlichen Konzepts.

Das bei weitem ehrgeizigste Werk von Byars war *Golden Tower*. Die Arbeit wurde 1974 konzipiert und sollte ursprünglich als 333 Meter hoher Zylinder auf dem Berliner Steinplatz aufgestellt werden, um dort »am Himmel zu rütteln«. Ausgeführt wurde das Werk mit wesentlich verringerten Maßen (mit einer Höhe von vier Metern) 1982 auf der *documenta 7* als *Golden Tower with Changing Tops* und nochmals 1990 bei der Ausstellung »Gegenwart Ewigkeit« im Martin-Gropius-Bau in Berlin mit einer Höhe von 25 Metern.

Byars war sicher nicht der einzige und nicht der erste Künstler, der vom Thema Tod fasziniert war. Im Jahr 1963 hatte Andy Warhol, ebenfalls ein Künstler, der seine eigene Persönlichkeit durch Distanzierung zum Verschwinden bringen wollte, etliche UPI-Fotos von Selbstmorden zusammengetragen; diese Sammlung nannte er *Death in America* und sie wurde zum Ausgangspunkt der Tod- und Desasterserie von 1963 mit Flugzeugabstürzen, Unfällen und elektrischen Stühlen. Franz Kafka hat in seiner Erzählung *In der Strafkolonie* die Praxis des Schreibens als eine Praxis des Todes mit der Metapher eines Schreibapparates eingeführt, der so konstruiert ist, dass er das Urteil auf die Haut eines zum Tode Verurteilten schreiben kann, aber letztendlich scheitert. Das »Schreiben« des Apparates verlangt vom »Leser« das endgültige Opfer: den Tod. Wie Kafkas Apparat, so zieht auch Byars' »Sternschrift« – eine äußerst ornamentale und für den Nichteingeweihten schwer zu entziffernde Schrift, die der Künstler in seinen Briefen und Zeichnungen verwendete – denjenigen, der an einer völligen Entzifferung scheitert, in eine Art »tödliche« Komplizenschaft.

In seinen Installationen und Performances zwang Byars die Zuschauer, sich mit der Sterblichkeit auseinander zu setzen. In der Performance *The Play of Death* aus dem Jahr 1976 erschien Byars zusammen mit zwölf schwarz gekleideten Ärzten, darunter dem Kölner Sammler und Urologen Reiner Speck, auf den 13 Balkonen des Kölner Dom-Hotels, die auf den Platz vor dem Dom hinausgehen. Byars hauchte den Laut

THE PLAY OF DEATH **DAS SPIEL DES TODES**
PERFORMANCE COLOGNE **KÖLN** 1976

the *sphere,* which for him not only symbolized the concept of the perfect, but of death as well. In 1986 he showed *The Tomb of James Lee Byars* at the Castello di Rivoli, consisting of a sphere of limestone, one meter in diameter. Coincidentally, Byars's real death did indeed come in the shape of a sphere: in the form of a large round tumor in his abdomen. (Byars suffered from a rare form of cancer, *pseudomyxoma peritonei* or "false mucinous tumor of the peritoneum," an incurable, slowly progressing disease that causes a "jelly belly.")

A Critical Retrospective

Byars literally lived his art, even arguably to a greater extent than Beuys or Warhol. Just as his life cannot be reduced to simple biographical facts, his art cannot be described with traditional art-historical methods.

This is the first critical retrospective of Byars's works since his death in 1997. Its unique challenge is to present the career of an artist whose work was closely linked to both his physical and conceptual presence. It strives to be the most comprehensive survey to date of the artist's performances, paper and cloth objects, sculptures, and installations. Unlike previous exhibitions that were done in close collaboration with the artist, this retrospective focuses less on the *presentation* of Byars's vision, and more on his *development,* on the works themselves and their art-historical and philosophical contexts, thus initiating a reassessment of the artist's work and life. Sometimes Byars may have "underplayed" his historical accomplishments and influence on others by constantly reworking and reassembling his objects in the belief that the works had no life on their own. The few exhibitions of his works since his death have focused on the presentation of his work rather than the

»th« (für grch. *thanatos,* Tod). Daraufhin zogen sich alle in die Zimmer zurück. Wie in Kafkas Erzählung ist für Byars das bloße Künstlersein eine Metapher für Tod und Scheitern.

Byars' Sternschrift bezieht sich auf eine Serie von Arbeiten mit dem Titel *Five Points Make a Man,* die wiederum auf Leonardo da Vincis »Vitruvianischen Mann« Bezug nimmt: Die ausgestreckten Arme und Beine eines Menschen ergeben zusammen mit dem Kopf einen fünfzackigen Stern. Sowohl seine mit dieser Sternschrift geschriebenen Briefe und Postkarten als auch die Papierstückchen mit mikroskopisch kleinen, gedruckten Texten, die er oft, in Briefumschlägen aufbewahrt, verschenkte, waren Beispiele seines Geschenkemachens, eines weiteren Aspekts seiner Kunst. Sie sind eine der Zeit angepasste Form der »Präsentationszeichnungen«, die ein weit verbreiteter Brauch in der Renaissance waren. (Michelangelo machte etliche dieser so genannten Präsentationszeichnungen, die er oft seinen Liebhabern schenkte.)

Der Tod kann viele Formen annehmen. Für den minimalistischen amerikanischen Bildhauer Tony Smith war es ein *Würfel* aus Stahl mit der Kantenlänge von 1,80 Metern *(Die,* 1962). Für Byars war es die Kugel, die seiner Auffassung nach nicht nur das Konzept der Vollkommenheit, sondern auch den Tod symbolisierte. 1986 zeigte er im Castello di Rivoli in Turin die aus einer Kalksteinkugel mit einem Durchmesser von einem Meter bestehende Arbeit *The Tomb of James Lee Byars.* Merkwürdigerweise kam Byars' wirklicher Tod auch in der Gestalt einer Kugel: in Form eines großen, runden Tumors in seinem Unterleib. (Byars litt an einem seltenen Krebs, einem muzinösen Tumor des Bauchfells. Diese unheilbare, langsam voranschreitenden Krankheit verursacht einen »Kugelbauch.«)

Eine kritische Retrospektive

Byars lebte wirklich seine Kunst, möglicherweise in einem noch höheren Maße als Beuys oder Warhol. Genauso wenig wie sein Leben auf schlichte biografische Fakten reduziert werden kann, ist es möglich, sein Werk mit den traditionellen Methoden der Kunstwissenschaft zu beschreiben. Dies ist die erste kritische Retrospektive seit seinem Tod im Jahr 1997. Die besondere Herausforderung besteht darin, das Werk eines Künstlers zu zeigen, das auf das Engste sowohl mit seiner physischen als auch konzeptionellen Präsenz verbunden war. Dies meint das Bestreben, einen möglichst umfassenden Überblick über Byars' Performances, Papier- und Stoffobjekte, Skulpturen und Installationen zu geben. Anders als frühere Ausstellungen, die in enger Zusammenarbeit mit dem Künstler entstanden, richtet diese Ausstellung in der Schirn Kunsthalle in Frankfurt

individual objects. Byars is until now mostly known for his late monumental sculptures, which are extreme in their formal simplicity, yet exceedingly luxurious in the choice of materials, while his performative paper objects, paintings, early plays, and performances, and their infuence on later generations of artists, have yet to be fully understood. If this exhibition can provide a broader understanding of this exceptional artist, it will all be to the good .

Byars believed in the responsibility of art to raise philosophical questions; in simplicity through luxury; in the pursuit of beauty and perfection; the simultaneous presence of materiality and immateriality, and in actions and happenings that are undramatic and quiet. His work cannot be situated and contextualized easily. His Minimalism is too baroque to be considered Minimal art; his Conceptualism, too concerned with the production of objects to be Conceptual art. As Dave Hickey writes, "There is nothing Minimalist in James Lee Byars's agenda: Abbreviation is his métier, and opera, his idiom . . . James Lee Byars, at the moment, is historically incorrect. His minimalism is, clearly, not minimalist; his historicism is nothing like pastiche; his theater, purged of angst and drama, is simply too theatrical; and he has no taste for the banal. Further, his politics are not Western enough; his Orientalism is not mystical enough."[46]

Of the three themes in this exhibition—life, love, death—the notion of love is the one least examined in Byars's work; however, I argue that love is a central theme in his work. Love is at the heart of Byars's notion of Perfect, which is most clearly expressed in his "perfect" performances, such as *The Perfect Kiss, The Perfect Smile, The Perfect Whisper,* or *The Perfect Love Letter.* There are two philosophical concepts of perfect love: in Spinoza's *amor Dei intellectualis,* the love of God as the highest form of knowledge, which is acomplished by the simple act of man loving himself; in Kierkegaard, Abraham's perfect love of God, expressed by his preparedness to sacrifice his son, is at the core of Kierkegaard's theory of the leap to faith. In both cases, it is marriage of love and certitude (knowledge that does not require objective proof) that results in perfection. Not surprisingly, however, Byars's perfect love is not the pure, platonic affair of Spinoza and Kierkegaard, as an early performance of *The Perfect Kiss* by two women in front of the Palais des Beaux-Arts in Brussels, directed by Byars and documented by Yves Gevaert, demonstrates. This 1974 version is formally still closer to his participatory plays of the sixties, particularly *Two in a Hat,* than Byars's later, more austere one-man performances. It also appears to allude to Brancusi's *Kiss.*

More than Beuys; more than Warhol, to name only two peers of equal rank, Byars has given his age its complexity. Like his idol T. S. Eliot, Byars found a *complete* art. Refusing no knowledge, and accepting no limits, he found the possibility of an art for all times by dividing or multiplying time and space by its smallest or largest factor. In her 1993 Nobel lecture, the novelist Toni Morrison said the following words about her profession, which could

am Main weniger das Augenmerk auf die Präsentation von Byars' Vision, sondern mehr auf seine Entwicklung, auf die Arbeiten selbst und ihren kunsthistorischen und philosophischen Kontext, und will somit zu einer Neubegegnung mit dem Leben und Werk des Künstlers anregen. Das strukturalistische Desinteresse von Byars an jeglicher historischer Reflexion oder Präsentation seiner Werke zugunsten einer ständigen Umarbeitung und Neuordnung seiner Objekte hat wahrscheinlich zu einer zeitweiligen Unterbewertung seiner Leistung und seines Einflusses im kunsthistorischen Sinne geführt. Die wenigen Ausstellungen seit seinem Tod haben den Schwerpunkt weiterhin eher auf die Präsentation seines Werks als auf die einzelner Objekte gelegt. Bislang ist Byars vor allem für seine späten, monumentalen Skulpturen mit ihren – trotz extremer formaler Einfachheit – spektakulär luxuriösen Materialien bekannt, während die Tragweite seiner performativen Papierobjekte, Zeichnungen, frühen Plays und Performances, und deren Einfluss auf die folgenden Generationen von Künstlern, noch nicht vollständig ermessen ist. Wenn diese Ausstellung zu einem besseren Verständnis dieses außerordentlichen Künstlers beitragen kann, ist damit ein Schritt in diese Richtung getan.

Byars sah das Stellen philosophischer Fragen als die Verantwortung der Kunst an. Er fragte, wie sich Einfachheit besser durch Luxus, in einem Streben nach Schönheit und Vollkommenheit, als durch Askese verwirklichen lasse, er fragte nach der gleichzeitigen Anwesenheit von Materialität und Immaterialität in seinen »Actions« und »Happenings«, die undramatisch und still waren. Sein Werk lässt sich nur schwer einem Kontext einordnen. Sein Minimalismus ist zu barock, um als Minimal Art zu gelten, sein Konzeptualismus ist zu sehr mit der Erschaffung von Objekten beschäftigt, um als Concept Art zu gelten. Dave Hickey schreibt: »Es gibt nichts Minimalistisches in der Agenda von James Lee Byars. Sein Metier ist die Verkürzung, sein Idiom die Oper [...] James Lee Byars ist zurzeit

also serve to summarize Byars's art and life: "We die. That may be the meaning of life. But we *do* language. That may be the measure of our lives."

Notes

1 T. S. Eliot. *Selected Essays 1917–1932* (New York, 1932), pp. 7–8.
2 The Museum of Modern Art Archives, N.Y., Dorothy C. Miller Papers, James Lee Byars Correspondence, I.1a.
3 Søren Kierkegaard, *Concluding Unscientific Postscript to Philosophical Fragments,* ed. Howard V. Hong and Edna H. Hong (Princeton, 1992), p. 625.
4 Michael S. Gazzaniga, *The Social Brain: Discovering the Networks of the Mind* (New York, 1985), p. 5.
5 Samuel J. Wagstaff Papers, Artists Correspondence James Lee Byars 1963–1971, Archives of American Art, Smithsonian Institution, Washington, D.C. (on microfilm).
6 Yves Aupetitallot, "Interview with Anny de Decker, Bernd Lohaus," in *Wide White Space: Behind the Museum* (Düsseldorf, 1995), p. 61.
7 Dave Hickey, "Detroit Dharma Diva," in *James Lee Byars: Works from the Sixties* (New York, 1993).
8 MoMA Archives, N.Y., DCM, JLB I.3.
9 Ludwig Wittgenstein, *Philosophical Investigations* (New York, 1958), §23, pp. 11–12.
10 *Vogue*, January 15, 1969.
11 Wagstaff papers (see note 5).
12 Michael Fried, "Art and Objecthood," in *Art in Theory 1900–2000: An Anthology of Changing Ideas*, ed. Charles Harrison and Paul Wood (Oxford, 2003), p. 848.
13 Wagstaff papers (see note 5).

 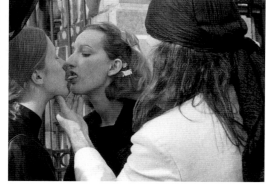

THE PERFECT KISS **DER VOLLKOMMENE KUSS**
PERFORMANCE BRUSSELS **BRÜSSEL** 1974

historisch nicht korrekt. Sein Minimalismus ist offensichtlich nicht mini-
malistisch, sein Historismus ist nichts als Persiflage, sein Theater, ge-
ronnene Angst und Drama, ist einfach zu theatralisch; und er hat keinen
Geschmack für das Banale. Außerdem ist seine Politik nicht westlich
genug und sein Orientalismus nicht mystisch genug.«[47]

Von den drei Themen dieser Ausstellung (Leben, Liebe, Tod)
ist das der Liebe in Byars' Werk am wenigsten untersucht. Es spielt
meiner Ansicht nach eine zentrale Rolle, was in seinen »perfekten«
Performances, wie *The Perfect Kiss, The Perfect Smile, The Perfect
Whisper* oder *The Perfect Love Letter*, am ersichtlichsten ausgedrückt
ist. Zwei philosophische Konzepte von perfekter Liebe sind in diesem
Zusammenhang anzuführen: Bei Spinoza ist es die *amor Dei intellec-
tualis,* die geistige Liebe zu Gott als höchste Form des Wissens, die in
dem einfachen Akt des Sich-selbst-Liebens erreicht werden kann; bei
Kierkegaard ist es Abrahams vollkommene Liebe zu Gott, ausgedrückt
in der Bereitschaft, seinen Sohn zu opfern, die Kierkegaards Theorie des
»Glaubenssprungs« zugrunde liegt. In beiden Fällen ist es das Bündnis
von Liebe und Gewissheit (ein Wissen, das keines Beweises bedarf),
das in Perfektion resultiert. Es überrascht nicht, dass Byars' perfekte
Liebe nicht die der reinen Form Spinozas und Kierkegaards ist, wie eine
frühe Aufführung des *Perfect Kiss* von zwei Frauen vor dem Palais des
Beaux-Arts in Brüssel (nach Anweisungen von Byars) bezeugt. Diese
Version aus dem Jahre 1974, dokumentiert von Yves Gevaert, ist formell
noch stärker seinen partizipatorischen Spielen der sechziger Jahre, be-
sonders dem *Two in a Hat*, verwandt als Byars' späteren Performances
für eine Person. Auch scheint sie auf Brancusis *Kuss* anzuspielen.

Mehr als Beuys, mehr als Warhol, um nur zwei der wenigen Künstler
gleichen Ranges zu nennen, hat Byars seiner Zeit ihre Komplexität gege-
ben. Wie sein Idol T. S. Eliot erfand Byars eine umfassende Kunst. Indem
er keinerlei Wissen ausschloss und keine Grenzen anerkannte, erfand er
eine Kunst für alle Zeiten. Er multiplizierte und dividierte Zeit und Raum
mit den größten und den kleinsten Variablen. In ihrer Dankesrede für den
Literaturnobelpreis 1993 sagte Tony Morrison die folgenden Sätze über
ihre Profession, die auch in vollkommener Weise auf das Leben und Werk
von Byars zutreffen: »Wir sterben. Das mag der Sinn des Lebens sein.
Aber wir *machen* Sprache. Das mag das Maß unserer Leben sein.«

14 Ibid.
15 Ibid.
16 Ibid.
17. Ibid.
18 Ibid.
19 Ibid.
20 RoseLee Goldberg, *Performance: Live Art 1909 to the Present* (London, 1979), p. 79.
21 Ibid., p. 82.
22 Yvonne Rainer, *Work 1961–73,* The Nova Scotia Series: Source Materials of Contemporary Arts, ed. Kasper Koenig (Halifax, 1974), p. 299.
23 MoMA Archives, N.Y., DCM, JLB I.1b.
24 John R. Searle, *Speech Acts: An Essay in the Philosophy of Language* (Cambridge, 1969), p. 3.
25 Ibid., p. 16.
26 Ibid., p. 17.
27 J. L. Austin, *How to Do Things with Words: The William James Lectures Delivered at Harvard University in 1955* (Cambridge, Mass., 1962), p. 22.
28 Samuel Weber, "Theatricality as Medium" (unpublished lecture).
29 MoMA Archives, N.Y., DCM, JLB I.4.
30 "The Performer as a Persona: An Interview with Yvonne Rainer," *Avalanche,* no. 5 (summer 1972).
31 MoMA Archives, N.Y., DCM, JLB I.4.
32 *James Lee Byars im Gespräch mit Joachim Sartorius* (Cologne, 1996), p. 48.
33 In conversation with the author.
34 MoMA Archives, N.Y., DCM, JLB I.1a.
35 Ibid., JLB I.2b.
36 Ibid., JLB I.3.
37 Ibid., JLB I.3.
38 Ibid., JLB I.3.
39 Wagstaff papers (see note 5).
40 MoMA Archives, N.Y., DCM, JLB I.1a (In her letter Dorothy Miller seems to have confused the date she first met Byars, which was 1958).
41 Ibid., JLB I.2b.
42 Wagstaff papers (see note 5).
43 MoMA Archives, N.Y., DCM, JLB I.1a.
44 Viola Maria Michely, "Tod als Performance," *Kunstforum International* 152 (October – December 2000), p. 107.
45 Sartorius, p. 17 (see note 32).
46 Hickey 1993 (see note 7).

Anmerkungen

1 T. S. Eliot, »Tradition und individuelle Begabung«, in: *Werke,* 4 Bde., hrsg. von Eva Hesse, Band 2: *Essays,* Frankfurt am Main 1967, S. 345–355, hier S. 351.
2 Der vollständige Titel lautet: »Memorabilia: ein notgedrungen unvollständiges Verzeichnis von Arbeiten mit Notizen für eine Chronik von fast vergessenen Begebenheiten aus dem Leben des James Lee Byars«.
3 The Museum of Modern Art Archives, N. Y., Dorothy C. Miller Papers, James Lee Byars Correspondence, I.1a.
4 Sören Kierkegaard, *Philosophische Brosamen und Unwissenschaftliche Nachschrift,* München 1976, S. 839 f.
5 Michael S. Gazzaniga, *Das erkennende Gehirn,* Paderborn 1988, S. 19.
6 Samuel J. Wagstaff Papers, Artists Correspondence James Lee Byars 1963–1971, Archives of American Art, Smithsonian Institution, Washington, D. C. (auf Mikrofilm).
7 Yves Aupetitallot, »Interview with Anny de Decker, Bernd Lohaus,« in: *Wide White Space. Behind the Museum,* Düsseldorf 1995, S. 63.
8 Dave Hickey, »Detroit Dharma Diva«, in: *James Lee Byars. Works from the Sixties,* New York 1993.
9 MoMA Archives, N. Y., DCM, JLB I.3.
10 Ludwig Wittgenstein, *Philosophische Untersuchungen,* Frankfurt am Main 1984 (Erstveröffentl. 1953), § 23, S. 250.
11 *Vogue,* 15. Januar 1969.
12 Wagstaff papers (wie Anm. 6).
13 Michael Fried, »Kunst und Objekthaftigkeit« (zuerst als »Art and Objecthood«, 1967), in: *Minimal Art. Eine kritische Retrospektive,* hrsg. von Gregor Stemmrich, Dresden und Basel 1995, S. 13 (Übersetzung modifiziert).
14 Wagstaff papers (wie Anm. 6).
15 Ebd.
16 Ebd.
17 Ebd.
18 Ebd.
19 Ebd.
20 Ebd.
21 RoseLee Goldberg, *Performance. Live Art 1909 to the Present,* London 1979, S. 79.
22 Ebd., S. 82.
23 Yvonne Rainer, *Work 1961–73,* The Nova Scotia Series: Source Materials of Contemporary Arts, hrsg. von Kasper Koenig, Halifax 1974, S. 299.

24 MoMA Archives, N. Y., DCM, JLB I.1b.
25 John R. Searle, *Sprechakte. Ein sprachphilosophischer Essay,* 3. Aufl., Frankfurt am Main 1988, S. 11.
26 Ebd., S. 30.
27 Ebd., S. 31.
28 John Langshaw Austin, *Zur Theorie der Sprechakte,* bearbeitet von Eike von Savigny, Ditzingen 1972, S. 41.
29 Samuel Weber, »Theatricality as Medium« (unveröffentlichter Vortrag).
30 MoMA Archives, N. Y., DCM, JLB I.4.
31 »The Performer as a Persona: An Interview with Yvonne Rainer«, in: *Avalanche,* Nr. 5 (Sommer 1972).
32 MoMA Archives, N. Y., DCM, JLB I.4).
33 *James Lee Byars im Gespräch mit Joachim Sartorius,* Köln 1996.
34 Im Gespräch mit dem Autor.
35 MoMA Archives, N. Y., DCM, JLB I.1a.
36 Ebd., DCM, JLB I.2b.
37 Ebd., DCM, JLB I.3.
38 Ebd., DCM, JLB I.3.
39 Ebd., DCM, JLB I.3.
40 Wagstaff papers (wie Anm. 6).
41 MoMA Archives, N. Y., DCM, JLB I.1a (Dorothy Miller scheint in ihrem Brief das Datum ihres ersten Treffens mit Byars, welches 1958 stattfand, verwechselt zu haben).
42 Ebd., DCM, JLB I.2b.
43 Wagstaff papers (wie Anm. 6).
44 MoMA Archives, N. Y., DCM, JLB I.1a.
45 Viola Michely, »Tod als Performance«, in: *Kunstforum International* 152 (Oktober – Dezember 2000), S. 107.
46 Sartorius, S. 17 (wie Anm. 33).
47 Hickey 1993, a. a. O. (wie Anm. 8).

KATALOG CATALOGUE

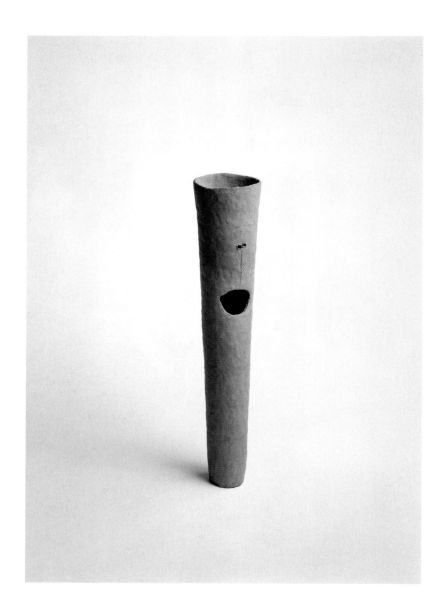

I

UNTITLED (A FACE) **OHNE TITEL (GESICHT)** CA. 1959

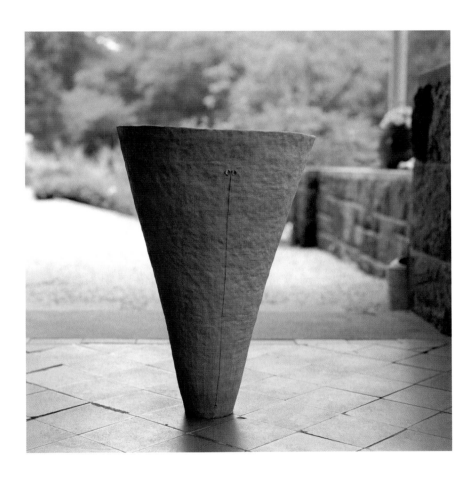

II

UNTITLED (A FACE) **OHNE TITEL (GESICHT)** CA. 1959

III

UNTITLED (THE BLACK FIGURE) **OHNE TITEL (SCHWARZE FIGUR)** CA. 1959

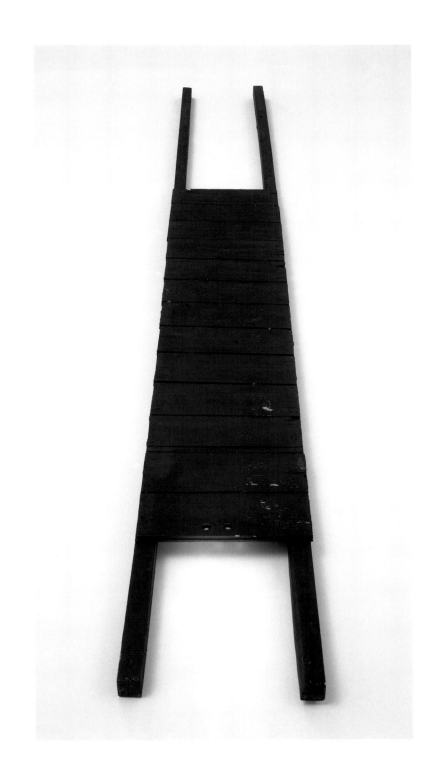

IV

SELF-PORTRAIT **SELBSTPORTRÄT** CA. 1959

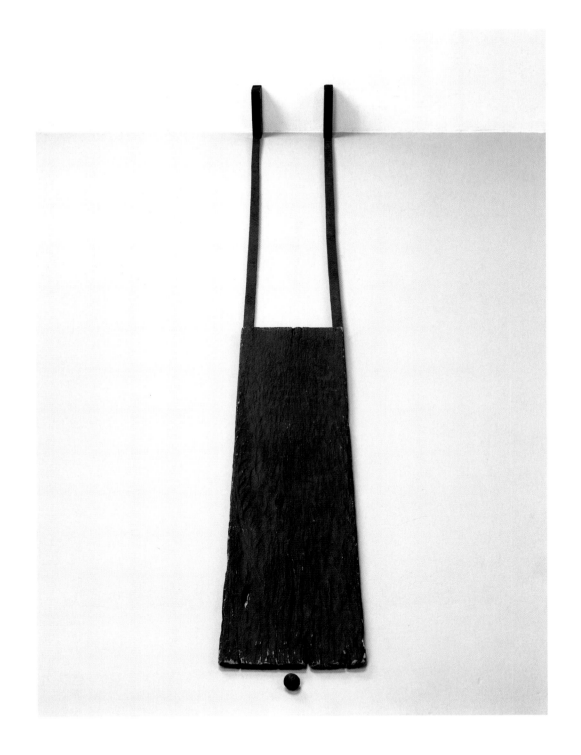

V

UNTITLED (EIGHT CONES) **OHNE TITEL (ACHT KEGEL)** CA. 1959

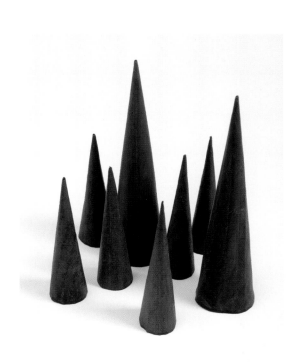

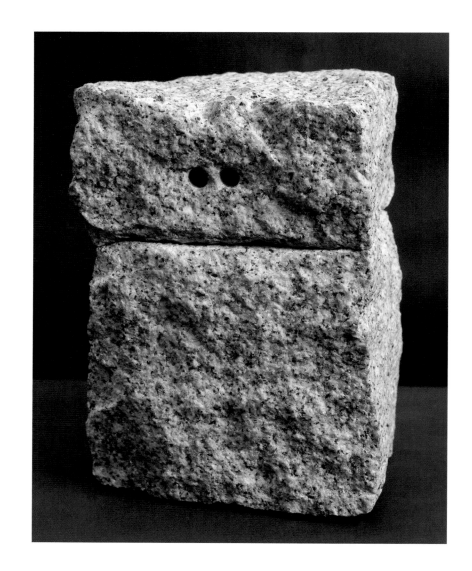

VI

UNTITLED (TANTRIC FIGURE) **OHNE TITEL (TANTRISCHE FIGUR)** 1960

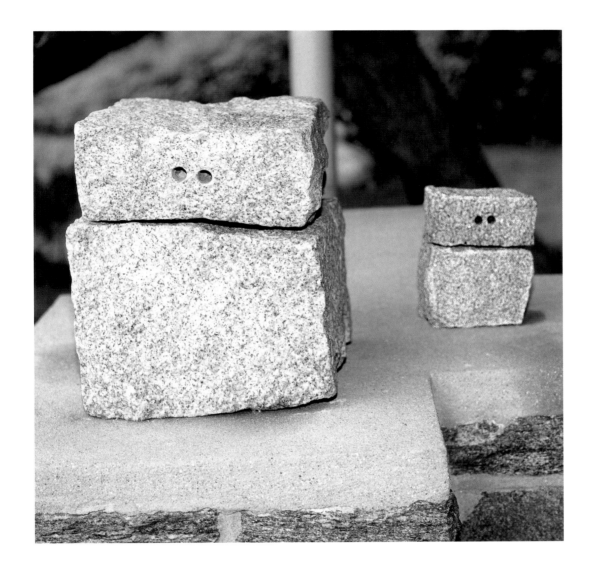

VII VIII

UNTITLED (TANTRIC FIGURES) **OHNE TITEL (TANTRISCHE FIGUREN)** 1960

IX

UNTITLED (TANTRIC FIGURE) OHNE TITEL (TANTRISCHE FIGUR) 1960

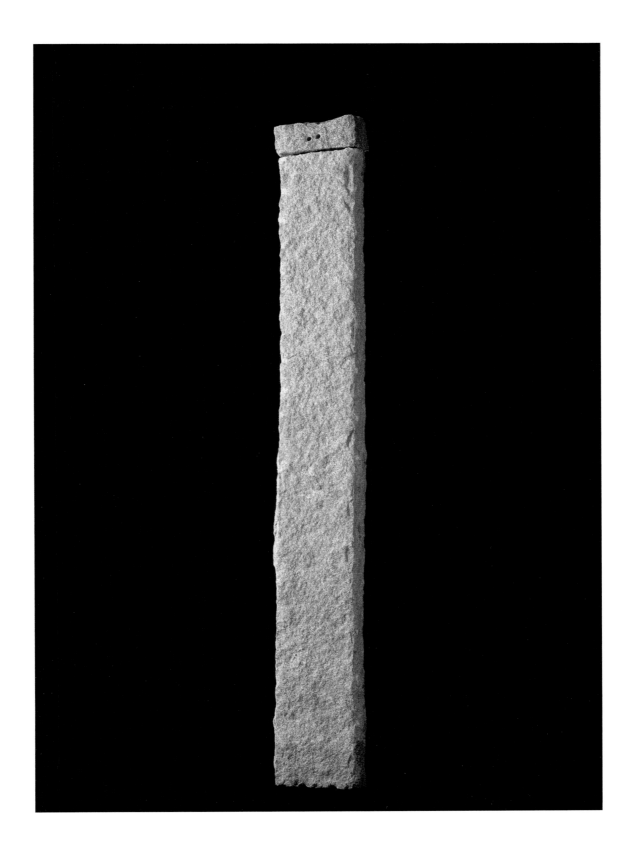

X

UNTITLED **OHNE TITEL** CA. 1960

XI ▶

UNTITLED (SCROLL) **OHNE TITEL (PAPIERROLLE)** CA. 1960

XII

IF YOU DON'T WASH YOUR OWN YOU STAY DIRTY JAMES BYARS **WENN DU DICH NICHT WÄSCHST, BLEIBST DU SCHMUTZIG, JAMES BYARS** CA. 1960

if
y
o
u
dont

wash your own

y
o
u

stay dirty

james byars

XIII

UNTITLED **OHNE TITEL** CA. 1960

XIV

UNTITLED **OHNE TITEL** CA. 1962

XV

UNTITLED (THE ACCORDIAN SCROLL/THE PERFECT PAINTING) **OHNE TITEL (AKKORDEONROLLE/DAS VOLLKOMMENE BILD)** 1962

A WHITE PAPER WILL BLOW THROUGH THE STREETS

XVI

A WHITE PAPER WILL BLOW THROUGH THE STREETS **EIN WEISSES PAPIER WIRD DURCH DIE STRASSEN WEHEN** 1967

XVII

FOUR IN A DRESS **VIER IN EINEM KLEID** 1967

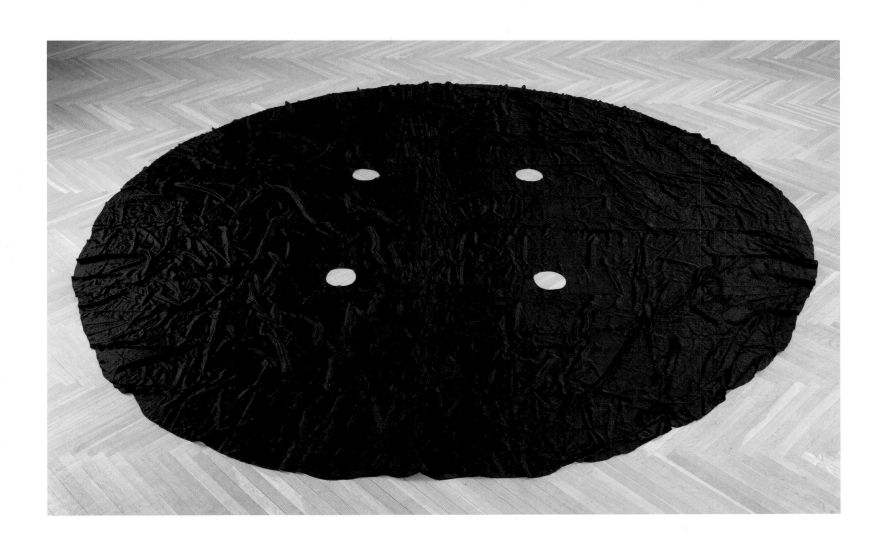

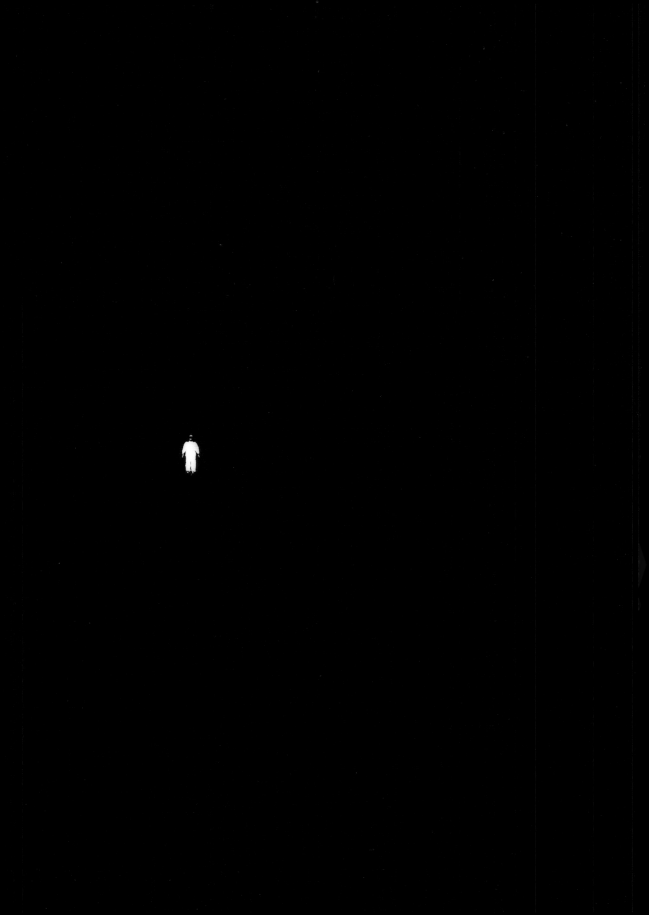

◄ XVIII "

AUTOBIOGRAPHY **AUTOBIOGRAFIE** 1970

XIX

100 MINDS **100 GEDANKEN** 1970

UNTITLED (AMERICAN FLAG FROM "TWO PRESIDENTS") **OHNE TITEL (AMERIKANISCHE FLAGGE AUS »ZWEI PRÄSIDENTEN«)** CA. 1974

TWO PRESIDENTS **ZWEI PRÄSIDENTEN** CA. 1974

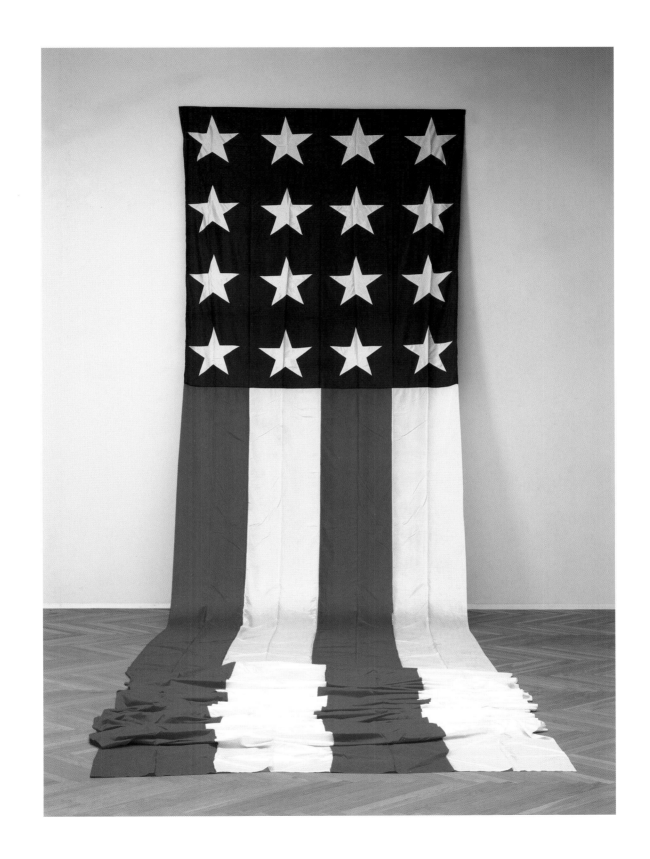

XXII

THE GOLDEN TOWER **DER GOLDENE TURM** 1974

XXIII

THE GOLDEN HOLE FOR SPEECH (THE PERFECT WHISPER) **DAS GOLDENE MUNDSTÜCK (DAS VOLLKOMMENE FLÜSTERN)** 1974/1981

THE HOLLOW SPHERE BOOK **DAS HOHLKUGEL-BUCH** 1978

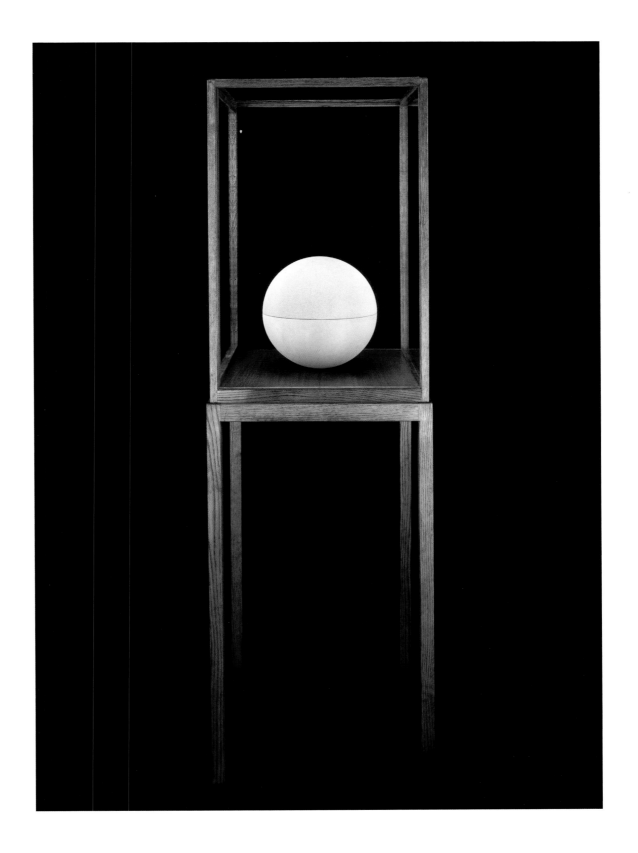

XXV

UNTITLED (THE CUBE BOOK) **OHNE TITEL (DAS KUBISCHE BUCH)** 1983

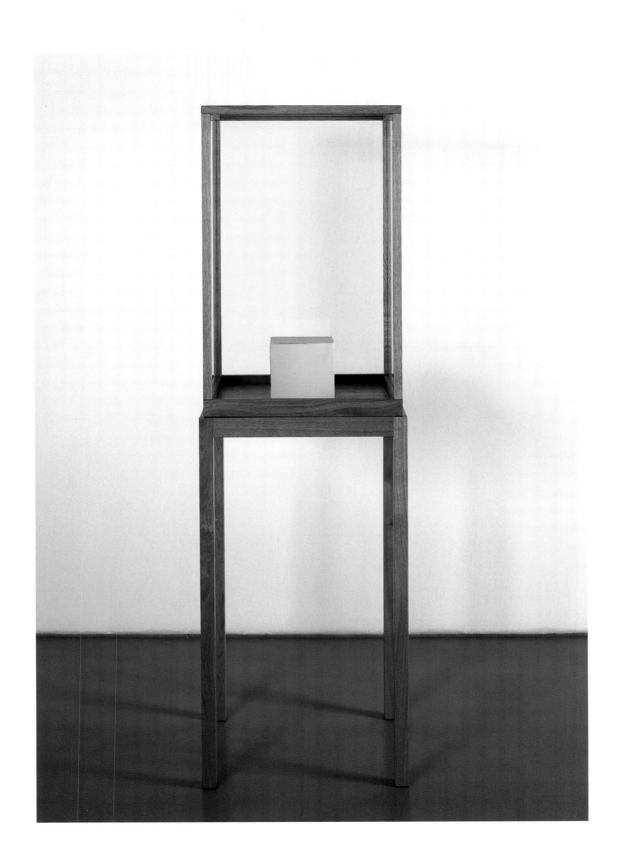

XXVI

THE PERFECT TEAR **DIE VOLLKOMMENE TRÄNE** 1984

XXVII

THE BOOK OF 100 PERFECTS **DAS BUCH DER 100 VOLLKOMMENHEITEN** 1985

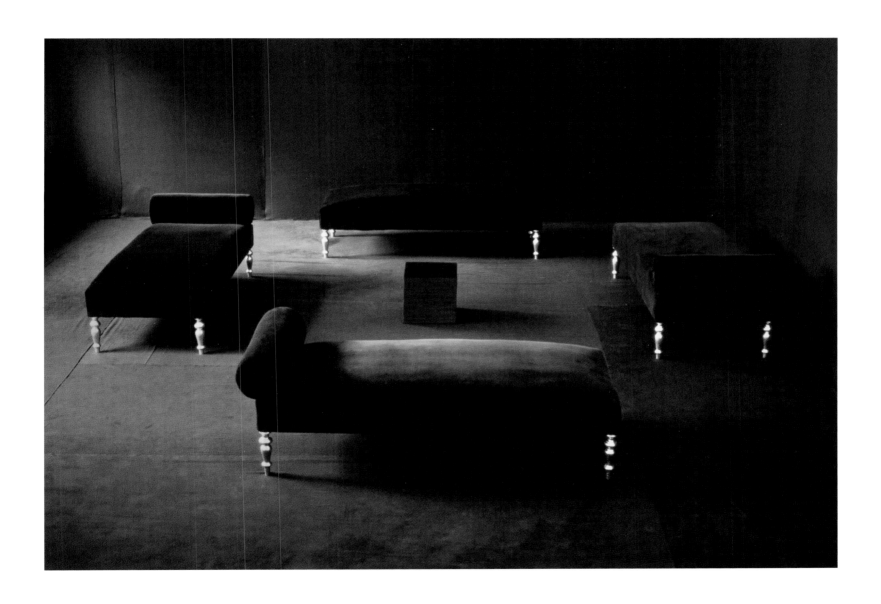

XXVIII

THE MOON BOOKS (PHASES OF THE MOON) **DIE MONDBÜCHER (MONDPHASEN)** 1988/89

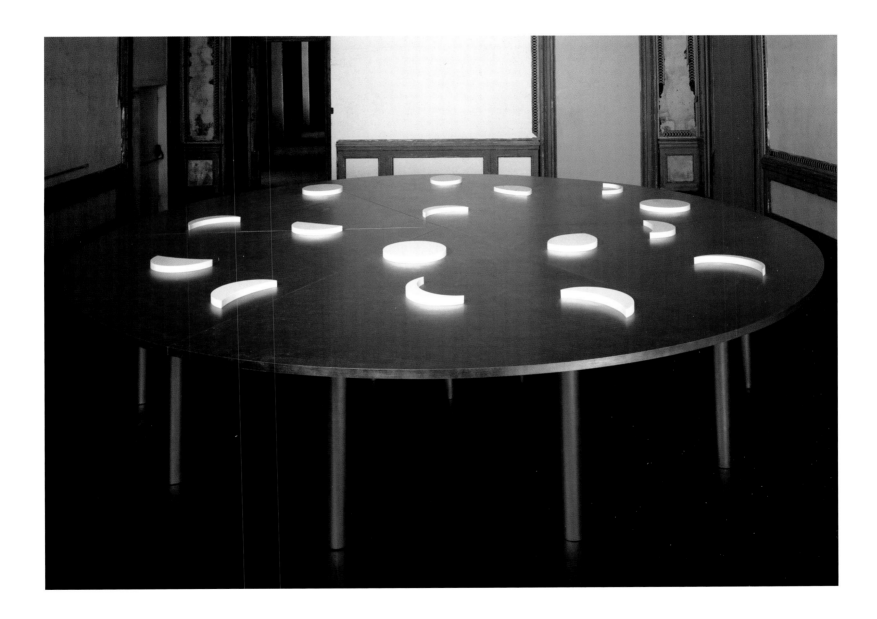

XXIX

THE ROSE TABLE OF PERFECT **DER ROSENTISCH DES VOLLKOMMENEN** 1989

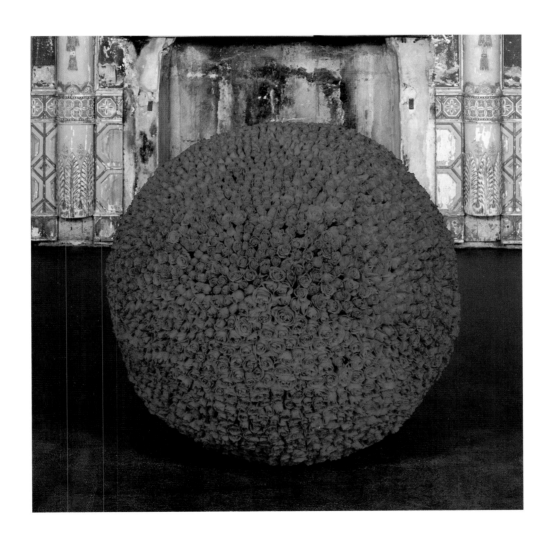

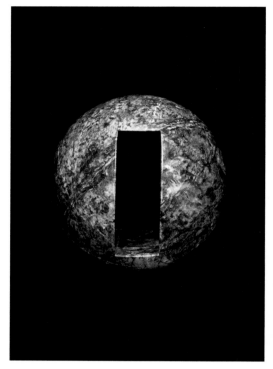 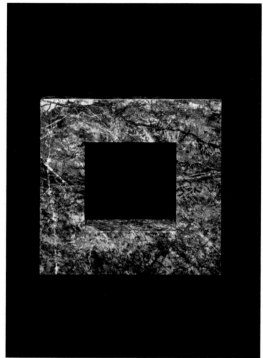

XXX

THE PATH OF LUCK: THE SPHERE DOOR **DER PFAD DES GLÜCKS: DIE SPHÄRISCHE TÜR** 1989

XXXI

THE PATH OF LUCK: THE SQUARE DOOR **DER PFAD DES GLÜCKS: DIE QUADRATISCHE TÜR** 1989

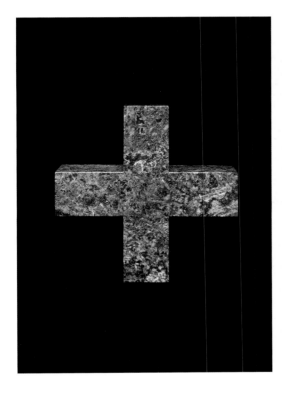 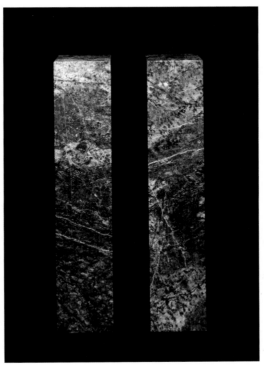 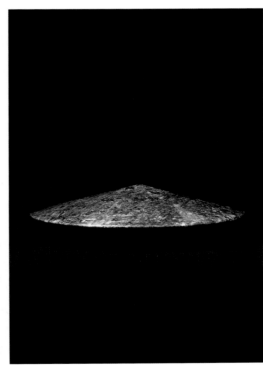

XXXII

THE PATH OF LUCK: THE CROSS **DER PFAD DES GLÜCKS: DAS KREUZ** 1989

XXXIII

THE PATH OF LUCK: THE TWO FIGURES **DER PFAD DES GLÜCKS: DIE ZWEI FIGUREN** 1989

XXXIV

THE PATH OF LUCK: THE DISCUS **DER PFAD DES GLÜCKS: DER DISKUS** 1989

XXXV

THE PATH OF LUCK: TWELVE FIGURES **DER PFAD DES GLÜCKS: ZWÖLF FIGUREN** 1989

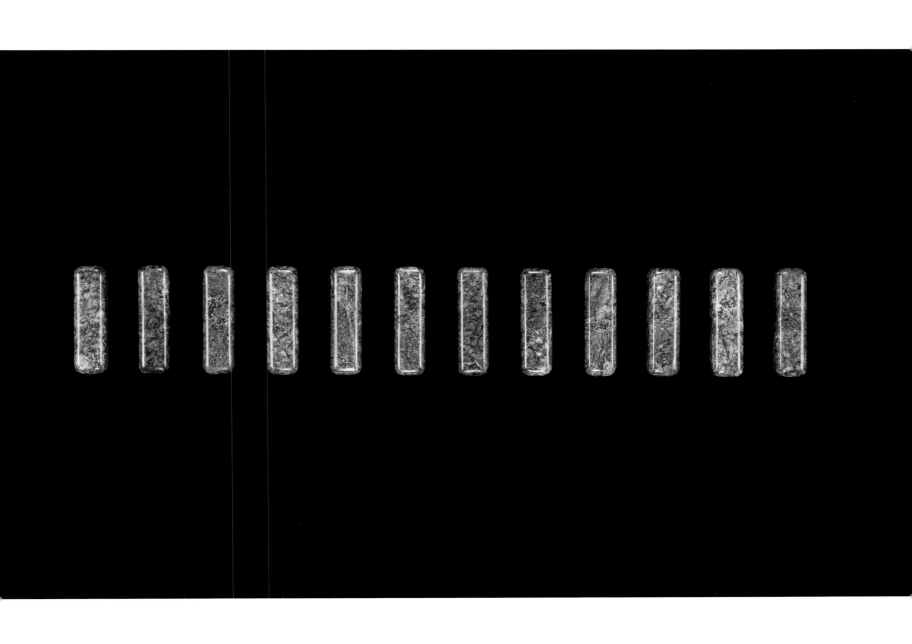

XXXVI

THE PERFECT THOUGHT **DER VOLLKOMMENE GEDANKE** 1990

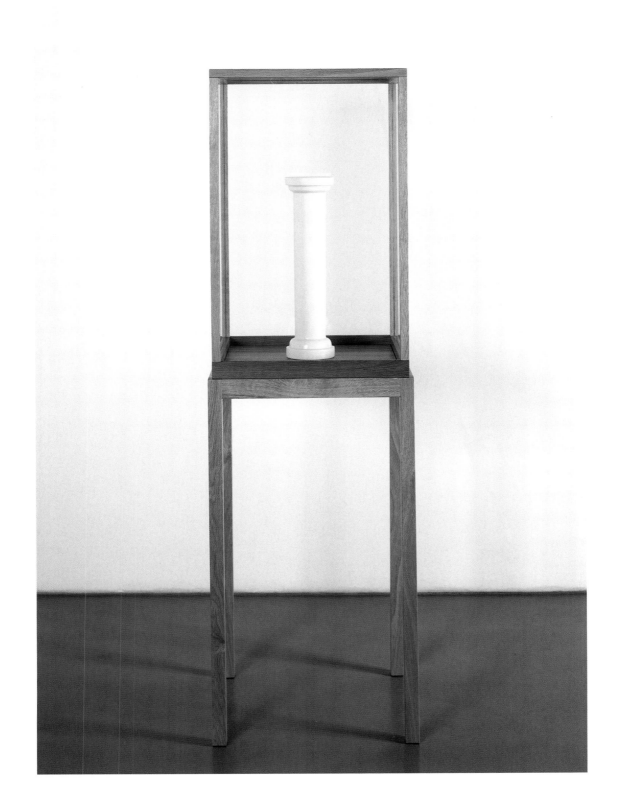

XXXVII

THE MOON COLUMN **DIE MONDSÄULE** 1990

XXXVIII

THE GOLDEN TOWER **DER GOLDENE TURM** 1990/2004

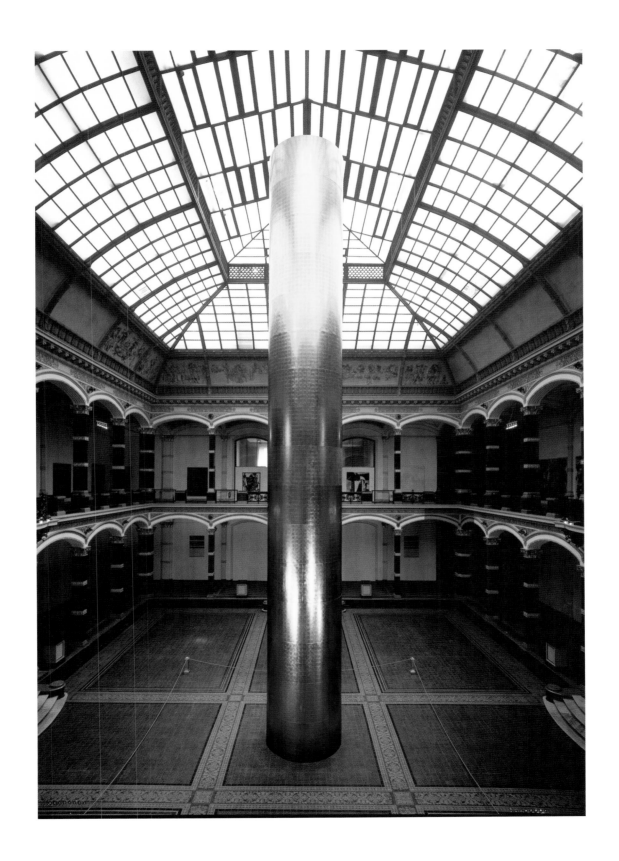

THE HUMAN FIGURE **DIE MENSCHLICHE FIGUR** 1992

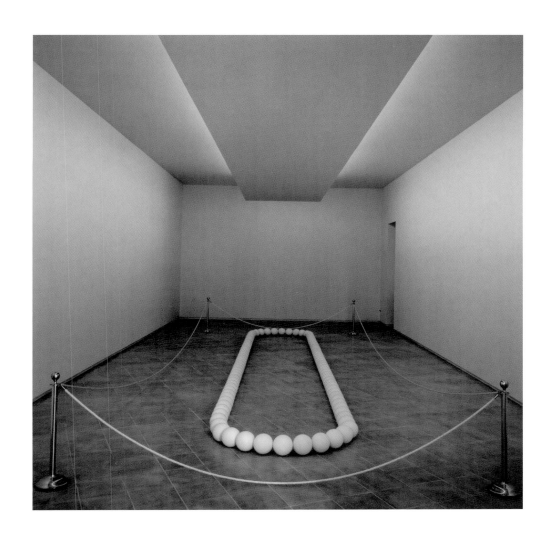

XL

THE RED ANGEL OF MARSEILLE **DER ROTE ENGEL VON MARSEILLE** 1993

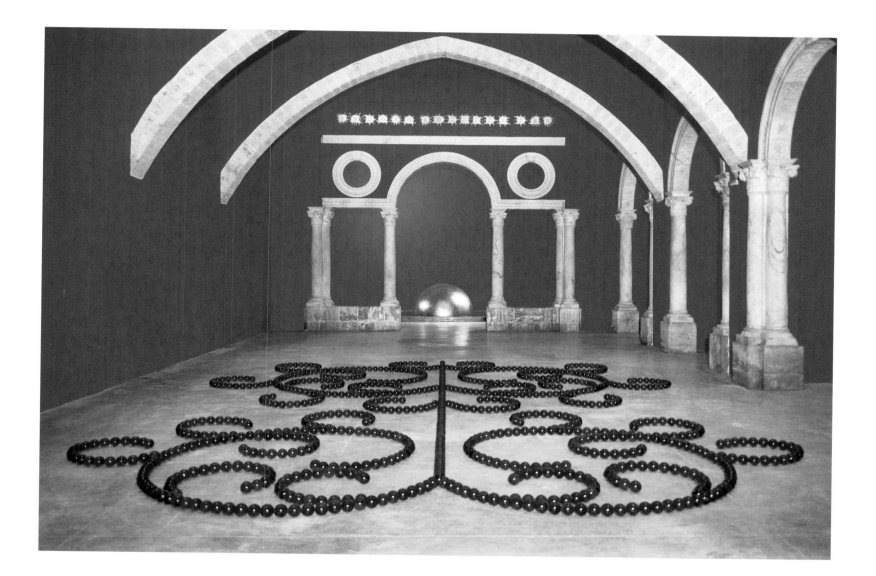

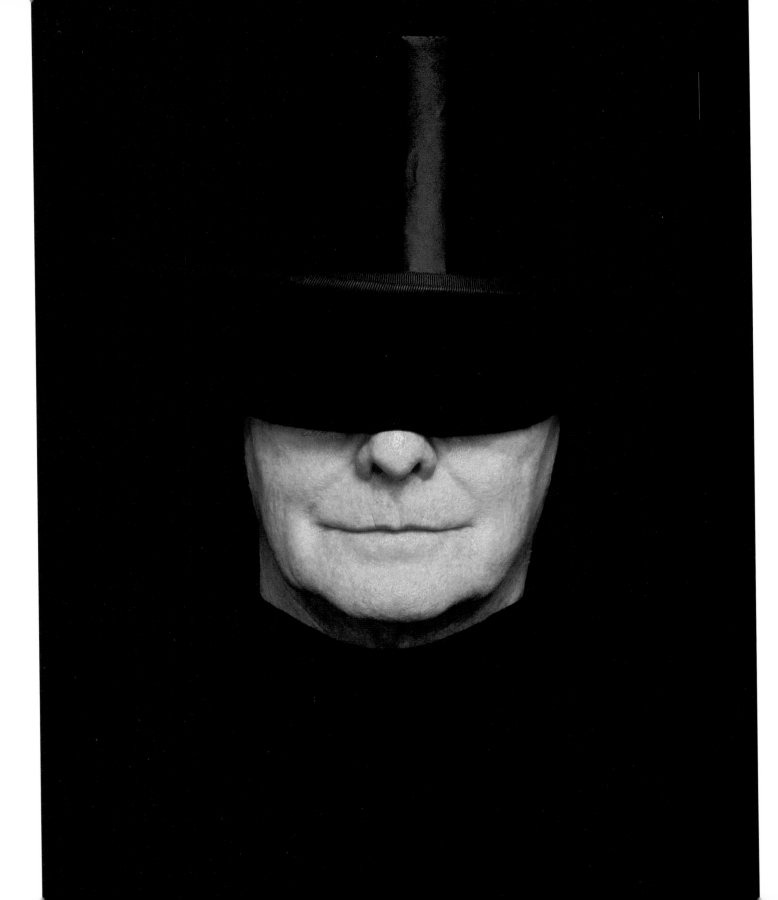

◄ XLI

THE PERFECT SMILE **DAS VOLLKOMMENE LÄCHELN** 1994

XLII

SLIT MOON **MONDSCHLITZ** 1994

XLIII

THE HALO **DER HALO** 1994

XLIV

THE DEATH OF JAMES LEE BYARS **DER TOD DES JAMES LEE BYARS** 1994/2004

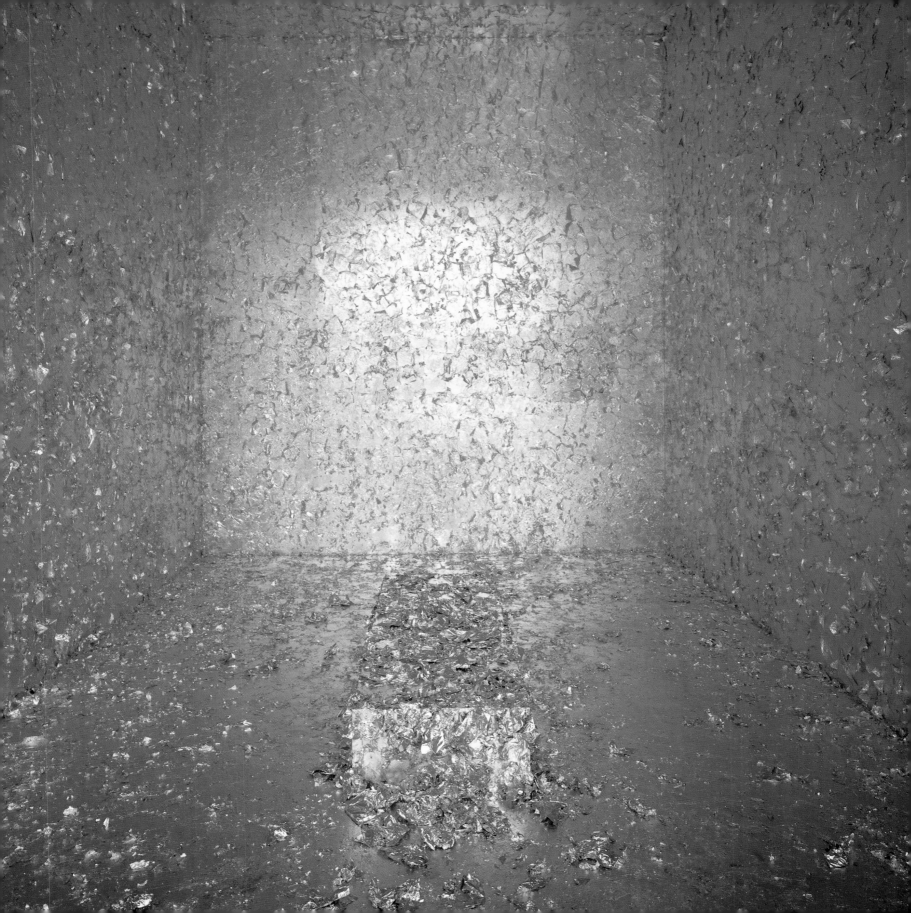

XLVI

UNTITLED (PAY ATTENTION NOW PLEASE) **OHNE TITEL (GEBEN SIE JETZT BITTE ACHT)** 1997

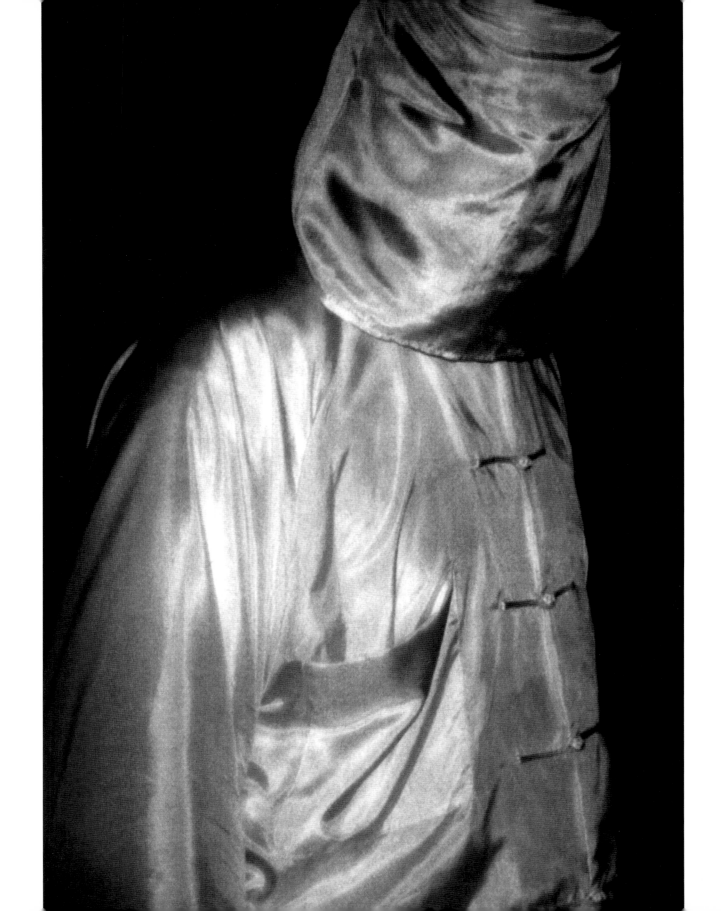

DER KÜNSTLER MIT DER MASKE
SELBSTDARSTELLUNG UND PERFORMATIVE PRÄSENZ
BEI JAMES LEE BYARS

THE ARTIST WITH THE MASK
SELF-REPRESENTATION AND PERFORMATIVE PRESENCE
IN THE WORK OF JAMES LEE BYARS

MARTINA WEINHART

Der Künstler als Kunstwerk

Die Verknüpfung von Leben und Werk, Biografie und künstlerischem Schaffen ist eines der Kernthemen der Moderne, die wie keine andere Epoche zuvor die Subjektivität des Künstlers in den Mittelpunkt rückt. James Lee Byars ist eine Figur, für die diese Verflechtung immer wieder besonders stark gemacht wird. Ein Schamane sei er, ein romantisches Genie, dessen künstlerische Strategien in einer Kreisbewegung von ihm ausgingen und immer wieder in ihm selbst mündeten – sein Werk sei eingebettet in ein »lebenslanges Projekt der Selbstmythologisierung«.[1] Da die ästhetische Intention alle seine Worte und Gesten durchdringe, komme die Präsenz von Byars der eines Kunstwerks gleich, schreibt Carter Ratcliff in diesem Sinne.[2] »Ich denke, ich sehe grundsätzlich wie mein Werk aus«, behauptet James Lee Byars selbst.[3] Ein Blick auf seine Performances lässt diese Auffassung zunächst plastisch werden. Wer erinnert sich nicht an die scheinbar omnipräsente Gestalt in Goldlamé, in Rot, im schwarzen oder weißen Anzug? Wieder und wieder taucht sie auf bei Gruppenausstellungen, Einzelaktionen, in Galerien oder Museen. Untrennbar sind seine Auftritte bei Eröffnungen mit einer performativen Rahmung und den Installationen selbst verknüpft. Sogar die Materialität spiegelt sich ineinander, setzt man seine goldschimmernden Gewänder ins Verhältnis zu seinen Goldarbeiten wie *Is, The Golden Tower* oder *The Perfect Death of James Lee Byars,* den Goldraum, der den Künstler inkarniert hat.

Doch nicht nur in seinen Performances war Byars präsent, bisweilen begleitete er auch seine Ausstellungen wie 1985 bei Mary Boone/Michael Werner in New York, wo er inmitten seines goldenen Turms, der goldenen Flagge, dem goldenen Nagel und dem goldenen *Halo* selbst in goldenem Anzug und goldenem Zylinder entweder seine Arbeit mit den Besuchern diskutierte oder bewegungslos als Teil seines Werkes verharrte, wie Thomas McEvilley beschreibt.[4] Eine Ausstellung seiner selbst als Höhepunkt des Selbstbezugs? Das trifft nur scheinbar zu, auch wenn

The Artist as Artwork

The linking of life and work, biography and artistic creation, is one of the core themes of modernity, which like no epoch before it has shifted the focus to the artist's subjectivity. James Lee Byars was a figure for whom this interweaving is particularly emphasized. It is said he was a shaman, a romantic genius whose artistic strategies radiated out from him in a circular movement and always flowed back into him—his work was a "lifelong project of self-mythologization."[1] "Because an aesthetic intention drove his every word and gesture, his presence is that of an artwork," Carter Ratcliff has written in this same spirit.[2] James Lee Byars himself asserted that he thought he looked fundamentally like his work.[3] A first glance at his performances makes this view very concrete. Who does not remember this seemingly omnipresent character in gold lamé, in red, in a black or white suit? Again and again this figure appeared at group shows, individual actions, in galleries and museums. His appearances at openings within a performative framework and the installations themselves were inseparable. Even the mutual materiality reflected back onto each other, if one relates the gold-shimmering garments with gold works like *Is, The Golden Tower,* and *The Perfect Death of James Lee Byars,* the gold room that incarnated the artist.

But Byars was not simply present at his performances, sometimes he accompanied his exhibitions, as in 1985 at Mary Boone/Michael Werner in New York, where, amid his golden tower, the golden flag, the golden needle, and the golden halo, he appeared himself in a golden suit and golden top hat, either discussing his work with visitors or remaining motionless as part of his work, as Thomas McEvilley has described.[4] An exhibition of himself as the height of self-reference? That is only apparently the case, even though several of his performative strategies would certainly seem to provide persuasive arguments for such a view, but the massiveness of his presence in the sense of a quantitative accumulation can only be one aspect. In fact, James Lee Byars organized his presence and its significance in a way that was certainly ambivalent. It is true that in *The Perfect Love Letter Is I Write I Love You Backwards in the Air*

einige seiner performativen Strategien durchaus überzeugende Argumente für eine solche Auffassung zu liefern scheinen, wobei die Massivität seiner Präsenz im Sinne einer quantitativen Akkumulation nur ein Aspekt bleiben kann. Tatsächlich organisiert James Lee Byars diese Anwesenheit und deren Bedeutung als durchaus ambivalent. Zwar steht er wie in *The Perfect Love Letter Is I Write I Love You Backwards in the Air* – unter anderem aufgeführt 1974 am Palais des Beaux-Arts in Brüssel – durchaus im Zentrum des Blickes und der Aufmerksamkeit des Betrachters, wenn er, wie der beschreibende Titel bereits nahe legt, mit dem Finger den Schriftzug in die Luft hinein ausführt. Dazu personalisiert er als Ausführender natürlich auf gewisse Weise die poetische Aussage. Wer jedoch dieses hier benannte Ich ist, wird offen gehalten. Nicht zwingend muss es auf den Künstler rückbezogen werden. Interessanterweise benennt der Titel dazu eine Relation – das Gegenüber von Ich und Du –, das in der Performance selbst komplett internalisiert wird. Sie erscheint buchstäblich als blinder Fleck. Dies geschieht dadurch, dass Byars wie so häufig eine schwarze Binde über den Augen trägt. Sein Blick kann sich auf diese Weise nur nach innen und keineswegs auf einen realen, gegenwärtig präsenten anderen richten. Das adressierte Du des Gegenübers markiert auf diese Weise eine Abwesenheit und kann nur auf das Imaginäre oder auf ein bereits Erinnertes gerichtet sein. Die ausgeführte Aktion verschiebt sich so vom Konkreten zum abstrakten Überpersönlichen. Das Ich und mit ihm der andere wird entkörpert und entpersonalisiert.

performed, among other places, at the Palais des Beaux-Arts in Brussels in 1974—he stood at the center of the viewer's gaze and attention when he, as the descriptive title suggests, drew letters in the air with a finger. Moreover, as the person executing the action he naturally personalized the poetic state to some degree. Nevertheless, it was never openly stated who the "I" mentioned here was. It need not be the artist. Interestingly, the title also specified a relation —the opposition of I and you—that is entirely internalized in the performance itself. It appeared literally as a blind spot. This is because Byars, as so often, was wearing a black blindfold over his eyes. Thus his gaze could only be directed inward and not at a real other present at that moment. The you of the contrast who was addressed thus marked an absence, and hence it could only be directed at the imaginary or something remembered. The executed action thus displaced from the concrete to the abstract and suprapersonal. The I, and thus the other, became disembodied and depersonalized.

Maskings

Our remembered gaze back at James Lee Byars is directed first at this mask. When we try to think of him as a figure, frequently all the remains is an outline, the clothes, the top hat, the golden suit, the red suit, and precisely that black mask over his eyes or even his entire face. All of this functions like a fade out. It causes the artist's real figure, his real face, to disappear. When not covered by

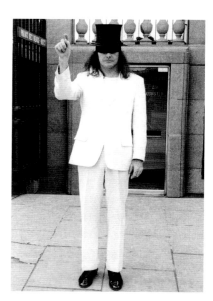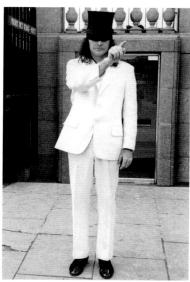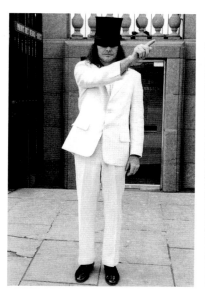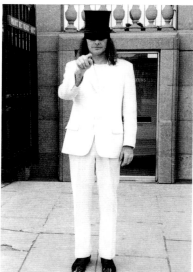

THE PERFECT LOVE LETTER IS I WRITE I LOVE YOU BACKWARDS IN THE AIR **DER VOLLKOMMENE LIEBESBRIEF IST ICH SCHREIBE ICH LIEBE DICH RÜCKWÄRTS IN DIE LUFT**
PERFORMANCE PALAIS DES BEAUX-ARTS, BRUSSELS **BRÜSSEL** 1974

Maskierungen

Unser erinnerter Blick zurück auf James Lee Byars richtet sich zuerst auf diese Maske. Denkt man an ihn als Figur, bleibt oft nur ein Umriss, die Kleidung, der Zylinder, der goldene Anzug, der rote Anzug und eben jene schwarze Maske über den Augen oder gar vor dem ganzen Gesicht. All dies funktioniert als Überblendung. Es bringt die reale Gestalt, das reale Antlitz des Künstlers zum Verschwinden. Ist es nicht verdeckt, so ist es geschminkt. Der ganze Körper ist mitbetroffen, oft nicht zu erahnen unter dem weiten Schnitt der Kleidung. Dieser Überblendung durch die Maske gibt James Lee Byars die Anekdote einer frühkindlichen Initiation an die Seite, mit der er eine naheliegende psychoanalytische Deutung als heuristischen Rahmen für seine Performanz anbietet. Er habe, so berichtet er Joachim Sartorius, als er vier Jahre alt war, von seinen Eltern einen Smoking bekommen, in dem er zu Hause vor Gästen getanzt habe und den er dann auch in der Schule trug. Dieser habe ihn, so bestätigt er, in den Zustand der Verkörperungsbereitschaft versetzt: »Mir wurde damals suggeriert, dass es äußerst bedeutsam sei, dass ich gerade auf diese Schule gehe, und dass diese Situation eine sehr wichtige sei. Ich wollte mich dieser Situation auch in meiner Kleidung ›stellen‹, mich dieser Situation ebenbürtig erweisen.« Diese frühkindliche Erfahrung auf seine Performance-Praxis übertragend, beschreibt er dann schließlich, wie auch die anderen durch diese Form der Transformation affiziert werden: »Und so, in einem ganz ähnlichen Sinn, fordert die Förmlichkeit der Kleidung die Aufmerksamkeit heraus, hält die Leute an, so hoffe ich, sich selbst und dem Ereignis Aufmerksamkeit zu zollen.«[5]

Eine entsprechend gewichtige Rolle spielt somit das Äußere des Ereignisses und nicht zuletzt das Äußere des Künstlers. Wenn Byars also bei einer Performance wie *The Perfect Love Letter* einen ebenso förmlichen wie eleganten weißen Anzug trägt, setzt er ihn als Mittel der Fokussierung der Aufmerksamkeit im beschriebenen Sinne ein, um die Bedeutsamkeit hervorzuheben. Gleichzeitig jedoch beinhalten seine Strategien aber auch ein Moment des Entzuges, des Verbergens und des Verschwindens – Form als Distanzmittel. Bietet doch die formelle Kleidung immer eine Nische, einen Ort des Rückzugs vor dem Individuellen hinter die gesellschaftliche Codierung. Im Falle des goldenen Anzugs trägt seine Kleidung ebenso dazu bei, durch den Leuchtreflex auf ihn als Figur aufmerksam zu machen, wie gleichzeitig durch dieses Leuchten zu blenden und ein Erkennen durch den Betrachter zu erschweren. Wenn er sich wie in der Performance *The Perfect Death of James Lee Byars* selbst in Gold gekleidet auf eine goldene Fläche legt, bringt er sich – wie es der Titel andeutet – einmal mehr zum Verschwinden. Indem er sich in Gold kleidet, taucht er, die Materialität seines Werkes aufnehmend, gleichsam

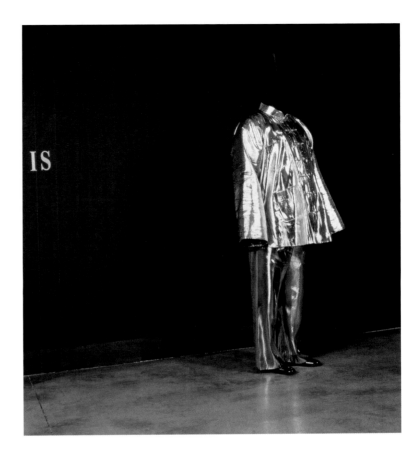

IS IST
PERFORMANCE MADRID 1992

a mask, it was covered by makeup. The whole body was affected as well; often it could not be detected beneath the broad cut of the clothes. With regard to this fading out by means of a mask, James Lee Byars told an anecdote of an initiation in early childhood that offers an obvious psychoanalytical interpretation as the heuristic framework for his performance. As he told it to Joachim Sartorius, when he was four years old his parents gave him a tuxedo in which he danced in front of guests at home and then wore to school. The tuxedo, he confirmed, transformed him into a state of readiness to embody other things: "At the time it was suggested to me that it was extremely important that I was going to just this school, and this situation was a very important one. I wanted to 'place' myself in this situation wearing these clothes, to prove myself worthy." Transferring this experience from early childhood to his performance practice, he then described how the others were affected by this kind of transformation: "And so, in a very similar sense, the formality of this clothing demanded attention, urged them to pay attention to themselves and the event."[5]

CALLING GERMAN NAMES **DEUTSCHE NAMEN AUSRUFEN**
PERFORMANCE KASSEL 1972

darin ein, um mit ihm zu verschmelzen. Diese Aufmerksamkeitsstruktur zieht sich durch viele der Byarsschen Performances und findet immer wieder neue Variationen. Auch die Hülle, die ihn anlässlich der Aktion *Calling German Names* auf dem Dach des Friedericianums bei der *documenta 5* in Kassel, 1972, teilweise umgibt, folgt diesem Muster. Die Fernwirkung berücksichtigend, ist er dieses Mal in die Signalfarbe Rot gekleidet. Kaum übersehbar einerseits, mit goldenem Megafon, mit dem er beliebige deutsche Vornamen wie Hans oder Marie in die Menge ruft, und goldenen Turnschuhen, andererseits theatralisch verhüllt in einem Berg von Tüllstoff, der ihn kaum noch unter dieser barocken skulpturalen Anmutung erahnen lässt.

Diese Strategie birgt für das Gegenüber – den an der Betrachtung gehinderten Betrachter – stets ein Moment der Verunsicherung, das durchaus intendiert ist. »Es ist schwierig, jemanden, der seine Augen verbunden hat, zu interviewen«, mit diesen Worten wehrt sich der Journalist Paul Taylor gegen die obligatorische Halbmaske, die Byars auch während ihres Gespräches trägt. Byars hält ihm entgegen, dass diese immer dazugehöre und die Irritation beabsichtigt sei. Er berichtet, dass eine solche Maske, wie er sie am selben Morgen in einer Galerie getragen habe, als er die Frage stellte: »The Poet of the World?«, stets für eine gewisse Stille und die Sensibilisierung der Anwesenden sorge. Die Maske sei den meisten Menschen nicht angenehm, als leicht formelle Geste erzeuge sie jedoch ein vollkommen anderes Herangehen an die Idee von Sprache.[6]

The external appearance of the event and not least that of the artist plays a correspondingly important role. Hence when, in a performance like *The Perfect Love Letter,* Byars wore a white suit that is as elegant as it is formal, he was employing it as a means of focusing attention in the way describe here, as a way of emphasizing importance. At the same time, however, his strategies also concealed a moment of denial, hiding, and disappearing—form as a means to create distance. This is because formal clothing always offers a niche, a place to withdraw from the individual into social coding. In the case of the golden suit, his clothing served just as much to call attention, by means of the bright reflection, to him as a figure as it did to blind us by this very brightness and make it more difficult to recognize him. When in a performance like *The Perfect Death of James Lee Byars* he dressed in gold and placed himself on a gold surface, he once again made himself disappear—just as the title suggests. By dressing himself in gold, he took up the materiality of his work, diving into it, as it were, in order to fuse with it. This structure of attentiveness ran through many of Byars's performances and was found in ever new variations. Even the shell in which he partially wrapped himself for the action *Calling German Names* on the roof of the Friedericianum for "documenta 5" in Kassel in 1972 followed this pattern. Taking into account the view from a distance, he wore the signal color red this time. On the one hand, he could hardly be overlooked, with his golden megaphone, through which he called out arbitrarily chosen German names, like Hans or Marie, into the crowd, and golden sneakers; on the other hand, he was theatrically wrapped in a mountain of tulle, which made it difficult to perceive beneath this baroque, sculptural evocation.

This strategy always conceals for the other—the viewer who is prevented from viewing—and this aspect of uncertainty is definitely intended: "It is difficult to interview someone with a blindfold over his eyes," as the journalist Paul Taylor said, by way of resisting the obligatory half mask that Byars wore during their interview as well. Byars countered, "But that's part of it, you know. You see, I do that deliberately. In the gallery this morning, when I asked the question, 'the Poet of the World?' blindfolded, it quieted the place down and people were polite enough to be sensitive. The mask—I mean it's not comfortable for most people—sets up a different approach to the idea of speech. It's like a slight formal gesture."[6]

With this seemingly contradictory aspect—heightening attention through exalted clothing that also obstructs the gaze by concealing the face and body—Byars created a tension between individual exposure and visual anonymity. It is certainly no surprise when the mask proved to be part of a strategy against determining something—one that, in this case, consisted in preventing recognition and recorded precisely this misapprehension as the basic pattern of his artistic activity. The danger of misapprehension was inscribed in every encounter. In the visual arts, especially in the sixties, this motif was

Mit diesem scheinbar widersprüchlichen Moment – der Erhöhung der Aufmerksamkeit durch exaltierte Kleidung, die mit der Versperrung des Blickes durch Verhüllung von Gesicht und Körper einhergeht – erzeugt Byars ein Spannungsfeld zwischen individueller Exponierung und bildlicher Anonymität. Es ist sicher keine Überraschung, wenn sich auf diese Weise die Maske als Teil einer Strategie gegen eine Festlegung erweist, die in diesem Falle in der Hinderung des Erkennens liegt und eben jene Verkennung als Grundmuster seines künstlerischen Handelns einschreibt. Die Gefahr der Verkennung ist jeder Begegnung eingeschrieben. In der bildenden Kunst ist dieses Motiv besonders in den sechziger Jahren in ein allgemeines Misstrauen gegenüber der Repräsentationsfähigkeit des menschlichen Abbildes eingebettet. Auf diese Weise steht die Maske ebenso wie das goldene Flirren für eine Verschiebung der Wahrnehmung, die einmal mehr den Graben zwischen dem Sagbaren und dem Sichtbaren beleuchtet.

Flüchtiges Selbst

Neben den Motiven des Verbergens und der Auflösung des Körpers scheint aber auch die Flüchtigkeit und Zeitgebundenheit der Repräsentation immer wieder in Byars' Aktionen auf. Spielt doch die Befragung des Verhältnisses von Objekthaftigkeit und Immaterialität bei Byars wie bei kaum einem anderen Künstler eine zentrale Rolle. Viele seiner Werke und Aktionen haben zudem den Charakter des Transitorischen. Für bestimmte Orte ausgewählt, mutieren Konzepte zu Kunstwerken, um nach dem Ende einer Ausstellung wieder abgebaut und zerstört zu werden. Bei einer neuen Gelegenheit entstehen sie vielleicht verändert aufs Neue. Byars vermeidet die Festlegung.

Die Vorstellung vom Ätherischen, sich Auflösenden und dem Verschwinden wird dabei immer wieder mit seiner Affinität zur japanischen Kultur in Verbindung gebracht. So taucht er am Rande eines Parks in Italien in großer Entfernung auf, gerade noch sichtbar für die geladenen Besucher, für eine Sekunde, um gleich darauf wieder zu verschwinden. Die vollkommenen Performances sind so kurz, dass sie oft »nur noch als Nachbild erahnt werden können«, wie Viola Michely schreibt.[7] Dazu passt, dass Byars seine Aktionen nicht systematisch durch Video oder Fotografie dokumentieren lässt. Oft werden sie fast zufällig festgehalten, wie *The Play of Death* (1976), der in Deutschland wohl prominentesten Performance, bei der Schlag 12 Uhr mittags Byars mit 12 anderen Personen, alle in Schwarz gekleidet, für einen Augenblick auf den Balkonen des Kölner Dom-Hotels erschien. »Lidschlagkurze Szenen«, hat Carl Haenlein die Aktionen genannt, »die schimmernde Gedächtnisspuren« hinterließen.[8]

embedded in a general mistrust of the ability to represent the human image. In this way, both the mask and the golden shimmer stood for a displacement of perception that one again illuminated the rift between what can be said and what can be seen.

Fleeting Self

In addition to the motifs of concealing and dissolving the body, however, the fleetingness of representation and its connectedness to time also seem to appear in Byars's actions. But questioning the relationship between objecthood and immateriality was central to Byars's work in a way it has been for few others. Many of his works and actions also had a transitory character. Chosen for particular places, the concepts mutated into artworks, only to be dismantled and destroyed after the exhibition ended. At every new opportunity they could evolve in a new way. Byars avoided any final determination.

The idea of the ethereal, the dissolving, and the disappearing has often been linked with his affinity for Japanese culture. For example, he appeared at the edge of a park in Italy, far from the invited visitors, barely visible, for one second, only to disappear. The complete performances were so brief that often they "can only be perceived as an afterimage," as Viola Michely has written.[7] It is consistent with this that Byars did not have his actions documented systematically on video or in photographs. Frequently they were captured almost by chance, like *The Play of Death* (1976), which in Germany is probably the best known of his performances: at the stroke of noon Byars appeared with twelve others, all dressed in black, on the balconies of the Dom-Hotel in Cologne. Carl Haenlein called the actions "scenes as brief as the batting of an eye . . . which left shimmering traces of memory."[8]

The principle of the fleeting, of the barely lasting perception, achieved by subverting the lasting, is one that Byars also applied in a genre in which it is least expected: the self-portrayal. This is usually considered a privileged place in which the artists sketch a likeness of themselves that is capable of offering the viewer glimpses of their biographies, their views of themselves and of the world, and that by revealing certain confessions is in the position to communicate, like a bridge between the artist and the work. In modernism in particular, self-portrait stood for the expression of individuality, of the artist's innermost self, and it evolves within the framework of tracking down and exploring the self. Subjectivity remained the leitmotiv of twentieth-century art.

Autobiography is the title of a film that Byars produced in 1970, and it undercut all of the known paradigms that the viewer associates with the genre. If viewers were to approach viewing the film with the attitude evoked by the title's associations, they would be completely frustrated. The announced autobiography turned out to be a very brief sixteen-millimeter film that consisted of

Das Prinzip des Flüchtigen, der kaum dauernden Wahrnehmung durch eine Subversion des Dauerhaften wendet Byars schließlich auch in einem Genre an, das dies kaum erwarten lässt: der Selbstdarstellung. Sie gilt zumeist als privilegierter Ort, an dem der Künstler eine Darstellung von sich selbst entwirft, die dem Betrachter Einblicke in seine Biografie, seine Selbstsicht, seine Weltsicht geben kann und die in der Offenbarung dieser besonderen Bekenntnisse als eine Art Brücke zwischen der Person des Künstlers und seinem Werk zu vermitteln in der Lage ist. Gerade in der Moderne steht die Selbstdarstellung für den Ausdruck der Individualität, des innersten Selbst des Künstlers, das im Rahmen einer Selbstaufspürung und Selbsterforschung entsteht. Die Subjektivität bleibt das Leitmotiv der Kunst des 20. Jahrhunderts.

Autobiography ist der Titel eines Filmes, den Byars 1970 produziert hat und der all die geschilderten Paradigmen, die der Betrachter mit diesem Genre verbindet, unterläuft. Brächte ein Zuschauer die durch den Titel erweckte Erwartungshaltung in die Betrachtung des Werkes ein, so würde sie gänzlich frustriert. Die angekündigte Autobiografie erweist sich als ein sehr kurzer 16-mm-Film, der aus nichts weiter besteht als Schwärze, aus der für 1/24stel Sekunde – das ist ein Bild des Filmes – die weiß gekleidete Figur von Byars auftaucht, um sofort wieder zu verschwinden. Nur klein hebt sie sich in der Mitte aus dem neutralen Dunkel. Eigentlich muss man beinahe wissen, dass der Künstler abgebildet ist, um ihn auszumachen. Von Erkennen kann keine Rede sein. Ebenso gut könnte dieses weiße Aufblitzen eine beliebige andere Form darstellen oder gar ein Fehler in der Projektion sein. Schon bei einer kleinen Unaufmerksamkeit ist es gut möglich, dass man diese Erscheinung auch gänzlich verpasst. Natürlich ist *Autobiography* eine Subversion des Mediums. So wie Byars hier die Frage stellt, was überhaupt ein Film ist, gibt er uns die Reflexion darüber mit, was das Auftauchen des Künstlers in seinem Werk heute bedeutet.

Auch dies stellt eine zentrale Erkundung in Byars' Gesamtwerk dar. So hatte er im Vorjahr, 1969, in der Galerie von Anny de Decker in Antwerpen *1/2 an Autobiography* – seine halbe Autobiografie – niedergelegt, seine halbe, da er mit seinen 37 Jahren die Hälfte der damaligen Lebenserwartung erreicht hatte. Auch diese Arbeit geht auf subversive Art und Weise mit den Grenzen des Genres um und bettet die Gestaltung in eine performative Aktion ein, in die die Besucher einbezogen werden, wie Anny de Decker beschreibt: »Stundenlang sass er auf einem Thonetstuhl in dem makellos weissen Galerieraum (die Wände und vor allem der Fussboden wurden innerhalb von drei Wochen mindestens fünfmal neu gestrichen). Dort schrieb er kurze Sätze oder sibyllinische Fragen auf Bögen Papier. Kam ein Besucher herein, las er den gerade geschriebenen Text vor, der dann gemeinsam besprochen wurde.

SELF-PORTRAIT **SELBSTPORTRÄT**

nothing but blackness from which the figure of Byars dressed in white emerged for one-twenty-fourth of a second—the duration of a single frame—only to disappear again. His figure rose up out of the neutral darkness only a little bit in the center of the frame. In fact, one almost needs to know that the artist is illustrated to make him out at all. One can hardly speak of perception. This white flash could easily represent some arbitrary form or even be a flaw in the projection. Even the briefest moment of inattention could mean missing the phenomenon entirely. *Autobiography* was, of course, a subversion of the medium. Just as Byars was questioning here what a film is altogether, he also caused us to think about what the appearance of the author in his work means today.

This issue is another central exploration in Byars's oeuvre. The previous year, 1969, he presented *1/2 an Autobiography* at Anny de Decker's gallery in Antwerp—half because he at thirty-seven had reached half the life expectancy of the time. This work too dealt with the limits of the genre in a subversive way, embedding its form in a performative action into which the viewers were also drawn, as Anny de Decker has described it: "He sat for hours on a Thonet chair in the flawlessly white gallery space (the walls and above all the floor had been repainted at least five times within three weeks). There he wrote brief sentences or sibylline questions on sheets of paper. When a visitor entered, he read the text he had just written, and then they would discuss it together. These texts were later published under the title '100.000, or 100.000 Minutes of Attention, or the Big Sample of Byars, or 1/2 an Autobiography, or the First Paper of Philosophy.'"[9]

Diese Texte wurden später unter dem Titel ›100.000, or 100.000 Minutes of Attention, or the Big Sample of Byars, or 1/2 an Autobiography, or the First Paper of Philosophy‹ herausgegeben.«[9] Als letzte Performance der Ausstellung wurde dann die vollendete Autobiografie schließlich dem Publikum vorgetragen. Auch dies geschah in den Paradigmen des Byarsschen Präsenzmodells: »Byars blieb dabei beinahe unsichtbar. Durch die runde Öffnung einer rosa gestrichenen Trennwand konnte man nur einen Schimmer seines Gesichtes erkennen. Die Besucher mussten beim Eintritt in den inzwischen rosa gestrichenen Raum ihre Schuhe ausziehen und sich zu einer runden Öffnung begeben, durch die Byars in vertraulichem Ton ein paar Sätze vorlas.«[10]

Byars stellt seine Arbeit in den Rahmen einer allgemeinen Auflösung und Erweiterung der Selbstdarstellung – eine Aushöhlung, die sich spätestens seit den sechziger Jahren des 20. Jahrhunderts des Genres bemächtigt hat. Zersprengt wird dabei ein konventioneller Apparat, die Basis hergebrachter Darstellungskonventionen wird destabilisiert. Eine solche Arbeit verweigert in letzter Konsequenz die Zuordnung nach herkömmlichen Kriterien. Gleichzeitig hat sich die Folie, vor der sich die Selbstdarstellung ausbreitet, mit einem immer stärker wahrgenommenen poststrukturalistischen Denkgebäude massiv umgestaltet. Die dekonstruktivistische Kritik erteilte in erster Linie modernen Konzeptionen von Subjektivität, künstlerischer Urheberschaft und Originalität eine radikale Absage. Dabei spielen zwei Motive, die in beiden »Werken« aufscheinen, eine zentrale Rolle. Zum einen geht es darum – und das ist bei Byars erst auf den zweiten Blick zu erkennen –, den Künstler aus dem Zentrum der Betrachtung zu rücken, zum anderen – und dies wird besonders bei der Performance der halben Autobiografie deutlich – gleichzeitig ein größeres Augenmerk auf den Zuschauer/Betrachter zu werfen. Immer wieder wird die hohe Affinität, die James Lee Byars zu den Schriften von Roland Barthes hatte, betont. An dieser Stelle lässt sich präzisieren, worauf er sich dabei im Besonderen bezog.

Die Tode des James Lee Byars

Die Figur des Todes, die das Werk von James Lee Byars durchzieht, in den Titeln seiner Arbeiten ebenso auftaucht wie im Motiv der Vollendung seiner *Perfects,* spiegelt einige andere Tode in der Philosophiegeschichte. Das apokalyptische Postulat vom »Tod des Menschen«, niedergelegt im viel zitierten letzten Satz von Michel Foucaults *Ordnung der Dinge,* in dem er prophezeit, »dass der Mensch verschwindet wie am Meeresufer ein Gesicht im Sand«[11], ist seit ihrem Erscheinen eine ebenso populäre wie häufig diskutierte Denkfigur,

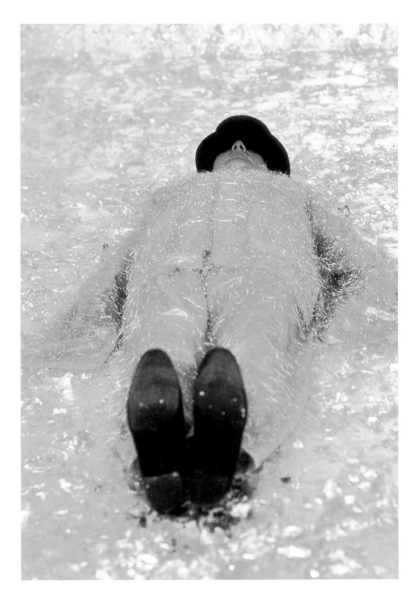

THE DEATH OF JAMES LEE BYARS **DER TOD DES JAMES LEE BYARS**
PERFORMANCE GALERIIE MARIE-PUCK BROODTHAERS, BRUSSELS **BRÜSSEL** 1994

As the final performance of the exhibition the completed autobiography was read to the public. That too took place within the paradigms of Byars's model of presence: "Byars remained almost entirely invisible. Through the round opening of a partition wall painted pink one could perceive just a glimmer of his face. The visitors had to remove their shoes when entering the room, which had since been painted pink, and gather about the round opening through which Byars read a few sentences with a familiar tone."[10]

mit der die Prämisse des Humanismus, der Mensch stehe im Zentrum seiner selbst und seiner Geschichte, ausgehebelt werden sollte. Bei Derrida liest sich dies als »Fines hominis«.[12] Mit der Figur des Menschen als Erfindung des modernen Denkens wird die Absolutheit des Subjekts – als Garant der Selbstdarstellung der Moderne – von unterschiedlichen Positionen und Ansätzen aus einer Kritik unterzogen. Die Totalisierung in den Begrifflichkeiten von Einheit und Autonomie des Subjekts war, seit sie ihren Gipfel im Geniekult des Fin de Siècle erreicht hatte, zunehmend unter Beschuss genommen worden und wurde in den unterschiedlichsten Spielarten demontiert. Auch diese Unternehmungen erreichten in den sechziger Jahren ihren Höhepunkt und markieren bis heute einen zentralen Bezugsrahmen künstlerischer Aktivität.

Doch zurück zu Roland Barthes: Mit seinem epochalen Aufsatz vom »Tod des Autors« wird dem Subjekt per Dekret die Domäne des von ihm verfassten Textes entzogen.[13] Die hier formulierten Thesen eröffnen damit eine Debatte um die Relevanz der Intentionen eines Autors für die Interpretation *seines* Textes – eine Frage, die für die Literaturgeschichte die gleiche Brisanz entwickelt wie für die bildende Kunst. Gegen eine Erklärung des Werkes aus biografischen Zusammenhängen entwirft Barthes das Modell einer Bedeutung, die zwischen den Strukturen entsteht. Mit der Kritik des konventionellen Autorbegriffs, wie sie von Roland Barthes und Michel Foucault formuliert worden ist, wird für das Genre des Selbstporträts nicht allein der lang nachhallende Geniebegriff der Romantik ausgehebelt. Der Sturz des souveränen Autors reißt gleichermaßen an den Grundpfeilern des Genres. Die Negierung einer solchen Autorfigur, mit der auch Einheit und Autonomie des Subjektes an sich in Frage gestellt werden, zieht in dieser Verlagerung des Ursprungs der Bedeutung die Möglichkeit von Originalität und Ausdruck des Inneren massiv in Zweifel. Mit dem traditionellen Werkbegriff wird der individuelle Ausdruck als eine Illusion verabschiedet, dessen Möglichkeiten, sich gegen vorgängige Muster, Strukturen, Diskurspraktiken und Konventionen durchzusetzen, weit geringer sind, als das die gesamte Moderne je angenommen hat. Der Abschied von einer Fokussierung auf Künstler und Autor bringt gleichzeitig die Existenzbedingungen stärker ins Spiel. Jenseits eines traditionellen Dreiecks zwischen Künstler, Rezipienten und einem Werk, das seine Bedeutung aus der Intention seines Urhebers erfährt, wird insbesondere die Rolle des Betrachters neu formuliert und er wird nicht als bloßes Gegenüber aufgefasst. Künstler und Publikum sind nicht länger antagonistisch gedacht. Vor diesem Hintergrund klingt es geradezu wie ein Nachhall auf den Barthesschen Meta-Aufsatz, wenn Byars 1993 auf der Biennale in Venedig Goldpapiertaler mit Schriftzügen verteilt, die zum einen verkünden: »Byars is dead« und zum anderen »Your presence is the best work«. Der Tod des Autors ist die Geburt des Betrachters.

Byars presented his work in the frame of a general dissolution and expansion of self-representation—an erosion that had taken hold of the genre at least since the sixties. In doing so a conventional apparatus was exploded; the basis of traditional conventions of depiction were destabilized. Such a work refuses with utmost rigor to be categorized according to traditional criteria. At the same time, the foil against which this self-depiction was presented has massively transformed as awareness of the poststructuralist storehouse of ideas has increased. The deconstructionist critique meant above all a radical renunciation of modern conceptions of subjectivity, artistic authorship, and originality. Two motifs that appeared in both "works" played a central role in this. First, and in Byars's case this is not evident at first glance, the point was to move the artist out of the center of attention; second, and this is particularly clear in the performance of the half autobiography, greater attention was to be drawn to the viewer-observer. Again and again, the great affinity that James Lee Byars had to the writings of Roland Barthes was emphasized. Here it is possible to say more precisely what he was referring to in detail.

Deaths of James Lee Byars

The figure of death—which ran through James Lee Byar's entire oeuvre, both in the titles of his works and in the motif of completion implicit in his *Perfects*—reflected several other deaths in the history of philosophy. The apocalyptic postulate of the "death of man" expressed in the final phrase of Michel Foucault's *The Order of Things,* in which he prophesied "that man would be erased, like a face drawn in sand at the edge of the sea,"[11] has become, since its publication, a figure of thought that is as popular as it is frequently discussed, by which the premise of humanism that man stands at the center of himself and his history can be dislodged. In Derrida it is called "the ends of man."[12] With this trope of man as an intention of modern thinking the absoluteness of the subject—as the guarantee of modernism's self-portrayal—is subjected to a critique from a variety of positions and approaches. The totalization in the terminologies of unity and autonomy of the subject—which reached their apex in the cult of genius of the fin de siècle—were increasingly under attack and were disassembled in many ways. These activities too had their apex, in this case in the seventies, but they still mark a central point of reference in artistic activity.

But back to Roland Barthes: In his epochal essay "The Death of the Author" the subject was removed by decree from the very text he or she wrote.[13] The theses formulated here thus opened up a debate over the relevance of an author's intentions for the interpretation of his or her own text—a question that came to have as much explosiveness for literary history as for the visual arts. Against an explanation of a work by means of biographical connections Barthes sketched a model of meaning that results between structures. In the

SELF-PORTRAIT **SELBSTPORTRÄT**

critique of the conventional conception of the author that was formulated by Roland Barthes and Michel Foucault, it is not just that the long reverberating conception of the genius is dislodged from the genre of the self-portrait. The collapse of the sovereign author brought down the very pillars of the genre, as it were. By displacing the origin of meaning, the negation of such an authorial figure—which also calls into question the unity and autonomy of the subject—cast massive doubts on the possibility of originality or the expression of interiority. Along with the traditional conception of the work, individual expression was also retired, or at least its possibilities for asserting itself against earlier models, structures, practices of discourse, and conventions were much more limited than all the modernists had assumed. Dispensing with a focus on artist and author brought the conditions of existence more into play. Beyond a traditional triangle between artist, recipient, and a work that gained its significance from the intentions of its author, the role of the viewer was reexamined in particular, reformulated, no longer seen as a mere other. Artist and public were no longer conceived antagonistically. Against this backdrop, it sounds almost like an echo of Barthes's metaessay when, at the Biennale di Venezia in 1993, Byars distributed rounds of golden paper that announced "Byars is dead," on the one hand, and "Your presence is the best work," on the other. The death of the author is the birth of the viewer.

Etwas Beliebiges ein Selbstporträt nennen

Das Zurückweichen des Selbst hinter eine Idee, einen flüchtigen Auftritt, einen Text hat Byars vorgeführt, seine Strategie des Entzuges setzt sich jedoch auch in seinen objekthaften Werken fort. Unzählige dieser Selbstdarstellungen sind entstanden, angefangen mit dem Selbstporträt von ca. 1959, einer minimalisierten Darstellung, bei der eine kleine Kugel vor einer Holzbohle mit zwei dünnen Leisten so angeordnet ist, dass das Gesamtarrangement eine menschliche Figur alludiert. Sie wurde in zwei Varianten – als sitzende und als liegende Figur – gezeigt. Auch der Titel wechselte. Byars bezeichnete sie ebenso lakonisch als *Black Figure*. Was also macht ein und dieselbe Arbeit einmal zur schwarzen Figur und das andere Mal zum Selbstporträt? Jacques Derrida, der das Selbstporträt ohnehin nur noch im Begriff der Ruine fasst, da dem Subjekt eine Art besondere Blindheit gegenüber der eigenen Person gegeben ist, argumentiert ganz im Byarsschen Sinne, wenn er schreibt: »Wenn das, was man Selbstporträt nennt, von der Tatsache abhängt, daß man es *Selbstporträt* nennt, so müßte ein Akt der Namensgebung mir zu Recht erlauben, etwas Beliebiges ein Selbstporträt zu nennen, nicht bloß eine beliebige Zeichnung (ob Porträt oder nicht), sondern alles, was mir zustößt und durch das ich affiziert werden oder mich affizie-

Calling Just About Anything a Self-Portrait

Byars demonstrated the self recoiling behind an idea, a fleeting appearance, a text, but his strategy of denial continued in his works with objects as well. Countless numbers of these self-portrayals were produced, beginning with *Self-Portrait* of ca. 1959, a minimized depiction in which a small sphere was arranged in front of a wooden plank with two thin strips in such a way that the overall arrangement alluded to a human figure. It was exhibited in two variants: as a seated and as a reclining figure. The title also changed. Byars also described it just as laconically as *Black Figure*. What makes one and the same work sometimes a black figure and sometimes a self-portrait? Jacques Derrida, who in any case conceives the self-portrait as a conception of ruins, since the subject always has a particular blindness with respect to his or her own person, argues very much in Byars's terms when he writes, "If what is called a self-portrait depends on the fact that it is called 'self-portrait,' an act of naming should allow or entitle me to call just about anything a self-portrait, not only a drawing ('portrait' or not) but anything that happens to me, anything by which I can be affected or let myself be affected."[14] Byars played with this (im)possibility of portrayal by following precisely this strategy. Thus his self-portrait could be a sphere of bread of the type that he often kneaded himself, or a golden sphere. It could be a gold ring. The portrait of the artist could con-

ren lassen kann.«[14] Byars spielt mit dieser (Nicht-)Darstellbarkeit, indem er eben dieser Strategie folgt. Auf diese Weise kann sein Selbstporträt eine kleine Brotkugel sein, wie er sie häufig geknetet hat, oder eine goldene Kugel. Es kann ein goldener Reif sein. Das Porträt des Künstlers kann aus Goldscheiben mit silberner Rahmung bestehen. Wie in seinen Performances muss er schließlich in seinem Werk verschwinden oder das Werk in ihm, im Sinne seines Postulats: Ich denke, ich sehe grundsätzlich wie mein Werk aus. Was bleibt, ist eine entsubjektivierte Kunst, die Biografisches ebenso wie Handwerkliches weitgehend ausschließt. Byars fertigt seine Objekte nicht selbst – zumindest nicht im Sinn einer klassischen Vorstellung von einer handwerklichen Kreativität. Seine perfekten Objekte werden nach seinen Anweisungen geschaffen. Die Figur James Lee Byars – sie ist omnipräsent und unauffindbar: »Man frage mich nicht, wer ich bin, und man sage mir nicht, ich solle der gleiche bleiben: das ist eine Moral des Personenstandes; sie beherrscht unsere Papiere. Sie soll uns frei lassen, wenn es sich darum handelt, zu schreiben.«[15]

sist of gold disks with silver frames. As in his performances he ultimately had to disappear in his work or his work in him, along the lines of his postulate that he thought he looked fundamentally like his work. What remains is an art desubjectivized, which largely precludes both biography and artisanship. Byars did not make his objects himself—at least not in the sense of a classical idea of artisanal creativity. His perfect objects were made according to his instructions. The figure of James Lee Byars was as omnipresent as it was untraceable: "Do not ask who I am and do not ask me to remain the same: leave it to our bureaucrats and our police to see that our papers are in order. At least spare us their morality when we write."[15]

Anmerkungen

1 Donald Kuspit, [Besprechung der Ausstellung »James Lee Byars« im MASS MoCA], in: *Artforum*, XLII, Nr. 5, Januar 2004, S. 60.

2 Carter Ratcliff, »James Lee Byars: Art in the Interrogative Mode«, in: *The Perfect Thought. Works by James Lee Byars*, Ausst.-Kat. University Art Museum, Berkeley 1990, S. 53–64, hier S. 57.

3 *James Lee Byars im Gespräch mit Joachim Sartorius*, Köln 1996, S. 39.

4 Thomas McEvilley, »More golden than gold«, in: *Artforum*, 24, 1985/86, S. 93.

5 *James Lee Byars im Gespräch mit Joachim Sartorius* (wie Anm. 3), S. 38.

6 Paul Taylor, »An interview with James Lee Byars«, in: *Flash Art*, 125, 1985/86, S. 57.

7 Viola Michely, »Tod als Performance?«, in: *Kunstforum International*, Bd. 152, Oktober – Dezember 2000, S. 113.

8 Carl Haenlein, »The Epitaph of Con. Art is which Questions have disappeared?«, in: *James Lee Byars. The Epitaph of Con. Art is which Questions have disappeared?*, Ausst.-Kat. Kestner Gesellschaft, Hannover 1999, S. 9.

9 Anny de Decker, in: *James Lee Byars*, Ausst.-Kat. Kunsthalle Bern, 1978, o. S.

Notes

1 Donald Kuspit, review of "James Lee Byars" at MASS Moca, *Artforum* XLII, no. 5 (January 2004), p. 60.

2 Carter Ratcliff, "James Lee Byars: Art in the Interrogative Mode," in *The Perfect Thought: Works by James Lee Byars,* exh. cat. University Art Museum (Berkeley, 1990), pp. 53–64, esp. 57.

3 *James Lee Byars im Gespräch mit Joachim Sartorius* (Cologne 1996), p. 39.

4 Thomas McEvilley, "More Golden than Gold," *Artforum* 24 (1985–86), p. 93.

5 *James Lee Byars im Gespräch mit Joachim Sartorius* (see note 3), p. 38 (trans. Steven Lindberg).

6 Paul Taylor, "An Interview with James Lee Byars," *Flash Art* 125 (1985–86), p. 57.

7 Viola Michely, "Tod als Performance?," *Kunstforum International* 152 (October–December 2000), p. 113.

8 Carl Haenlein, "The Epitaph of Con.Art Is Which Questions Have Disappeared?," in *James Lee Byars: The Epitaph of Con Art Is Which Questions Have Disappeared?,* exh. cat. Kestner Gesellschaft (Hanover, 1999), p. 201.

9 Anny de Decker, in *James Lee Byars,* exh. cat. Kunsthalle Bern (Bern, 1978), unpaginated.

10 Ibid.

11 Michel Foucault, *The Order of Things* (New York, 1970), p. 387.

12 Jacques Derrida, "The Ends of Man," in idem, *Margins of Philosophy,* trans. Alan Bass (Chicago, 1982), pp. 109–136. The original text is dated May 12, 1968, and was presented as a lecture in New York in October 1968 on the occasion of an international colloquium on "Philosophy and Anthropology."

10 Ebd.

11 Michel Foucault, *Die Ordnung der Dinge,* Frankfurt am Main 1974, S. 462.

12 Jacques Derrida, »Fines hominis«, in: ders., *Randgänge der Philosophie,* hrsg. von Peter Engelmann, Wien 1988, S. 119–141. Der Text ist datiert auf den 12. Mai 1968 und wurde anlässlich eines Internationalen Kolloquiums zu »Philosophie und Anthropologie« als Vortrag im Oktober 1968 in New York gehalten.

13 Roland Barthes, »La mort de l'auteur/The Death of the Author«, 1967 zur Publikation in dem amerikanischen Magazin *Aspen,* Nr. 5/6, Herbst/Winter 1967, geschrieben und ein Jahr darauf in Frankreich veröffentlicht in: *Manteia,* V, 1968.

14 Jacques Derrida, *Aufzeichnungen eines Blinden. Das Selbstporträt und andere Ruinen,* München 1997 (zuerst Ausst.-Kat. Musée du Louvre, Paris 1990), S. 67.

15 Michel Foucault, *Archäologie des Wissens,* Frankfurt am Main 1973, S. 30.

13 Roland Barthes, "The Death of the Author," was written in 1967 for publication in the American magazine *Aspen* 5–6 (fall/winter 1967) in a translation by Richard Howard and was published in France a year later as "La mort de l'auteur" in *Manteia* 5 (1968), pp. 12–17.

14 Jacques Derrida, *Memoirs of the Blind: The Self-Portrait and Other Ruins,* trans. Pascale-Anne Brault and Michael Naas (Chicago, 1993), p. 65.

15 Michel Foucault, *The Archaeology of Knowledge & The Discourse on Language,* trans. A. M. Sheridan Smith (New York, 1972), p. 17.

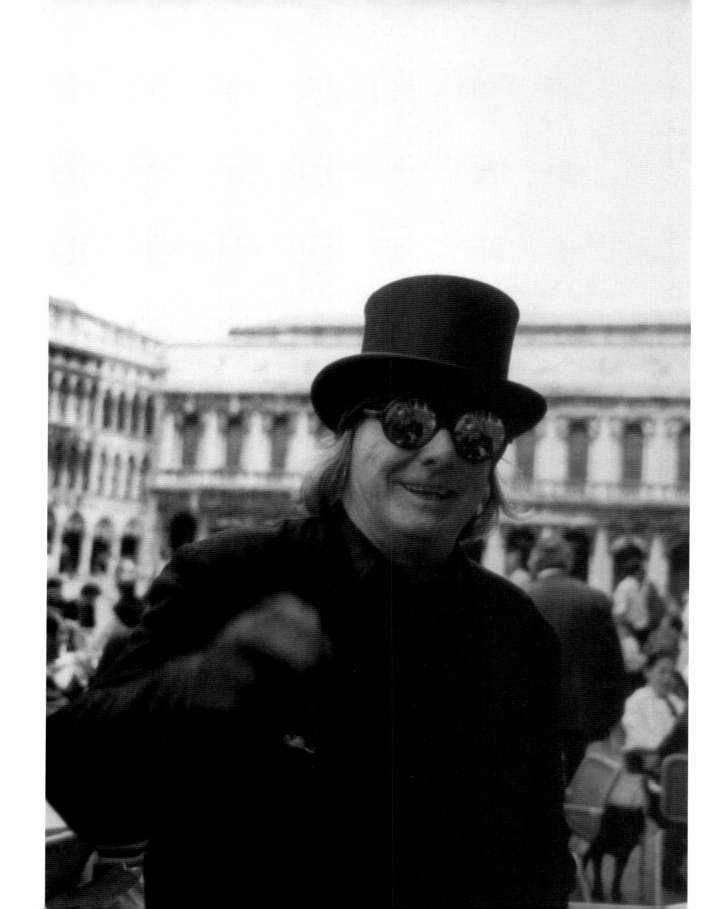

DAS PRESENT PERFECT DER MALEREI

THE PRESENT PERFECT OF PAINTING

VIOLA MICHELY

»Glück? Darüber spricht man nicht. Ein Wort zuviel, und es ist lächerlich. Zwei Worte, und es ist verschwunden, fort.«[1]

James Lee Byars hat bis auf ein Leinwandbild keine Gemälde hervorgebracht, dennoch beziehen sich seine Inszenierungen immer wieder auf das Medium Malerei. Schon die erste Byars-Ausstellung in Japan trug im Titel den Begriff »Malerei«, ohne Malerei im herkömmlichen Sinn zu zeigen. Zu sehen waren großformatige Tuschzeichnungen, deren Form und Material zwar der japanischen Tuschmalerei entlehnt zu sein schienen, deren Motive jedoch ganz uneindeutig blieben – auch vor dem Hintergrund der abstrakt-westlichen Maltradition.[2] Die Dokumentationsfotografien offenbaren eine fragliche Verbindung zwischen den gemalten Flächen und der Person, die sie betrachtet. Möglicherweise als körperliche Entsprechung gedacht, künden die schwarzen Flächen von einer Schwere, und ihre Verbindung zum weißen Grund und zur unteren Bildkante erfolgt meist unvermittelt, höchstens eine dünne Linie fungiert als Standbein. Weitere so genannte *Paper Paintings* des Künstlers zeigen immer wieder kleine schwarze Kreise in der Nachbarschaft von größeren schwarzen Flächen. Sie erinnern an aus der Form geratene Ausrufezeichen oder an Augen – übertrieben wie die Augen von Comicfiguren, von Goofy oder Mickymaus. Disproportionalität, Dezentralität und das Beschnittene der Formen, das alles hat etwas Bestürzendes. Das Versetzen der Kreisflächen aus dem Zentrum ist bedeutsam, weicht es doch bald der alles beherrschenden Zentralität künstlerischen Nomadentums. In diesen Zeichnungen steckt viel Kraft, Gestaltungs- und Behauptungswille. Unvermittelt und nackt erscheint mir dieser Byars. Vielleicht bezeugen die Arbeiten ein Gefühl der Fremdheit in Japan und im Heimatland Amerika. Erst später, über den Umweg der interaktiven Seidenkleider, fand Byars sein Zuhause in der Kunst.

Den Wendepunkt im Schaffen des Künstlers markiert das Jahr 1975. Byars führte auf Einladung der Stichting de Appel in Amsterdam mehrere Aktionen durch, zu denen er wie folgt einlud: »IN QUIET PLACES OUT IN THE CITY LANDSCAPE THERE WILL BE FLASH SHOWINGS OF MY PAINTINGS DURING THE NEXT

"Happiness? You shouldn't talk about it. One word too many and it becomes ridiculous. Two words and it's banished, gone."[1]

With the exception of a single work on canvas, James Lee Byars did not produce paintings, and yet his stagings repeatedly allude to the medium of painting. Byars's first exhibition in Japan was entitled *Paintings,* although it did not include any paintings in the traditional sense. What one saw were large-format ink drawings whose forms and materials appeared to be borrowed from Japanese ink painting but whose motifs remained entirely ambiguous—even against the backdrop of the tradition of Western abstract painting.[2] The photographs documenting the exhibition expose a questionable connection between the painted surfaces and the person observing them. Perhaps conceived as a physical counterpart, the black surfaces announce a certain gravity, and their connection to the white background and to the lower edge of the image is usually abrupt, with at most a thin line acting as the engaged leg. Others of the

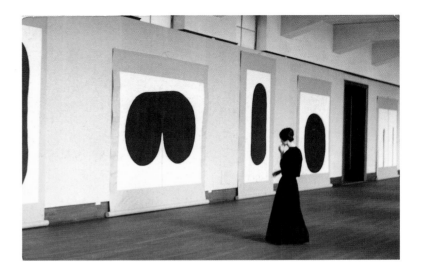

NATIONAL MUSEUM OF MODERN ART, KYOTO 1962

FEW WEEKS MAY I INVITE YOU TO WATCH FOR THEM JAMES BYARS.«³ Fotografien do-
kumentieren die Verortung des Künstlers, der ganz in Gold gehüllt auf
der Mitte verschiedener Plätze in Amsterdam zu sehen ist: vor dem Tor
zum Rijksmuseum, auf der Brücke über einer Gracht. Er hält einen lan-
gen vergoldeten Holzstab als vertikale Verlängerung seiner selbst in die
Luft. Das Gold des Stabes bindet den Blick und fungiert als Lichtquelle
und Mittelachse der zum ephemeren Bild komponierten Stadtlandschaft.
Flash Showings im Einladungstext künden von der Flüchtigkeit, wie wohl
auch von etwas, das ungeachtet des momentanen Zeigegestus des
Künstlers immer und überall besteht: der Ubiquität der Malerei. Die Stadt
wird zum Zuhause der Kunst, Byars ein Nomade darin – ohne Atelier,
mit der immer währenden Anstrengung, den gesehenen Zusammenhang
zu beleuchten.

The Golden Tower, die Idee entstand 1975, wird zum stetig wach-
senden Leuchtturm für die Städte, in denen sich der Künstler bewegt.⁴
Parallel dazu entwickelt Byars die so genannten *Perfect Performances,*
kurze minimale Gesten, die er dort aufführt, wo die Malerei zu Hause ist:
im räumlichen Kontext der Museen. Die erste dieser Performances ist
ein flüchtiger Liebesbrief: *The Perfect Love Letter Is I Write I Love You
Backwards in the Air,* aufgeführt vor dem Palais des Beaux-Arts in Brüssel
1974.⁵ Es folgt die Performance *The Perfect Kiss* vor dem Musée du Louvre
1975, *The Perfect Whisper* in der Gemäldeabteilung der Kunstsammlung
Bern 1978, *The Exhibition of Perfect* in der National Gallery of London
und im Busch-Reisinger Museum in Cambridge/Massachusetts 1980,
The Perfect Death of James Lee Byars vor dem Philadelphia Museum
of Art 1984 und schließlich *The Perfect Smile* 1986 und 1994, mittler-
weile Sammlungsbestand des Museum Ludwig in Köln.⁶ Sie alle sind in
Anlehnung an die in den jeweiligen Museen präsentierte Kunst entstan-
den. *The Perfect Kiss* und *The Perfect Smile* beziehen sich auf die *Mona
Lisa* von Leonardo da Vinci und auf andere gemalte Schönheiten, deren
Lächeln über Jahrhunderte hinweg bezaubert. Es scheint, als ob diese
Perfects den Gemälden ihr Ewiges entziehen und als Flüchtiges entlar-
ven. Charles Baudelaire fordert vom »Maler des modernen Lebens«, »von
der Mode das loszulösen, was sie im Geschichtlichen an Poetischem, im
Flüchtigen an Ewigem enthalten mag«.⁷ *Perfect* markierte fortan in Byars'
Schaffen diese Koexistenz von Flüchtigem und Ewigem, ist Quintessenz
seines Denkens über Modernität, um weiterhin der Begrifflichkeit
Baudelaires zu folgen.

Die Performance *The Perfect Death of James Lee Byars* kann in
Anlehnung an Marcel Duchamps Abkehr von der Malerei und der post-
humen Präsentation von *Given: 1. The Waterfall 2. The Illuminating Gas*
(1946–1966, Philadelphia Museum of Art) verstanden werden. Zu sehen
ist eine Holztür, die den uneingeschränkten Blick auf das Tableau dahinter

THE WAND **DER STAB**
PERFORMANCE AMSTERDAM 1975

artist's so-called *Paper Paintings* repeatedly feature small black circles along-
side larger black planes. They recall exclamation points that have come apart
or eyes—the exaggerated eyes of comic book figures like Goofy or Mickey
Mouse. The disproportionality, decentrality, and clipped aspect of the forms all
have something shocking to them. The displacing of the circular planes from
the center is significant because it departs from the centrality of the artistic
nomadism that will soon dominate everything. These drawings conceal a great
deal of power, of a will to design and assert oneself. This Byars seems abrupt
and naked to me. Perhaps these works testify to a feeling of alienation in Japan
and in his native country, America. Only later, by means of the roundabout way
of interactive silk clothing, did Byars find his artistic home.

The turning point in the artist's oeuvre is marked by the year 1975. In
response to an invitation from the Stichting de Appel in Amsterdam, Byars
carried out several actions, for which his invitation read: "IN QUIET PLACES OUT IN
THE CITY LANDSCAPE THERE WILL BE FLASH SHOWINGS OF MY PAINTINGS DURING THE NEXT FEW
WEEKS MAY I INVITE YOU TO WATCH FOR THEM JAMES BYARS."³ Photographs document
the artist's location, showing him completely covered in gold in the center of
various squares in Amsterdam: in front of the gate to the Rijksmuseum or on
the bridge over a canal. He holds a long gilded wooden rod in the air as a
vertical extension of himself. The gold of the rod fixes the viewer's gaze and
functions as a light source and central axis of the cityscape, which has been
composed in an ephemeral image. The title *Flash Showings* from the invitation
announces the ephemerality, as well as something that, despite the artist's
passing gesture of pointing, always exists everywhere: the ubiquity of paint-
ing. The city becomes art's home; Byars, a nomad therein, without a studio,
constantly faced with the effort to illuminate the context shown.

verhindert, das auf diese Weise nur mittels zweier Löcher durch einen momentanen, an eine voyeuristische Situation gemahnenden, geheimen Blick zugänglich ist. Ich möchte hier nicht darüber sprechen, was durch die zwei Löcher zu sehen ist, sondern über die Holztür und die mit ihr verhinderte Permanenz der Malerei. Duchamp vermochte mittels solch einer nachträglichen Geste, dieser eingebauten Barriere, den Widerspruch zwischen dem Ewigen der Malerei und dem Lebendigen im Akt des Schaffens und Sehens, wenn nicht aufzulösen, so doch brüsk zur Sprache zu bringen.[8] Byars' Performance formuliert diesen Widerspruch am eigenen Körper, der mit der Aktions- und Performancekunst Werkcharakter annimmt, doch einem Ewigen nur in der Vollendung, im Tod zugeführt werden kann. Dementsprechend schritt der Künstler in Gold gehüllt vor dem Philadelphia Museum of Art in seiner Performance *The Perfect Death of James Lee Byars* einen Zirkel ab und legte sich auf eine golden gefärbte Fläche – eine kurzzeitige Auflösung von Gold in Gold, Lebendigem in Ewigem. Dreh- und Angelpunkt der Bewunderung, aber auch der Kritik an seinem Kollegen Joseph Beuys ist sein Zweifel an der Möglichkeit eines lebendigen Werkes, dennoch versucht auch Byars Kunst als Lebendiges zu initiieren.[9]

Zeitgleich mit der Performance in Philadelphia artikulierte Byars programmatisch seinen Standpunkt zur Malerei mit *The Perfect Tear,* einem schwarzen, kreisrunden Leinwandbild, dem einzigen im Schaffen des Künstlers.[10] Es ist nicht als Gemälde zu betrachten, da es auf Wunsch des Künstlers extrem hoch gehängt wurde. Mit dieser nachlässig gemalten Fläche richtete sich Byars gegen Malerei in ihrer Abbildfunktion – denn eine Träne ist weder rund noch schwarz – und gegen Malerei im Sinne von Meisterschaft, obwohl die Träne oder der Wassertropfen als Sujet der Trompe-l'Œil-Malerei von höchster Meisterschaft kündete.[11] Weder ist der Malerei in ihrer Permanenz die Möglichkeit gegeben, dies augenblickliche Verlieren zu fassen, denn eine Träne behält ihre Tropfenform nur für einen kurzen Moment, noch kann sie eine abstrakte Form dafür finden, denn die Träne ist nicht losgelöst vom Menschen zu sehen. Der Titel dieser Arbeit gibt mit dem Zusatz *Perfect* einen Hinweis, benennt einen Anspruch, das stete Zerrinnen zu vollenden, es zu beschließen, ihm Einhalt zu gebieten, so wie es Yve-Alain Bois noch 1990 für die Malerei der Zukunft im Sinne einer Katharsis formuliert.[12]

Doch wenn Malerei das augenblickliche Verlieren nicht vorführen kann, kann sie es in ihrer statischen und verewigenden Form auch nicht zur Katharsis führen. Malerei als Permanenz, das ist ein Abgrund am Himmel, eine schwarze Sonne am Firmament, ihr Licht erloschen, so das poetische Bild, das Byars mit *The Perfect Tear* vorführte. Eine Deutung seiner Arbeiten im Sinne einer Poetik schließt auch ihre Titel als literarische Form mit einer syntaktischen, semantischen und zeitlichen Struktur ein.

The Golden Tower, an idea that originated in 1975, became a constantly growing lighthouse for the cities within which the artist moved about.[4] In parallel with that work Byars developed the so-called *Perfect Performances:* brief minimal gestures that he performs wherever painting is at home, in the spatial contexts of museums. The first of these performances is an ephemeral love letter: *The Perfect Love Letter Is I Write I Love You Backwards in the Air,* performed in front of the Palais des Beaux-Arts in Brussels in 1974.[5] It was followed by the performance *The Perfect Kiss* in front of the Musée du Louvre in 1975; *The Perfect Whisper* in the paintings department of the Kunstsammlung Bern in 1978; *The Exhibition of Perfect* in the National Gallery in London and in the Busch-Reisinger Museum at Harvard University in Cambridge, Massachusetts, in 1980; *The Perfect Death of James Lee Byars* in front of the Philadelphia Museum of Art in 1984; and finally *The Perfect Smile* in 1986 and 1994, which is now in the collection of the Museum Ludwig in Cologne.[6] All were created in relation to art presented at the museum in question. *The Perfect Kiss* and *The Perfect Smile* refer to Leonardo da Vinci's *Mona Lisa* and other painted beauties whose smiles captivate us even after centuries. It seems as if these *Perfects* strip the paintings of their eternal aspect and reveal them to be ephemeral. Charles Baudelaire says of the "painter of modern life" that he makes "it his business to extract from fashion whatever element it may contain of poetry in history, to distil the eternal from the transitory."[7] From that point on *Perfect* marked this coexistence of the ephemeral and the eternal in Byars's work; it is the quintessence of his way of thinking about modernity, to borrow another of Baudelaire's terms.

The performance *The Perfect Death of James Lee Byars* can be understood in relation to Marcel Duchamp's turn away from painting and in terms of the posthumous presentation *Given: 1. The Waterfall 2. The Illuminating Gas*

THE PERFECT DEATH OF JAMES LEE BYARS DER VOLLKOMMENE TOD DES JAMES LEE BYARS
PERFORMANCE PHILADELPHIA MUSEUM OF ART 1984

Die englische Sprache, um auf einer streng grammatikalischen Deutungs-ebene zu bleiben, unterscheidet zwei Formen: das *Progressive* und das *Perfect.* Das *Perfect* selbst gliedert sich in *Past Perfect* und *Present Perfect.* Die Träne, Ausdruck unmittelbar gelebter Verlust- oder – im Falle der Freuden-träne – Glückserfahrung, verbindet sich mit dem *Present Perfect,* der vollen-deten Gegenwart.[13] Grammatikalisch gesehen hat der Aspekt *Perfect* kein Futur, markiert das Ende einer Vergangenheit und kennzeichnet diesen Punkt als Gegenwart.

Die gesamte Tradition der Malerei lebt von einer Zukunft, um der Gegenwart zu entgehen. Als Beispiel möchte ich ein spätes Selbstbildnis von Rembrandt Harmensz. van Rijn aus dem Jahr 1658 anführen.[14] Wohl zeigt sich darin ebenfalls eine Koexistenz von Flüchtigem und Ewigem. Das Selbstbildnis ist gemalt in der Gewissheit des eigenen Todes und in der Gewissheit, darin gemalt zu überdauern. Die rote Schärpe wie einen Lebensfaden um den Leib geschlungen, tritt Rembrandt, der sich in diesem Moment Modell sitzt, aus dem Dunkel ans Licht und blickt in eine Zukunft, die da Tod heißt. Deutet man den Bildraum als zeitliches Kontinuum vom dunklen Hintergrund der Vergangenheit zur vorderen Bildgrenze, so ist die Zukunft die Bildbetrachtung. Von hier fällt das Licht ein und beleuchtet den Rembrandt der Vergangenheit.[15]

Byars gestaltet Objekt und Umraum durch Zentralität, Allansichtigkeit und durch die Ton-in-Ton-Setzung zum Bild. Mit großem Aufwand und anderen Mitteln als denen der Malerei inszeniert er die Auflösung des Materials, der physischen Objekte in Licht. Die vielen Arbeiten aus Thassos-Marmor sind von aderlosem Weiß und so bearbeitet, dass ihre porös geschliffene Oberfläche und ihre abgerundeten Kanten sich mit dem weißen Umraum verbinden, die Schwere sich vom Boden löst, sie zu schweben beginnen, Licht werden. Auch in *The Book of 100 Perfects* von 1985 verschmilzt die samtene Oberfläche der Sofas und des Buchs mit dem Dunkel, in dem alles zu versinken droht. Einzig die goldenen Füße der Sofas bewirken ein Lösen vom Boden, ein Aufheben der Schwerkraft. Immer ist das Licht eine Bewegung. In *The Moon Books* von 1989 sind die Phasen des Mondes vom Himmel geholt und plastisch in weißem Marmor aufbereitet und auf einem vergoldeten Esstisch zum Verzehr ausgebreitet. Das weiße Licht wird zur Speise.[16] Der Hinweis, diese Kunst auch tatsächlich als Speise in den Körper aufzunehmen, ist durch das Selbstporträt aus Brotteig mit auffälliger Affinität zur Praxis der Liturgie gegeben. Das *Present Perfect* der Malerei ist eine Bewegung, das Licht in den eigenen Körper zurückzuführen. James Lee Byars beschließt die Dematerialisierungsdebatte mit der Rückführung in den Körper.[17]

Das von Besitzstrukturen losgesagte Überall der Malerei zuzulassen bedeutet auch, sich der Fortschrittsgläubigkeit zeitlicher Linearität zu

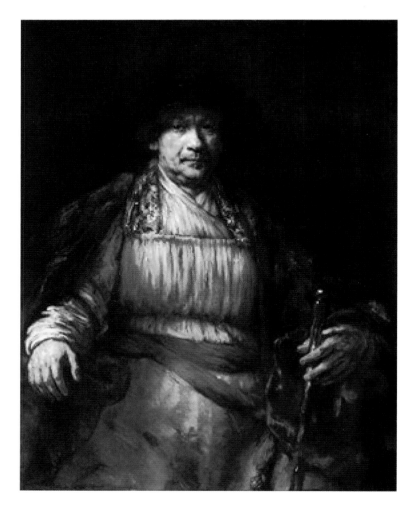

REMBRANDT HARMENSZ. VAN RIJN
SELF-PORTRAIT **SELBSTBILDNIS** 1658
THE FRICK COLLECTION NEW YORK

(1946–66, Philadelphia Museum of Art). The latter has a wooden door that pre-vents an unobstructed view onto the tableau behind it, and thus it can only be viewed through two holes—a passing, secret gaze that calls voyeuristic situations to mind. Here I prefer to speak not of what is seen through the two holes but of the wooden door and the permanence of painting that it obstructs. Duchamp was able, by means of this subsequent gesture of a built-in barrier, if not to overcome the contradiction between the eternal aspect of painting and the living aspect in the act of creating and seeing then at least to articulate it succinctly.[8] Byars's performance formulates this same contradiction in terms of his own body, which takes on the character of an artwork through action and performance art but can only lead to the eternal in completion—that is, in death. Accordingly, in his performance *The Perfect Death of James Lee Byars*

entziehen: ein Zeiterleben auf des Messers Schneide, die Existenz als schmaler Pfad zwischen Vergehen und Bestehen.

Licht ist eine von Raum und Zeit unabhängige Kategorie, die somit nicht von kapitalistischen Prinzipien beherrscht wird. An beiden Enden, der Kunstproduktion wie der Kunstbetrachtung, muss sich notwendigerweise ein Widerstand gegen diese Prinzipien ausbilden, um Kunst zu erhalten. Immer werden Kunstschaffende den Krieg, die Krise als Fakt des Vorher und allein durch den Umstand, überlebt zu haben, berühren müssen. Diese Berührung betrifft Gefühle von Trauer, Schuld und Scham.[18] Das Leiden an der Geschichte ist spürbar im Leben und Werk von James Lee Byars, verweigerte er sich doch sowohl dem Besitz als auch einem festen Zuhause, reagierte auf Fragen nach Herkunft und Familie verletzt und verhinderte selbst in retrospektiv angelegten Einzelausstellungen eine Werkgeschichte. Das *Present Perfect,* die Vollendung in der Gegenwart, birgt in sich ein Leiden, muss sich gegen jede unumstößliche Vollendung richten, was Byars dazu veranlasste, mehrfach die Zerstörung seiner Arbeiten anzukündigen und diese auch partiell in Angriff zu nehmen.

Es gibt keinen Schutzraum für diese Kunst, weder in den Museen noch im öffentlichen Raum. Damit möchte ich nicht die Museen und die Kunstgeschichte ihrer Verantwortung entheben, zu bewahren, was zu bewahren ist: das *Present Perfect* der Malerei, als Licht flüchtig und ewig zugleich. »Wenn dem Vergänglichen und dem Zeitlosen keine Koexistenz eingeräumt wird, lässt sich in der bildenden Kunst nichts schaffen, was von Bedeutung wäre. Concept-art ist nichts anderes als die Erörterung dieser Tatsache.« So lautet das Fazit aus John Bergers grundsätzlichen Überlegungen zur Malerei.[19] Berger sieht diese Koexistenz weder in der transatlantischen Malerei der Nachkriegszeit, die das Vergängliche im Diktum des Hier und Jetzt ausschließt, noch in der Pop Art, in der das Vergängliche zur einzigen Zeitkategorie erhoben wird, gewährleistet.

Mit dem Wandel von einer Malerei als beleuchteter Bildwelt zum Impressionismus wird auch eine durch das Licht konstruierte Einheit von Kunst und Leben aufgegeben, zugunsten einer anderen möglichen Konstruktion. Wolfgang Schöne spricht von einem Unsichtbarwerden des Lichts, was wohl in einem noch extremeren Maß auf die konkrete Malerei und den abstrakten Expressionismus zutrifft. Umso radikaler ist die Wende Byars' zu bewerten, das Licht der Malerei wieder aufzugreifen.[20]

Das Licht in den Inszenierungen von James Lee Byars – flüchtig und ewig zugleich – ist als Bewegung sichtbar, nicht als Licht und Schatten, verursacht durch eine Lichtquelle. Der Künstler forderte stets eine gleichmäßige Ausleuchtung seiner Objekte. In dem Maße, wie sich die Werke in Licht auflösen und wir nicht mehr wie angesichts eines Rembrandt-Gemäldes in einem konstruierten Zusammenhang aus beleuchteter Bildwelt und natürlicher oder künstlicher Lichtquelle unserer Gegenwart

in front of the Philadelphia Museum of Art the artist, enveloped in gold, paces off a circle and lies down on a gold-painted surface—briefly gold dissolves into gold, the living into the eternal. The pivot of both Byars's admiration for and his criticism of his colleague Joseph Beuys is his doubt about the possibility of a living work, but nevertheless Byars's art also attempts to initiate something living.[9]

Contemporaneously with the performance in Philadelphia, Byars was articulating programmatically his stance toward painting in *The Perfect Tear,* a black, circular painting on canvas, the only one in the artist's oeuvre.[10] It should not be viewed as a painting, however, since it has been hung extremely high up, at the artist's request. With this indifferently painted surface Byars is taking aim at the representational function of painting—since a tear is neither round nor black—and at painting in the sense of mastery, even though the choice of a tear or drop of water as a subject bore witness to great mastery in the tradition of *trompe l'oeil* painting.[11] Painting in its permanence is neither given the possibility of grasping this present loss, since the tear retains its bead form only for a brief moment, nor can it find an abstract form for the loss, since the tear cannot be seen independently of a human being. The title of the work, with its adjective "perfect," offers a hint and announces its claim to complete the constant flow, to conclude it, to put an end to it, just as Yve-Alain Bois expressed it in 1990 for the painting of the future in the sense of a catharsis.[12]

But if painting cannot reveal momentary loss, neither can it lead to catharsis in its static and immortalizing form. Painting as permanence is an abyss in the sky, a black sun on the firmament, with its light extinguished—that is the poetic image that Byars presents in *The Perfect Tear.* Interpreting his works as a kind of poetics also means reading their titles as a literary form with a syntactic, semantic, and temporal structure. If we keep to interpreting them on this strictly grammatical level, we note that English distinguishes between progressive and perfect verb forms. The perfect is divided in turn into the past perfect and the present perfect. The tear, and expression of immediately experienced loss or happiness—in the case of tears of joy—is associated with the present perfect, the completed present.[13] Seen grammatically, the perfect has no future; it marks the end of a past and identifies this point as a present.

The whole tradition of painting lives from a future in order to escape the present. I would like to cite as an example a late self-portrait by Rembrandt Harmensz. van Rijn from 1658.[14] It surely reveals the coexistence of the ephemeral and the eternal as well. The artist painted the self-portrait in the certainty of his own death and in the certainty that he would live on in painted form. The red sash wrapped around his body like a life thread brings Rembrandt, who at this moment is sitting as his own model, out of the darkness and into the light to gaze on a future that is called death. The pictorial space is interpreted as a temporal continuum from the dark background of the past to the front edge of the painting; thus the future is the observation

stehen, wird fraglich, welche Verbindung wir mit der Kunst und im weitesten Sinne mit der Kultur eingehen können.

Die verschwindend kleinen Selbstporträts oder *Is,* eine mit Blattgold überzogene Marmorkugel, sind in ihrem Gold ebenso wie Licht nicht greifbar und kein Reflex. Es ist weder möglich, sich darin zu spiegeln, noch darauf einen klar umrissenen Schatten zu werfen. Die stumpfe Weichheit des Glanzes verleugnet die undurchdringliche Härte des Materials. Der Blick sucht an diesen Ort, ins Innere zu gelangen. Am ehesten ist diese Suche als eine Berührung aufzufassen und das damit verbundene Gefühl dem Heimweh vergleichbar.

»Niemand kann mir erzählen, daß man Glück nicht anfassen kann, daß es ein Glück ohne Körper gibt.«[21]

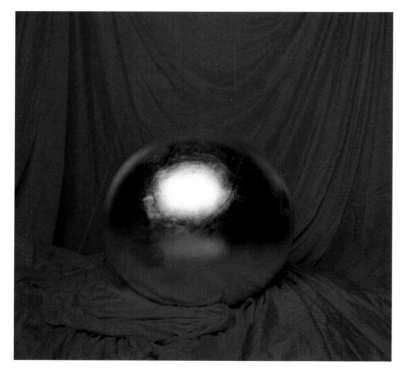

IS **IST** 1989

of the painting. The light falls from this side and illuminates the Rembrandt of the past.[15]

Byars turns the object and its surroundings into an image by means of centrality, all-visibility, and by placing shade within shade. With great effort, using means other than those of painting, he dramatizes the dissolution of the material, of physical objects, in light. His many works in Thassos marble are of an unveined white, and they are worked in such a way that their porous, polished surfaces and their rounded edges are connected to the white surroundings, releasing gravity from the earth and causing it to float, becoming light. In *The Book of 100 Perfects* of 1985, too, the velvet surface of the sofa and of the book blend with the darkness in which everything threatens to sink. Only the gold feet of the sofa achieve a release from the earth, an abolition of the force of gravity. The light is always a motion. In *The Moon Books* of 1989 the phases of the moon are brought down from the sky and spread out sculpturally in white marble, presented on a gilded dining table to be consumed. The white light becomes food.[16] The suggestion that this art should indeed be absorbed into the body as food is made in the self-portrait in bread dough, with a striking affinity to liturgical practice. The present perfect of painting is a movement that leads light back into one's own body. James Lee Byars settles the debate over dematerialization by coming back to the body.[17]

Allowing a ubiquity of painting that renounces all ownership structures also means escaping the temporal linearity of a faith in progress: experience time on knife edge, existence as a narrow path between dying and surviving.

Light is a category that is independent of space and time and that is not dominated by capitalist principles. On both ends—in the production of art and in the viewing of art—a resistance to such principles has to develop in order for art to survive. Artists will always have to touch upon war and crisis as facts of the past, even by the very circumstance of having survived them. This evokes feelings of mourning, guilt, and shame.[18] The suffering of history is palpable in the life and work of James Lee Byars; he renounced both property and a permanent home, responded to questions about his origins and family as if he had been hurt, and prohibited a history of his works even in solo exhibitions conceived as retrospectives. The present perfect, the completion in the present, conceals within it a suffering, is compelled to take aim at any inalterable completion, which led Byars to announce more than once that he would destroy his works and in fact to do so in part.

There is no refuge for such art, neither in museums nor in public spaces. By saying that I do not wish to relieve museums or art historians of the responsibility for preserving what can be preserved: the present perfect of painting, at once ephemeral and eternal in the form of light. "Without an acknowledged coexistence of the ephemeral and the timeless, there is nothing of consequence for pictorial art to do. Conceptual art is merely a discussion of this fact." That is the conclusion of John Berger's fundamental reflections on painting.[19]

Anmerkungen

1 Hans Maarten van den Brink, *Über das Wasser,* München/Wien 2000, S. 11.

2 Siehe die Einladung zur dieser Ausstellung in Kyoto 1962. Zur Entwicklung von den *Paper Paintings* zu den *Paper Sculptures,* die in *The Performable Square,* einer Synthese aus Malerei und Skulptur, münden, siehe Viola Maria Michely, *Glück in der Kunst? Das Werk von James Lee Byars,* Berlin 1999, S. 130–142.

3 Der Text ist ohne Zwischenräume auf Zellophan gedruckt und hier zur besseren Lesbarkeit mit Zwischenräumen wiedergegeben.

4 Ursprünglich als Denkmal für Berlin angedacht, entstanden verschiedene Versionen des *Golden Tower* im In- und Ausland (u. a. Berlin, Brüssel, Bern, Köln, Kassel, Turin, Berkeley), wobei Größe, Titel und Präsentationsform immer wieder variierten.

5 Entsprechend der nomadischen Lebensweise des Künstlers stellen die zahlreichen künstlerisch gestalteten Briefe das einzige Mittel dar, sich kontinuierlich an Menschen und bestimmte Orte zu binden – eine Notwendigkeit angesichts der Weigerung des Künstlers nach einem tatsächlichen festen Zuhause.

6 Eine Auflistung und Erläuterungen zu den *Perfect Performances* finden sich in Michely 1999 (wie Anm. 2), S. 63–65.

7 Charles Baudelaire, »Der Maler des modernen Lebens« (1863), in: *Charles Baudelaire. Der Künstler und das moderne Leben. Essays, »Salons«, intime Tagebücher,* hrsg. von Henry Schuhmann, Leipzig 1990, S. 300. Es soll nicht unerwähnt bleiben, dass es Künstlerinnen sind, die zu einem großen, vielleicht sogar größerem Teil diese schwierige Aufgabe innerhalb der Gesellschaft wahrnehmen. Kim Soo-Ja, um nur ein zeitgenössisches Beispiel zu nennen, führt auf eine mit Byars vergleichbare Weise die Radikalität eines nomadischen Daseins ihrer Kunst mit ihren *Bottaris* vor: Stoffbündel, die sich im Ausstellungsraum wie an Kriegsschauplätzen entfalten und damit eine ästhetische wie politische Position beziehen. Siehe *Echolot oder 9 Fragen an die Peripherie,* Bd. 6: *Kim Soo-Ja,* Ausst.-Kat. Museum Fridericianum, Kassel 1998, S. 18.

8 Siehe Arturo Schwarz, *The Complete Works of Marcel Duchamp,* 3., überarbeitete und erweiterte Ausgabe, Bd. 2, New York 1996, S. 865. Die Verbindung von Byars zu Duchamp genau auszuführen würde den Rahmen dieses Aufsatzes sprengen.

9 Etwa hundert Briefe des Künstlers bezeugen diese Auseinandersetzung. Siehe *James Lee Byars. Letters to/Briefe an Joseph Beuys,* Ausst.-Kat. Museum Schloss Moyland, Ostfildern-Ruit 2000.

10 Allerdings gibt es zwei Versionen des Bildes: ein größeres mit 55 Zentimeter Durchmesser in der Sammlung Speck, Köln, und ein kleineres

Berger believes this coexistence has been achieved neither in the transatlantic painting of the postwar period, which precludes the transitory in the dictum of the here and now, nor in Pop Art, in which the transitory is elevated to the sole category of time.

When painting as an illuminated pictorial world transformed into Impressionism, it also meant abandoning a unity of art and life that was built on light, in favor of another possible construction. Wolfgang Schöne speaks of light becoming invisible, something that is probably even more true of Concrete painting and Abstract Expressionism. Byars's decision to turn again to the light of painting should be seen as still more radical.[20]

The light in James Lee Byar's stagings—at once ephemeral—is visible as movement, not as light and shadow caused by a light source. The artist always insisted that his objects be lighted evenly. To the extent that works dissolve into light, and we are no longer confronted, as a in Rembrandt painting, with a constructed context consisting of an illuminated pictorial world and a natural or artificial light source from our time, it calls into question our possible connection to art or culture in the broadest sense.

The gold of the self-portrait, which is so small as to disappear, or of *Is,* a marble sphere covered with gold leaf), is as impalpable as light and not simply a reflection. It is not possible to see oneself reflected in it or to cast a clear shadow on it. The dull softness of its luster denies the impenetrable hardness of the material. The gazes seeks to get inside here. This search can best be understood as a kind of touching and is thus comparable to a related feeling of homesickness.

"No one can convince me that you can't touch happiness, that there is such a thing as happiness without a body."[21]

mit 25 Zentimeter Durchmesser in der Sammlung Silverman in South-field/Michigan.

11 Die gemalte Fläche ist nicht von der Schwärze eines Ad Reinhardt, bei dem man im Licht auch noch die feinsten Nuancen seines *Grid* erkennen kann, oder eines Günter Umberg, dessen Pigmentoberflächen das Auge in die Tiefen ziehen. Beide Künstler führen Malerei in der Reduktion sogar zu noch größerer Meisterschaft. Hier wird Malerei selbst in licht-absorbierender Schwärze als verewigende Form bewahrt. Gegen diesen Punkt richtet sich die Speerspitze konzeptioneller Überlegungen, evident in den Werken Duchamps und Byars'.

12 »Painting. The Task of Mourning«, in: Yve-Alain Bois, *Painting as Model,* Cambridge/London 1990, S. 229–244.

13 Die Anregung, *Perfect* im konkret grammatikalischen Sinn zu deuten, verdanke ich Gertrude Betz, Kassel. *Perfect* ist ein schillernder Begriff, der in der Werkexegese Byars' schon viele Deutungen erfahren hat. Ihn jedoch rein in Anlehnung an die Ästhetiktradition als Anspruch der Kunst auf Vollkommenheit und im Sinne einer Meisterschaft als Perfektion aufzufassen hieße, das Lebendige an der Kunst Byars' zu leugnen.

14 Eine Postkarte dieses Bildnisses mit der Aufschrift »Happy Birthday to me James Lee« fand sich im Nachlass des Künstlers, eine weitere ist abgebildet in: *James Lee Byars. The Perfect Moment,* Ausst.-Kat. IVAM Instituto Valenciano de Arte Moderno, Valencia 1995, S. 223.

15 Zu den Selbstporträts Rembrandts in Auseinandersetzung mit dem Tod siehe Georg Simmel, *Ein kunstphilosophischer Versuch,* Leipzig 1917, S. 90–99. Wolfgang Schöne unterscheidet das Eigenlicht der mittelalterlichen Malerei und das mit der Renaissance einsetzende Beleuchtungs-licht. Siehe Wolfgang Schöne, *Über das Licht in der Malerei,* Berlin 1954, zu Rembrandt siehe S. 156–158.

16 Dasselbe Prinzip wandte der Künstler 1993 bei den Großinstallationen von *Sonne, Mond und Sterne* im Württembergischen Kunstverein in Stuttgart an, allerdings installierte er die Objekte auf weißem Grund in einem komplett weißen Raum, sodass sie sich, als Objekte vom Himmel auf die Erde geholt, vor Ort wieder in Licht verwandelten.

17 Lucy Lippard, *Six Years. The Dematerialization of the Art Object from 1966 to 1972,* New York 1973. Das gesamte Buch ist durchsetzt mit Byars' ironischen Kommentaren zum Thema, siehe z. B. S. 186 und 191.

18 Primo Levi mit *Ist das ein Mensch?* (1958), Ruth Klüger mit *Weiter leben* (1990) oder Louis Begley mit *Lügen in Zeiten des Krieges* (1991) treffen genau diesen Punkt, und ihre Sprache ist ein Ringen darum, dennoch zu bestehen. Die Künstlerin Jenny Holzer spricht in einem Interview den Zusammenhang von Kunst und Schuld konkret an. Der amerikanische Puritanismus verurteile alles, was mit Empfindungen zu tun habe, daher mache die Kunst schuldig. Siehe »Jenny Holzer«, in: *Kunst heute,* 9, 1993,

Notes

1 Hans van den Brink, *On the Water,* trans. Paul Vincent (London, 2001), p. 4.

2 See the invitation to this exhibition in Kyoto in 1962. On the evolution from the *Paper Paintings* to the *Paper Sculptures,* which led to *The Performable Square,* a synthesis of painting and sculpture, see Viola Maria Michely, *Glück in der Kunst? Das Werk von James Lee Byars* (Berlin, 1999), pp. 130–142.

3 The text is printed on cellophane with no intervening spaces, but it is reproduced here with space in order to improve legibility.

4 Originally conceived as a memorial for Berlin, various versions of *The Golden Tower* were created in Germany and elsewhere (including Berlin, Brussels, Bern, Cologne, Kassel, Turin, and Berkeley), with variations in the dimensions, title, and form of presentation.

5 In keeping with the artist's nomadic lifestyle the numerous, artistic letters represent the only way to remain in constant contact with people and particular places—a necessity given the artist's refusal to establish a truly permanent home.

6 A list and explanations of the *Perfect Performances* may be found in Michely 1999 (note 2), pp. 63–65.

7 Charles Baudelaire, "The Painter of Modern Life" (1863), in idem, *The Painter of Modern Life, and Other Essays,* ed. and trans. Jonathan Mayne (London, 1964), p. 12. It must be said that to a large extent, perhaps even predominately, it is women artists who perceive this difficult task within society. Kim Soo-Ja, to give just one contemporary example, demonstrates the radicalness of a nomadic existence in her art, in a way comparable to Byars's work, in her *bottaris:* cloth bundles that are unfolded in the exhibition space as well as in theaters of war, thus establishing and an aesthetic and a political position. See *Kim Soo-Ja,* vol. 6 of *Echolot; oder, 9 Fragen an die Peripherie,* exh. cat. Museum Fridericianum (Kassel, 1998), p. 18.

8 See Arturo Schwarz, *The Complete Works of Marcel Duchamp,* 3rd ed., vol. 2 (New York, 1996), p. 865. A detailed exposition of Byars's connection to Duchamp would exceed the scope of the present essay.

9 Approximately a hundred letters by the artist testify to this attempt to come to terms with Beuys; see *James Lee Byars: Letters to/Briefe an Joseph Beuys,* exh. cat. Museum Schloss Moyland (Ostfildern-Ruit, 2000).

10 There are, however, two versions of the painting: a larger one with a diameter of 55 cm in the Sammlung Speck in Cologne, and a smaller one with a diameter of 25 cm in the Silverman Collection in Southfield, Michigan.

11 The surface is not painted with the black of Ad Reinhardt, in whose oeuvre one can still recognize in the light the most delicate nuances of his *Grid,* say, or of Günter Umberg, whose pigment surfaces draw the viewer's eye into the depths. Both artists bring painting to even greater mastery by means of reduction; here painting itself is preserved as an immortalizing form in the light-

S. 52: »Überhaupt [...] existiert in Amerika, wenn nicht gerade Schuld, so doch ein ungutes Gefühl darüber, dass man im Krieg nicht so gelitten hat wie die anderen.«

19 John Berger, »Malerei und Zeit« (1979), in: *Das Kunstwerk. Über das Lesen von Bildern,* Berlin 1992, Anm. 3, S. 82.

20 Zu Ausführungen zum Licht in der Malerei des 20. Jahrhunderts siehe Schöne 1954 (wie Anm. 15), S. 198–219, bes. S. 219.

21 Van den Brink 2000 (wie Anm. 1), S. 159.

MARCEL DUCHAMP
GIVEN: 1. THE WATERFALL 2. THE ILLUMINATING GAS 1946–66
PHILADELPHIA MUSEUM OF ART

absorbing black. The spearhead of conceptual considerations that is evident in the work of Duchamp and Byars is directed against point.

12 "Painting: The Task of Mourning," in Yve-Alain Bois, *Painting as Model* (Cambridge, Mass., 1990), pp. 229–244.

13 I am indebted to Gertrude Betz of Kassel for suggesting that *perfect* should be interpreted in a concretely grammatical sense. *Perfect* is a elusive term that has already been interpreted a number of ways in relation to Byars's oeuvre. To understand it purely in relation to the aesthetic tradition as a claim that art is perfect and that this perfection is found in mastery would be to deny the living aspect of Byars's art.

14 A postcard of this portrait, with the words "Happy Birthday to me James Lee," was found in the artist's papers; it is also illustrated in James Lee Byars, *The Perfect Moment,* exh. cat. IVAM Instituto Valenciano de Arte Moderno (Valencia, 1995), p. 223.

15 On Rembrandt's self-portraits as a coming to terms with death, see Georg Simmel, *Rembrandt: Ein kunstphilosophischer Versuch* (Leipzig, 1917), pp. 90–99. Wolfgang Schöne distinguishes between the intrinsic lighting of medieval painting and the illuminating light that was introduced in the Renaissance. See Wolfgang Schöne, *Über das Licht in der Malerei* (Berlin, 1954); on Rembrandt, see pp. 156–158.

16 The artist used the same principle in 1993 for the large installations of *Sonne, Mond und Sterne* (Sun, moon, and stars) in the Württembergischer Kunstverein in Stuttgart; however, he installed the objects on a white ground in a completely white room so that, as objects pulled down from the sky, they transformed back into light where they stood.

17 Lucy Lippard, *Six Years: The Dematerialization of the Art Object from 1966 to 1972* (New York, 1973); the entire book is permeated with Byars's ironic commentaries on the theme; see, for example, pp. 186 and 191.

18 Primo Levi in *Se questo è un uomo* (1947; translated in 1959 as *If This Is a Man* and later published as *Survival in Auschwitz*), Ruth Klüger in *Weiter leben* (1990; translated in 2001 as *Still Alive*), and Louis Begley in *Wartime Lies* (1991) strike precisely this point, and their language is a struggle to carry on anyway. The artist Jenny Holzer has explicitly addressed in an interview the connection between art and guilt. American Puritanism condemns everything having to do with emotions, and hence art makes one guilty. See "Jenny Holzer im Gespräch mit Noemi Smolik," *Kunst heute 9* (Cologne, 1993), p. 52: "In general . . . there exists in America if not guilt, exactly, then a kind of bad feeling that we didn't suffer as much in war as others did."

19 John Berger, "Painting and Time" (1979), in idem, *The Sense of Sight* (New York, 1993), p. 210.

20 For discussions of light in twentieth-century painting, see Schöne 1954 (note 15), pp. 198–219, esp. p. 219.

21 Brink 2001 (see note 1), p. 134.

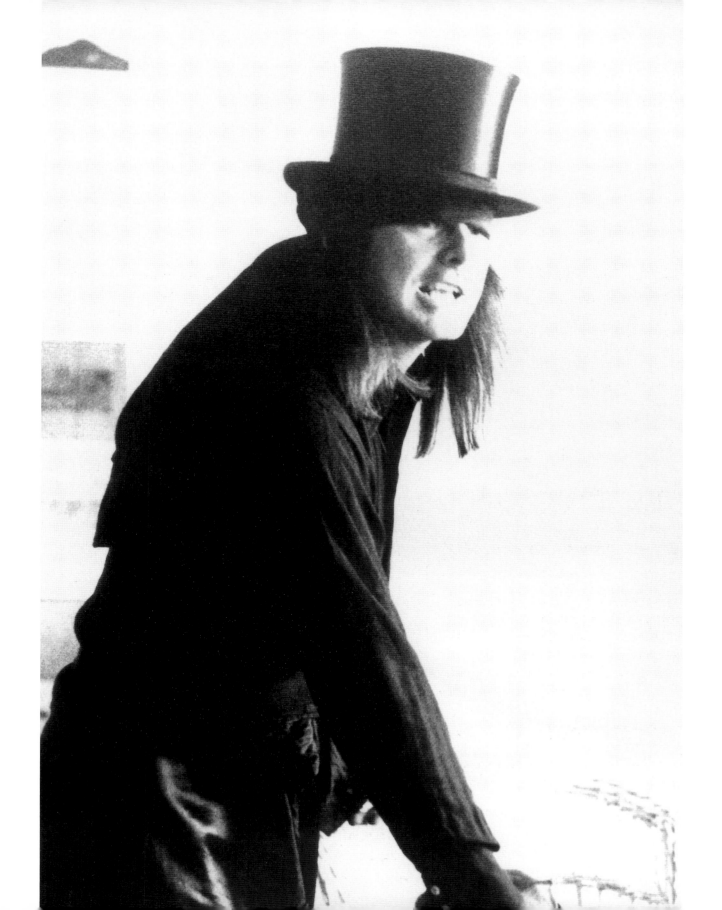

WERKLISTE
LIST OF WORKS

I

UNTITLED (A FACE) **OHNE TITEL (GESICHT)** CA. 1959

GEBRANNTER TON FIRED CLAY

52,5 x 11,2 CM 20¾ x 4½ IN.

ESTATE OF JAMES LEE BYARS, COURTESY GALERIE MICHAEL WERNER, KÖLN/NEW YORK

II

UNTITLED (A FACE) **OHNE TITEL (GESICHT)** CA. 1959

GEBRANNTER TON FIRED CLAY

61 x 40,6 x 8,9 CM 24 x 16 x 3½ IN.

MIANI JOHNSON

III

UNTITLED (THE BLACK FIGURE) **OHNE TITEL (SCHWARZE FIGUR)** CA. 1959

BEMALTES HOLZ, ZWEITEILIG PAINTED WOOD, IN TWO PARTS

350,5 x 40,6 x 7 CM 138 x 16 x 2¾ IN.

ESTATE OF JAMES LEE BYARS, COURTESY GALERIE MICHAEL WERNER, KÖLN/NEW YORK

IV

SELF-PORTRAIT **SELBSTPORTRÄT** CA. 1959

BEMALTES HOLZ, SCHWARZE PAPIERKUGEL, SECHSTEILIG, VARIABEL

PAINTED WOOD, BLACK PAPER BALL, IN SIX PARTS, VARIABLE

24 x 33 x 365 CM 9½ x 13 x 143¾ IN.

ESTATE OF JAMES LEE BYARS, COURTESY GALERIE MICHAEL WERNER, KÖLN/NEW YORK

V

UNTITLED (EIGHT CONES) **OHNE TITEL (ACHT KEGEL)** CA. 1959

JAPANPAPIER JAPANESE PAPER

6 KEGEL CONES **15 x 4 CM** 6 x 1⅝ IN.; **2 KEGEL** CONES **24,5 x 6 CM** 9⅝ x 2⅜ IN.

ESTATE OF JAMES LEE BYARS, COURTESY GALERIE MICHAEL WERNER, KÖLN/NEW YORK

VI

UNTITLED (TANTRIC FIGURE) **OHNE TITEL (TANTRISCHE FIGUR)** 1960

GRANIT, ZWEITEILIG GRANITE, IN TWO PARTS

8,9 x 15,9 x 13,7 CM 3½ x 6¼ x 5⅝ IN.; **15,2 x 15,2 x 14 CM** 6 x 6 x 5½ IN.

WHITNEY MUSEUM OF AMERICAN ART, NEW YORK

GIFT OF THE HOWARD AND JEAN LIPMAN FOUNDATION, INC.

VII

UNTITLED (TANTRIC FIGURE) **OHNE TITEL (TANTRISCHE FIGUR)** 1960

GRANIT, ZWEITEILIG GRANITE, IN TWO PARTS

24,1 x 30,5 x 33 CM 9½ x 12 x 13 IN.; **12,7 x 30,5 x 33 CM** 5 x 12 x 13 IN.

MIANI JOHNSON

VIII

UNTITLED (TANTRIC FIGURE) **OHNE TITEL (TANTRISCHE FIGUR)** 1960

GRANIT, ZWEITEILIG GRANITE, IN TWO PARTS

12,7 x 15,2 x 11,4 CM 5 x 6 x 4½ IN.; **7,6 x 15,2 x 11,4 CM** 3 x 6 x 4½ IN.

MIANI JOHNSON

IX

UNTITLED (TANTRIC FIGURE) **OHNE TITEL (TANTRISCHE FIGUR)** 1960

GRANIT, ZWEITEILIG GRANITE, IN TWO PARTS

231,1 x 29,2 x 17,8 CM 91 x 11½ x 7 IN.; **30,5 x 20,3 x 12,7 CM** 12 x 8 x 5 IN.

ESTATE OF JAMES LEE BYARS, COURTESY GALERIE MICHAEL WERNER, KÖLN/NEW YORK

X

UNTITLED **OHNE TITEL** CA. 1960

SCHWARZE TUSCHE AUF JAPANPAPIER, IN SECHZEHN TEILEN

BLACK INK ON JAPANESE PAPER, IN SIXTEEN PARTS

JE EACH **15,7 x 15,7 CM** 6¼ x 6¼ IN.

INSGESAMT OVERALL **62,8 x 62,8 CM** 25 x 25 IN.

ESTATE OF JAMES LEE BYARS, COURTESY GALERIE MICHAEL WERNER, KÖLN/NEW YORK

XI

UNTITLED (SCROLL) **OHNE TITEL (PAPIERROLLE)** CA. 1960

KOHLEZEICHNUNG AUF JAPANPAPIER CHARCOAL DRAWING ON JAPANESE PAPER

2705,1 x 180,3 CM 1065 x 71 IN.

ESTATE OF JAMES LEE BYARS, COURTESY GALERIE MICHAEL WERNER, KÖLN/NEW YORK

XII

IF YOU DON'T WASH YOUR OWN YOU STAY DIRTY JAMES BYARS

WENN DU DICH NICHT WÄSCHST, BLEIBST DU SCHMUTZIG, JAMES BYARS

CA. 1960

SCHREIBMASCHINE, WASSERFARBE AUF JAPANPAPIER

TYPEWRITER, WATERCOLOR ON JAPANESE PAPER

24,9 x 17,6 CM 9¾ x 7 IN.

ESTATE OF JAMES LEE BYARS, COURTESY GALERIE MICHAEL WERNER, KÖLN/NEW YORK

XIII

UNTITLED **OHNE TITEL** CA. 1960

SCHWARZE TUSCHE AUF JAPANPAPIER BLACK INK ON JAPANESE PAPER

91,4 x 182,9 CM 36 x 72 IN.

ESTATE OF JAMES LEE BYARS, COURTESY GALERIE MICHAEL WERNER, KÖLN/NEW YORK

XIV

UNTITLED **OHNE TITEL** CA. 1962

SCHWARZE TUSCHE AUF JAPANPAPIER BLACK INK ON JAPANESE PAPER

279,4 x 114,3 CM 110 x 45 IN.

ESTATE OF JAMES LEE BYARS, COURTESY GALERIE MICHAEL WERNER, KÖLN/NEW YORK

XV

UNTITLED (THE ACCORDIAN SCROLL/THE PERFECT PAINTING)

OHNE TITEL (AKKORDEONROLLE/DAS VOLLKOMMENE BILD) 1962

SCHWARZE TUSCHE AUF JAPANPAPIER BLACK INK ON JAPANESE PAPER

AUFFALTBAR IN 31 SEITEN UNFOLDS INTO 31 PAGES

JEDE EACH **30,2 x 30,2 CM** 12 x 12 IN.

INSGESAMT OVERALL **360 x 30,2 CM** 11¾ x 141¾ IN.

SAMMLUNG HOFFMANN

XVI

A WHITE PAPER WILL BLOW THROUGH THE STREETS

EIN WEISSES PAPIER WIRD DURCH DIE STRASSEN WEHEN 1967

SCHWARZER TEXT AUF WEISSEM SEIDENPAPIER BLACK LETTERING ON WHITE SILK PAPER

⌀ **63 CM** 24 ¾ IN. **OHNE RAHMEN** UNFRAMED

70 x 70 CM 27½ x 27½ IN. **GERAHMT** FRAMED

SAMMLUNG SPECK, KÖLN

XVII

FOUR IN A DRESS **VIER IN EINEM KLEID** 1967

SCHWARZE KUNSTSEIDE BLACK ACETATE SILK

⌀ **488 CM** 192 IN.

ESTATE OF JAMES LEE BYARS, COURTESY GALERIE MICHAEL WERNER, KÖLN/NEW YORK

XVIII

AUTOBIOGRAPHY **AUTOBIOGRAFIE** 1970

EINZELNER RAHMEN 16-MM-FARBFILM SINGLE FRAME OF 16MM COLOR FILM

ESTATE OF JAMES LEE BYARS, COURTESY GALERIE MICHAEL WERNER, KÖLN/NEW YORK

XIX

100 MINDS **100 GEDANKEN** 1970

EINZELNER RAHMEN 16-MM-FARBFILM SINGLE FRAME OF 16MM COLOR FILM

(1/24 MIN.)

0,8 x 1,6 CM ⅜ x ⅝ IN. **OHNE RAHMEN** UNFRAMED

60 x 50 x 6 CM 23⅝ x 19¾ x 2⅜ IN. **GERAHMT** FRAMED

SAMMLUNG SPECK, KÖLN

XX

UNTITLED (AMERICAN FLAG FROM "TWO PRESIDENTS")

OHNE TITEL (AMERIKANISCHE FLAGGE AUS »ZWEI PRÄSIDENTEN«)

CA. 1974

BLAUE, ROTE UND WEISSE KUNSTSEIDE BLUE, RED, AND WHITE ACETATE SILK

965 x 223,5 CM 380 x 88 IN.

ESTATE OF JAMES LEE BYARS, COURTESY GALERIE MICHAEL WERNER, KÖLN/NEW YORK

XXI

TWO PRESIDENTS **ZWEI PRÄSIDENTEN** CA. 1974

SUPER-8-FILM (0:21 MIN.)

ESTATE OF JAMES LEE BYARS, COURTESY GALERIE MICHAEL WERNER, KÖLN/NEW YORK

XXII

THE GOLDEN TOWER **DER GOLDENE TURM** 1974

SCHWARZES PAPIER, BEDRUCKT IN GOLD MIT 100 VON BYARS AUSGEWÄHLTEN SÄTZEN WILLIAM SHAKESPEARES, IN DENEN DAS WORT »GOLD« VORKOMMT

BLACK PAPER, PRINTED IN GOLD WITH 100 SENTENCES BY SHAKESPEARE CONTAINING THE WORD "GOLD"

177 x 50 CM 69¾ x 19¾ IN. **OHNE RAHMEN** UNFRAMED

190 x 55 CM 74¾ x 21⅝ IN. **GERAHMT** FRAMED

NEUES MUSEUM WESERBURG BREMEN

XXIII

THE GOLDEN HOLE FOR SPEECH (THE PERFECT WHISPER)

DAS GOLDENE MUNDSTÜCK (DAS VOLLKOMMENE FLÜSTERN) 1974/1981

HOLZ, GLAS MIT RUNDER, RANDVERGOLDETER ÖFFNUNG IN DER MITTE

WOOD, GLASS WITH ROUND, OPENING IN CENTER, GILDED AT THE EDGE

GLASSCHEIBE GLASS ø 288 CM 113³/₈ IN.

HOLZKONSTRUKTION WOOD CONSTRUCTION 457 x 174 CM 180 x 68½ IN.

HÖHE INSGESAMT OVERALL HEIGHT 292,5 CM 115¹/₈ IN.

ESTATE OF JAMES LEE BYARS, COURTESY GALERIE MICHAEL WERNER, KÖLN/NEW YORK

XXIV

THE HOLLOW SPHERE BOOK DAS HOHLKUGEL-BUCH 1978

BERNER SANDSTEIN, ZWEITEILIG BERNESE SANDSTONE, IN TWO PARTS

JE EACH 17,5 x 35 x 35 CM 7 x 13¾ x 13¾ IN.

INSGESAMT OVERALL 35 x 35 x 35 CM 13¾ x 13¾ x 13¾ IN.

VITRINE DISPLAY CASE 175 x 50 x 50 CM 69 x 19¾ x 19¾ IN.

NEUES MUSEUM WESERBURG BREMEN

XXV

UNTITLED (THE CUBE BOOK) OHNE TITEL (DAS KUBISCHE BUCH) 1983

PAPIER, OFFSETDRUCK (1800 SEITEN) PAPER, OFFSET PRINT (1800 PAGES)

BUCH BOOK 16,5 x 16,5 x 15,2 CM 6½ x 6½ x 6 IN.

VITRINE DISPLAY CASE 175 x 50 x 50 CM 69 x 19¾ x 19¾ IN.

NEUES MUSEUM WESERBURG BREMEN

XXVI

THE PERFECT TEAR DIE VOLLKOMMENE TRÄNE 1984

ÖL AUF LEINWAND OIL ON CANVAS

55 CM 21⁵/₈ IN.

SAMMLUNG SPECK, KÖLN

XXVII

THE BOOK OF 100 PERFECTS DAS BUCH DER 100 VOLLKOMMENHEITEN 1985

VIER CHAISELONGUES, BUCH AUS SAMT UND BÜTTEN

FOUR CHAISE LONGUES, BOOK OF VELVET AND HANDMADE PAPER

CHAISELONGUES CHAISE LONGUES JE EACH 69 x 75,5 x 180 CM 27¼ x 29¾ x 71 IN.

BUCH BOOK 35 x 35 x 35 CM 13¾ x 13¾ x 13¾ IN.

STAATSGALERIE STUTTGART

XXVIII

THE MOON BOOKS (PHASES OF THE MOON) DIE MONDBÜCHER (MONDPHASEN) 1988/89

SECHZEHN STÜCKE WEISSER MARMOR AUF VERGOLDETEM HOLZTISCH, SECHSTEILIG

SIXTEEN PIECES OF WHITE MARBLE ON GOLDLEAFED WOODEN TABLE, IN SIX PARTS

TISCH TABLE 120 CM 47¼ IN. ø 500 CM 197 IN.

GALERIE DE FRANCE, PARIS

XXIX

THE ROSE TABLE OF PERFECT DER ROSENTISCH DES VOLLKOMMENEN 1989

3333 ROTE ROSEN, STYROPOR 3333 RED ROSES, STYROFOAM

ø 100 CM 39³/₈ IN.

IVAM, INSTITUTO VALENCIANO DE ARTE MODERNO, GENERALITAT VALENCIANA

XXX

THE PATH OF LUCK: THE SPHERE DOOR DER PFAD DES GLÜCKS: DIE SPHÄRISCHE TÜR 1989

BLAUER AFRIKANISCHER GRANIT BLUE AFRICAN GRANITE

ø 36 CM 14¼ IN.

VITRINE DISPLAY CASE 199 x 60 x 60 CM 78³/₈ x 23⁵/₈ x 23⁵/₈ IN.

COLLECTION MAGASIN 3 STOCKHOLM KONSTHALL

XXXI

THE PATH OF LUCK: THE SQUARE DOOR DER PFAD DES GLÜCKS: DIE QUADRATISCHE TÜR

1989

BLAUER AFRIKANISCHER GRANIT BLUE AFRICAN GRANITE

40 x 40 x 10 CM 15¾ x 15¾ x 4 IN.

VITRINE DISPLAY CASE 199 x 60 x 60 CM 78³/₈ x 23⁵/₈ x 23⁵/₈ IN.

COLLECTION MAGASIN 3 STOCKHOLM KONSTHALL

XXXII

THE PATH OF LUCK: THE CROSS DER PFAD DES GLÜCKS: DAS KREUZ 1989

BLAUER AFRIKANISCHER GRANIT BLUE AFRICAN GRANITE

40 x 40 x 10 CM 15¾ x 15¾ x 4 IN.

VITRINE DISPLAY CASE 199 x 60 x 60 CM 78³/₈ x 23⁵/₈ x 23⁵/₈ IN.

COLLECTION MAGASIN 3 STOCKHOLM KONSTHALL

XXXIII

THE PATH OF LUCK: THE TWO FIGURES DER PFAD DES GLÜCKS: DIE ZWEI FIGUREN 1989

BLAUER AFRIKANISCHER GRANIT, ZWEITEILIG BLUE AFRICAN GRANITE, IN TWO PARTS

JE EACH 60 x 12 x 12 CM 23⁵/₈ x 4¾ x 4¾ IN.

VITRINE DISPLAY CASE 199 x 60 x 60 CM 78³/₈ x 23⁵/₈ x 23⁵/₈ IN.

COLLECTION MAGASIN 3 STOCKHOLM KONSTHALL

XXXIV

THE PATH OF LUCK: THE DISCUS **DER PFAD DES GLÜCKS: DER DISKUS** 1989

BLAUER AFRIKANISCHER GRANIT BLUE AFRICAN GRANITE

10 x 42 CM 4 x 16½ IN.

VITRINE DISPLAY CASE **199 x 60 x 60 CM** 78⅜ x 23⅝ x 23⅝ IN.

COLLECTION MAGASIN 3 STOCKHOLM KONSTHALL

XXXV

THE PATH OF LUCK: TWELVE FIGURES **DER PFAD DES GLÜCKS: ZWÖLF FIGUREN** 1989

BLAUER AFRIKANISCHER GRANIT, ZWÖLFTEILIG BLUE AFRICAN GRANITE, IN TWELVE PARTS

JE EACH **18 x 5 x 5 CM** 7 x 2 x 2 IN.

VITRINE DISPLAY CASE **199 x 149 x 60 CM** 78⅜ x 58⅝ x 23⅝ IN.

COLLECTION MAGASIN 3 STOCKHOLM KONSTHALL

XXXVI

THE PERFECT THOUGHT **DER VOLLKOMMENE GEDANKE** 1990

WEISSE MARMORSÄULE WHITE MARBLE COLUMN

49,5 x 13 CM 19½ x 5 IN.

VITRINE DISPLAY CASE **175 x 51,5 x 51,5 CM** 69 x 20¼ x 20¼ IN.

NEUES MUSEUM WESERBURG BREMEN, SAMMLUNG TU

XXXVII

THE MOON COLUMN **DIE MONDSÄULE** 1990

THASSOS-MARMOR THASSOS MARBLE

250 x 60 x 30 CM 98½ x 23½ x 11¾ IN.

ESTATE OF JAMES LEE BYARS, COURTESY GALERIE MICHAEL WERNER, KÖLN/NEW YORK

XXXVIII

THE GOLDEN TOWER **DER GOLDENE TURM** 1990/2004

REKONSTRUKTION RECONSTRUCTION

SCHLAGMETALL, HOLZ COMPOSITION GOLD, WOOD

1750 x 250 CM 738¼ x 98½ IN.

DARIN INTEGRIERT INCLUDES

THE CAPITAL OF THE GOLDEN TOWER **DAS KAPITELL DES GOLDENEN TURMS** 1991

BLATTGOLD, EDELSTAHL GOLD LEAF, STAINLESS STEEL

125 x 250 x 250 CM 49¼ x 98½ x 98½ IN.

ESTATE OF JAMES LEE BYARS, COURTESY GALERIE MICHAEL WERNER, KÖLN/NEW YORK

XXXIX

THE HUMAN FIGURE **DIE MENSCHLICHE FIGUR** 1992

(IN ANDERER KONFIGURATION IN ANOTHER CONFIGURATION

THE THINKING FIELD OF 100 SPHERES SHOWN IN A CUBIC ROOM

DAS DENKENDE FELD VON 100 KUGELN IN EINEM KUBISCHEN RAUM 1989)

100 WEISSE MARMORKUGELN 100 MARBLE SPHERES

JE EACH **20 CM** 8 IN.

MUSEUM LUDWIG, KÖLN

LEIHGABE DER GESELLSCHAFT FÜR MODERNE KUNST AM MUSEUM LUDWIG E.V., KÖLN

XL

THE RED ANGEL OF MARSEILLE **DER ROTE ENGEL VON MARSEILLE** 1993

1000 ROTE VENEZIANISCHE GLASKUGELN 1000 RED VENETIAN GLASS SPHERES

INSGESAMT OVERALL **11 x 1100 x 900 CM** 4⅜ x 433 x 354⅜ IN.

FONDS NATIONAL D'ART CONTEMPORAIN

XLI

THE PERFECT SMILE **DAS VOLLKOMMENE LÄCHELN** 1994

PERFORMANCE

MUSEUM LUDWIG, KÖLN

LEIHGABE DER GESELLSCHAFT FÜR MODERNE KUNST AM MUSEUM LUDWIG E.V., KÖLN

XLII

SLIT MOON **MONDSCHLITZ** 1994

THASSOS-MARMOR THASSOS MARBLE

4 x 40 x 4 CM 1½ x 15¾ x 1½ IN.

ESTATE OF JAMES LEE BYARS, COURTESY GALERIE MICHAEL WERNER, KÖLN/NEW YORK

XLIII

THE HALO **DER HALO** 1994

MESSING, FEUERVERGOLDET GOLD-PLATED BRASS

220 x 20 CM 86⅝ x 7⅞ IN.

ESTATE OF JAMES LEE BYARS, COURTESY GALERIE MICHAEL WERNER, KÖLN/NEW YORK

XLIV

THE DEATH OF JAMES LEE BYARS **DER TOD DES JAMES LEE BYARS** 1994/2004

SCHLAGMETALL, FÜNF KRISTALLE, PLEXIGLAS COMPOSITION GOLD, FIVE CRYSTALS, PLEXIGLAS

PODEST PEDESTAL **30 x 60 x 180 CM** 11⅝ x 23⅝ x 70⅞ IN.

INSGESAMT OVERALL **280 x 280 x 240 CM** 110¼ x 94½ IN.

WALTER VANHAERENTS, TORHOUT

XLV (OHNE ABB. NOT REPRODUCED)

PERFECT IS MY DEATH WORD **PERFEKT IST MEIN TODESWORT** 1995

AUDIO COMPACT DISC (22 MIN.)

AUS FROM JAMES LEE BYARS. PERFECT IS MY DEATH WORD: BÜCHER – EDITIONEN
– EPHEMERA, **HRSG. VON** ED. GUY SCHRAENEN

AUSST.-KAT. EXH. CAT. NEUES MUSEUM WESERBURG BREMEN 1995

XLVI

UNTITLED (PAY ATTENTION NOW PLEASE) **OHNE TITEL (GEBEN SIE JETZT BITTE ACHT)** 1997

GOLDSTIFT AUF ROTEM JAPANPAPIER GOLD PEN ON RED JAPANESE PAPER

23,9 x 23,9 CM 9½ x 9½ IN. **OHNE RAHMEN** UNFRAMED

ESTATE OF JAMES LEE BYARS, COURTESY GALERIE MICHAEL WERNER, KÖLN/NEW YORK

Das Archiv des Museums of Modern Art in New York gewährte mir beispiellosen Zugang zu den Unterlagen Dorothy Millers und ermöglichte es mir dadurch, die Titel und Entstehungsdaten mehrerer Arbeiten von Byars genauer zu überprüfen. Aus Skizzen, die den Briefen Byars' an Dorothy Miller beiliegen, wurde auch ersichtlich, dass einige seiner Werke auf Papier, darunter auch Kat. XIII, ursprünglich als Querformate gedacht waren, nicht als Hochformate, wie sie bisher gezeigt wurden. Von daher wird jenes Werk in dieser Ausstellung und dem vorliegenden Katalog der ursprünglichen Vorstellung des Künstlers entsprechend präsentiert, wenn Byars auch später eine Hängung im Hochformat vorzuziehen schien. (KO)

Thanks to The Museum of Modern Art Archives in New York, which granted me unprecedented access to Dorothy Miller's papers, I have been able to revise the dates and titles of several of Byars's works. From sketches attached to Byars's letters to Dorothy Miller I also learned that several of his untitled paintings on papers, including cat. XIII, were originally meant to be hung horizontally, not vertically, as they have been until now. Thus we are presenting this work in the exhibition and catalogue the way it had been conceived by the artist, although it appears that he may later have favored a vertical presentation. **(KO)**

JAMES LEE BYARS AND A DOZEN FACTS

1 BORN IN APRIL 1932

2 PUBLIC SCHOOLED IN DET MICH

3 INTERESTED IN PHILOSOPHY

4 LIVES IN KYOTO LA SAN FRANCISCO AND NEW YORK CITY

5 WORKS IN PAPER AS AN ARTIST

6 COLLECTED BY MOMA GUGG CARNEGIE LA COUNT MUS ETC

7 FAVORITE SENTENCE LIKE A DREAM LIKE A VISION LIKE A

 BUBBLE LIKE A SHADOW LIKE DEW LIKE LIGHTNING

8 FAVORITE SIGHT WATER

9 FAVORITE SOUND O

10 FAVORITE SMELL SEAWEED

11 FAVORITE TASTE POPPYSEED

12 FAVORITE TOUCH SILK

AUTOBIOGRAPHY AUTOBIOGRAFIE 1967
ON DISSOLVO PAPER AUF DISSOLVO-PAPIER

BIOGRAFIE / AUSWAHLBIBLIOGRAFIE
BIOGRAPHY / SELECTED BIBLIOGRAPHY

Detroit 1932 – 1997 Cairo **Kairo**

Mitte bis Ende der fünfziger Jahre Studium der Kunst und Philosophie an der Wayne State University in Detroit. Ab 1957/58 Aufenthalt in Japan für die Dauer von etwa zehn Jahren, unterbrochen von zahlreichen Reisen in die USA und nach Europa. Lebte hauptsächlich in Kyoto und arbeitete dort als Englischlehrer. Befasste sich während zahlreicher Reisen durch das Land mit der traditionellen Kultur Japans, der Töpferkunst, der Papierherstellung sowie dem No-Spiel und der buddhistischen Philosophie. 1960 William-Copley-Preis der Cassandra Foundation in New York. 1961 Erste Einzelausstellung in der Marion Willard Gallery in New York. 1968 J. Clawson Mills Stipendium der New York Architectural League. 1969 Ernennung zum Artist in Residence am New Yorker Hudson Institute und Gründung des »World Question Center«. 1972 Teilnahme an der *documenta* 5 in Kassel (wo Byars internationale Anerkennung erfuhr); später an der *documenta* 6 (1977) und der *documenta* 7 (1982). 1974 DAAD-Stipendium in Berlin. Teilnahme an der Biennale in Venedig 1980 und 1986.

Studied art and philosophy at Wayne State University in Detroit in the mid to late fifties. Spent some ten years in Japan starting in **1957/58**, interrupted by many trips to the United States and Europe. Until **1967** lived mostly in Kyoto teaching English. Traveled extensively in Japan to study traditional Japanese culture, pottery, and papermaking, as well as Noh theater and Buddhist philosophy. **1960**: William Copley Prize, Cassandra Foundation, New York. **1961**: First solo exhibition at Marion Willard Gallery, New York. **1968**: Awarded the J. Clawson Mills Scholarship, New York Architectural League. **1969**: Appointed Artist in Residence at the Hudson Institute, New York, and founded the "World Question Center." **1972**: Participated in "documenta 5," Kassel (receiving international recognition), and later "documenta 6" (**1977**) and "documenta 7" (**1982**). **1974**: DAAD scholarship in Berlin. **1980** and **1986**: Participated in the Venice Biennale.

Einzelausstellungen
Solo Exhibitions

1958	The Museum of Modern Art, New York
1961	Willard Gallery, New York
1962	National Museum of Modern Art, Kyoto
1964	Shokoku-ji Hojo, Kyoto – »The Performable Square«, National Museum of Modern Art, Kyoto – Carnegie Museum, Pittsburgh
1967	Gallery 16, Kyoto
1968	»The World Question Center«, Hudson Institute, Croton-on-Hudson
1969	»The World Question on Belgian TV«, Wide White Space Gallery, Antwerpen
1970	»The Gold Curb«, The Metropolitan Museum of Art, New York
1971	»The Black Book«, Galerie Michael Werner, Köln
1973	Wide White Space Gallery, Antwerpen
1974	»The Perfect Love Letter«, Palais des Beaux-Arts, Bruxelles – »The Golden Tower«, Galerie Rudolf Springer, Berlin
1975	»The Perfect Kiss«, Pavillon Denon – Musée du Louvre, Paris
1976	»The Perfect Performance is to Stand Still«, ICC, Antwerpen
1977	»The Play of Death«, Dom-Hotel, Köln – »The First Totally Interrogative Philosophy«, Städtisches Museum, Mönchengladbach
1978	»The Perfect Kiss«, University Art Museum, Berkeley – »Hear Th in Ph around This Chair and It Knocks You Out«, Marian Goodman Gallery, New York – »The Exhibition of Perfect«, Kunsthalle Bern

1980 »The Exhibition of Perfect«, Busch-Reisinger Museum, Cambridge, Mass.

1981 Galerie Michael Werner, Köln – »The Classical Exhibition of to Be Quiet«, Galerie Helen van der Meij, Amsterdam

1982 Westfälischer Kunstverein, Münster

1983 Stedelijk Van Abbemuseum, Eindhoven

1984 Galerie Michael Werner, Köln – »The Death of James Lee Byars«, Philadelphia Museum of Art – »The Perfect Quiet«, Institute of Contemporary Art, Boston – Mary Boone Gallery, New York

1986 »Palast der Philosophie/The Philosophical Palace«, Kunsthalle Düsseldorf

1986/87 »Beauty Goes Avantgarde«, Galerie Michael Werner, Köln

1987 »Zeichnungen«, Galerie Fred Jahn, München – »The Letter Reading Society of James Lee Byars«, Galerie Marie-Puck Broodthaers, Bruxelles

1988 Mary Boone Gallery, New York – Hoffman Borman Gallery, Santa Monica

1989 »Monument to Cleopatra«, Cleto Polcina Arte Moderna, Roma – Mary Boone Gallery, New York – »The Palace of Good Luck«, Castello di Rivoli/Museo d'Arte Contemporanea, Torino – Galerie de France, Paris

1989/90 Galerie Michael Werner, Köln

1990 »The Perfect Thought«, University Art Museum, Berkeley/ Contemporary Arts Museum, Houston

1991 »The Path of Luck«, Michael Werner Gallery, New York/ Galerie Michael Werner, Köln

1992 »IS«, Vrej Baghoomian Gallery, New York – »The Human Figure«, Mary Boone Gallery, New York – »IS«, Galería La Máquina Española, Madrid – Magasin 3 Stockholm Konsthall – Fundación Alhambra, Granada – Galerie de France, Paris

1993 »Sonne, Mond und Sterne«, Württembergischer Kunstverein, Stuttgart – »The Red Angel«, Cirva, Marseille – »IS«, Mulier Gallery, Knokke-Heist – SCAI The Bathhouse, Shiraishi Contemporary Art, Tokyo – »Works from the Sixties and Recent Works«, Michael Werner Gallery, New York

1994 »The Perfect Love«, Laura Carpenter Fine Art, Santa Fe – »The Death of James Lee Byars«, Galerie Marie-Puck Broodthaers, Bruxelles

1994/95 »The Perfect Moment«, IVAM Valencia

1995/96 »Five Points Make a Man«, »The Moons and Constellations«, Michael Werner Gallery, New York – »The Monument to Language, The Diamond Floor«, Fondation Cartier pour l'art contemporain, Paris

1996 Henry Moore Institute, Leeds – Galerie Joan Prats, Barcelona – »The Angel«, Michael Werner Gallery, New York

1997 »The Palace of Perfect«, Fundação de Serralves, Porto

1998 The Arts Club of Chicago

1999 »The Epitaph of Con. Art is which Questions have disappeared?«, Kestner Gesellschaft Hannover

2000 »The Treasures of James Lee Byars«, Toyama Memorial Museum, Kawajima – »James Lee Byars, Briefe an Joseph Beuys«, Stiftung Museum Schloß Moyland, Bedburg-Hau/Museum van Heden-daagse Kunst, Antwerpen/Museum Fridericianum, Kassel – »perfect is my death word«, Maison Levanneur, Chatou – »James Lee Byars. Arbeiten von 1985 bis 1990«, Sabine Knust Maximilian Verlag, München – »The Poetic Conceit and Other Black Works«, Michael Werner Gallery, New York

2001 Galerie Er Rashid, Düsseldorf – »James Lee Byars. Letters to Joseph Beuys«, Museum für Kommunikation, Frankfurt am Main – »James Lee Byars. Works on Paper from the 1960s and 1990s and Sculpture from the 1990s«, Rhona Hoffman Gallery, Chicago – »James Lee Byars, Ephemera«, Low, Los Angeles

2002 »James Lee Byars, The Angel«, Timothy Taylor Gallery, London

2003 »The Moon Books, Above and Below«, Michael Werner Gallery, New York

2004 Devon Borden Hiram Butler Gallery, Houston – »James Lee Byars: Letters from the World's Most Famous Unknown Artist«, MassMOCA, North Adams, Mass.

Monografien und Kataloge zu Einzelausstellungen
Monographs and Catalogues of Solo Exhibitions

Ware Kunst: Eine Ausstellung mit einer Fotoserie von Benjamin Katz, mit dem 1. Selbstporträt von James Lee Byars, mit Bildern und Dokumenten, hrsg. von/ed. Hans Backes, Ausst.-Kat./exh. cat. Museum der Stadt Ratingen, 2002.

James Lee Byars. Letters to/Briefe an Joseph Beuys, Ausst.-Kat./exh. cat., hrsg. von/ed. Stiftung Museum Schloß Moyland – Sammlung van der Grinten – Joseph-Beuys-Archiv des Landes Nordrhein-Westfalen, Museum Schloß Moyland, Bedburg-Hau et al., Ostfildern-Ruit 2000.

The Treasures of James Lee Byars, Ausst.-Kat./exh. cat. Toyama Memorial Museum, Kawajima 2000.

Michely, Viola Maria: *Glück in der Kunst? Das Werk von James Lee Byars,* Berlin 1999.

Vierzehn Fotografien zu James Lee Byars 666, hrsg. von/ed. Erzbischöfliches Diözesanmuseum, Köln 1999.

James Lee Byars. THE EPITAPH OF CON. ART IS WHICH QUESTIONS HAVE DISAPPEARED?, hrsg. von/ed. Carl Haenlein, Ausst.-Kat./exh. cat. Kestner Gesellschaft, Hannover 1999.

James Lee Byars, Ausst.-Kat./exh. cat. The Arts Club of Chicago, 1998.

James Lee Byars. The Palace of Perfect, Ausst.-Kat./exh. cat. Fundação de Serralves, Porto 1997.

James Lee Byars im Gespräch mit Joachim Sartorius, Köln 1996.

James Lee Byars. What Is Question?, hrsg. von/ed. The Henry Moore Institute, Leeds 1996.

James Lee Byars, Ausst.-Kat./exh. cat. Artek Gallery, Helsinki 1995.

James Lee Byars. Perfect Is My Death Word: Bücher – Editionen – Ephemera, hrsg. von/ed. Guy Schraenen, Ausst.-Kat./exh. cat. Neues Museum Weserburg, Bremen 1995.

James Lee Byars. The Monument to Language. The Diamond Floor, hrsg. von/ed. Jean-Michel Ribettes, Ausst.-Kat./exh. cat. Fondation Cartier pour l'art contemporain, Paris 1995.

James Lee Byars. The Perfect Moment, Ausst.-Kat./exh. cat. IVAM Instituto Valenciano de Arte Moderno, Centre del Carme, Valencia 1995.

James Lee Byars, White Mass, Ausst.-Kat./exh. cat. Kunst-Station St. Peter, Köln 1995.

James Lee Byars: Works from the Sixties, Ausst.-Kat./exh. cat. Michael Werner Gallery, New York 1994.

James Lee Byars, Ausst.-Kat./exh. cat. Shiraishi Contemporary Art Inc., SCAI The Bathhouse, Tokyo 1993.

James Lee Byars, Ausst.-Kat./exh. cat. Magasin 3 Stockholm Konsthall, Stockholm 1992.

IS, James Lee Byars, Ausst.-Kat./exh. cat. Galería La Máquiña Española, Madrid 1992.

James Lee Byars: The Path of Luck, Ausst.-Kat./exh. cat. Michael Werner Gallery, New York 1991.

Elliott, James: *The Perfect Thought. Works by James Lee Byars,* Ausst.-Kat./exh. cat. University Art Museum, Berkeley, Contemporary Arts Museum, Houston, Berkeley 1990.

The Palace of Good Luck, hrsg. von/ed. Rudi Fuchs et al., Ausst.-Kat./exh. cat. Castello di Rivoli, Museo d'Arte Contemporanea, Torino 1989.

The Great James Lee Byars/The Letter Reading Society of James Lee Byars, Galerie des Beaux-Arts, Bruxelles 1987.

James Lee Byars: Beauty Goes Avantgarde, Ausst.-Kat./exh. cat. Galerie Michael Werner, Köln 1987.

James Lee Byars: The Philosophical Palace/Palast der Philosophie, hrsg. von/ ed. Jürgen Harten, Ausst.-Kat./exh. cat. Kunsthalle Düsseldorf, 1986.

James Lee Byars, Ausst.-Kat./exh. cat. Stedelijk Van Abbemuseum, Eindhoven 1983.

James Lee Byars, Ausst.-Kat./exh. cat. ARC, Musée d'Art moderne de la Ville de Paris, 1983.

James Lee Byars im Westfälischen Kunstverein, Ausst.-Kat./exh. cat. Westfälischer Kunstverein, Münster 1982.

James Lee Byars. The White Book, hrsg. von/ed. James Butler, Los Angeles 1980.

James Lee Byars: The Perfect Whisper Is to Nothing, Ausst.-Kat./exh. cat. Kunstmuseum Bern, 1978.

James Lee Byars: TH FI TO IN PH, Ausst.-Kat./exh. cat. Städtisches Museum, Mönchengladbach 1977.

James Lee Byars, Extra Terrestrial, Ausst.-Kat./exh. cat. ICC, Antwerpen 1976.

James Lee Byars: The Golden Tower, Ausst.-Kat./exh. cat. DAAD-Galerie, Galerie Rudolf Springer, Berlin 1974.

James Lee Byars, 100 000. Ausst.-Kat./exh. cat. Wide White Space, Antwerpen 1969.

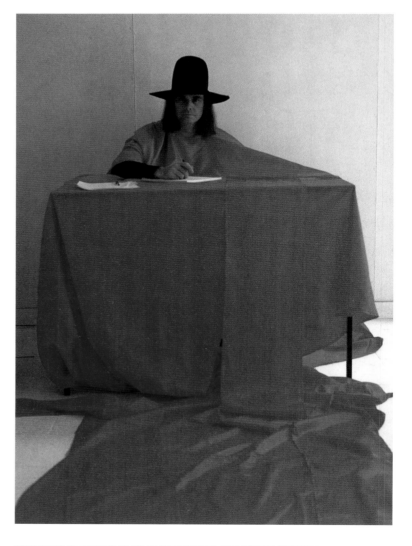

1000 MINUTES OF ATTENTION OR 1/2 AN AUTOBIOGRAPHY **1000 MINUTEN AUFMERKSAMKEIT ODER EINE HALBE AUTOBIOGRAFIE** PERFORMANCE WIDE WHITE SPACE, ANTWERP **ANTWERPEN** 1969

Ausgewählte Aufsätze
Selected Articles

Ottmann, Klaus: »The Art of Happenstance: The Performative Sculptures of James Lee Byars«, in: *Sculpture* (November 2002): 32–37.

Rubinyi, Kati: »James Lee Byars's Performable Objects«, in: *X-tra* 5, 2 (2002): 2–11.

Lischka, Gerhard Johann: »100 Momente. Auflösung des Werks im Akt der Präsentation. Ein Report aus 25 Jahren mit James Lee Byars«, in: *Kunstforum International* 152 (2000): 229–239.

Michely, Viola: »Tod als Performance? James Lee Byars oder es lebe die performative Kraft der Kunst«, in: *Kunstforum International* 152 (2000): 105–119.

Köhler, Stephan: »James Lee Byars: The Guardian of Virtues«, http://www.jointadventures.org/byars/jameslee.htm.

McEvilley, Thomas: »Johnny Wakes«, in: *Artforum* (September 1997): 9–10.

Power, Kevin: »James Lee Byars«, in: *Third Text* 39 (1997): 108–110.

Hickey, Dave: »James Lee Byars: Just Make Me Up«, in: *Flash Art* 177 (1994): 86–90.

Ottmann, Klaus: »James Lee Byars: A Master Thief of Time«, in: *Flash Art* 147 (1989): 141.

Pagel, David: »James Lee Byars«, in: *Arts* (September 1988): 89.

Speck, Reiner: »The Perfect Tear«, in: *Durch* 5 (1988): 67–70.

Deecke, Thomas: »James Lee Byars – The Philosophical Palace«, in: *Artefactum* 17 (1987): 13–15.

McEvilley, Thomas: »More Golden than Gold«, in: *Artforum* (November 1987): 92–97.

Ottmann, Klaus: »The World According to ... Byars, Beuys, Dokoupil«, in: *Flash Art* 125 (1985/86): 55–56.

Taylor, Paul: »An Interview with James Lee Byars«, in: *Flash Art* 125 (1985/86): 57.

Groot, Paul: »James Lee Byars«, *Flash Art* 115 (1984): 40–41.

Johnen, Jörg: »James Lee Byars«, in: *Kunstforum International* 44/45 (1981): 308–310.

McEvilley, Thomas: »James Lee Byars and the Atmosphere of Question«, in: *Artforum* (November 1981): 50–55.

Deecke, Thomas: »James Lee Byars. Die Idee – ein goldener Turm – eine Idee«, in: *Kunstmagazin* 19, 1 (1979): 40.

Ruhrberg, Karl: »Das goldene Mundstück – Monografie – James Lee Byars«, in: *Kunstmagazin* 19, 1 (1979): 46–47.

Junker, Howard: »James Lee Byars: Performance as Protective Coloration«, in: *Art in America* (November 1978): 109–113.

Szeemann, Harald: »James Lee Byars, New York«, in: *Das Werk* 62, 6 (1975): 580.

Szeemann, Harald: »James Lee Byars«, in: *Chroniques de l'Art Vivant* 40 (1973): 16–17.

Glueck, Grace: »A Mile of Red Acetate Parades Up 65th Street«, in: *The New York Times* (13. Dezember 1968/December 13, 1968).

DANK DES KURATORS
CURATORIAL ACKNOWLEDGMENTS

1988 erreichte mich ein Telefonanruf von James Lee Byars, mit dem er auf den kurzen Text reagierte, den ich für das Kunstmagazin *Flash Art* über seine Arbeit verfasst hatte. Auf ein erstes Treffen folgten zahlreiche weitere, einige zufällig, andere geplant, immer aber in den Lobbys eleganter Hotels oder anlässlich einer seiner Ausstellungen. Diese Treffen endeten unvermeidlich in einem Ritual: James Lee Byars überreichte mir einen oder mehrere geheimnisvolle schwarze Umschläge, die verschlossen waren. Jeder von ihnen enthielt winzige Schriftstücke, dünne Fasern aus Gold oder auch Selbstporträts aus kleinen Brotkugeln. Die Begegnungen bedeuteten für mich den Beginn einer ständig wachsenden Faszination, Werk und Person James Lee Byars' betreffend, die letztendlich Grundlage dieser Ausstellung ist, hiermit aber keinesfalls ein Ende gefunden haben wird.

Die Organisation dieser Ausstellung und die damit verbundene fünf Jahre andauernde Recherche, die mich nach Europa, Japan und quer durch die Vereinigten Staaten von Amerika führte, hätte nicht ohne die Mitwirkung anderer Beteiligter erfolgen können. Ich bin besonders Gwendolyn Dunaway, Byars' Frau, und Michael Werner, seinem langjährigen Galeristen, für die Großzügigkeit und Begeisterung dankbar, mit der sie meine Arbeit unterstützten; ebenso Max Hollein, dem Direktor der Schirn Kunsthalle, für seine Einladung, die Ausstellung in Frankfurt am Main zu realisieren.

Bei der Entwicklung dieses Projektes war darüber hinaus die Unterstützung durch folgende Personen von unschätzbarer Bedeutung: Gordon VeneKlasen und Jason Duval, Michael Werner Gallery, New York; Ilonca Mrosek und Iris Poßegger, Galerie Michael Werner, Köln; Koichi Toyama, Toyama Memorial Museum, Kawajima, Japan; Masahiro Aoki, Toyota Municipal Museum of Art, Toyota City, Japan; Thomas Deecke, Neues Museum Weserburg Bremen; Michelle Elligott und Eve Lambert, The Museum of Modern Art Archives, New York; Callie Angell, Whitney Museum of American Art, New York; Thomas C. Padon, American Federation of Arts, New York; Sara Seagull und Larry Miller,

In 1988 I received a phone call from James Lee Byars after he had read a short text I wrote about his work for *Flash Art* magazine. Numerous meetings followed, some fortuitous, others planned, always in elegant hotels lobbies or in one his exhibitions. These encounters inevitably ended in the ritual of his handing over to me one or several mysterious, sealed black envelopes, each containing miniscule bits of writing, thin strands of gold, or self-portraits made out of rolled-up bread. For me it was the beginning of an ever-growing fascination with the artist and man James Lee Byars, which has resulted in but will not end with this exhibition.

The task of organizing this exhibition and the five-years of research into Byars's life and work, which took me to Europe, Japan, and across the United States, could not have been possible without the collaboration and help of others. I am especially grateful to the generosity and enthusiasm of Byars's wife, Gwendolyn Dunaway, to Michael Werner, his longtime dealer, and to Max Hollein, director of the Schirn Kunsthalle, for inviting me to originate the exhibition in Frankfurt.

Throughout the development of this project the following individuals have been a source of invaluable support: Gordon VeneKlasen and Jason Duval, Michael Werner Gallery, New York; Ilonca Mrosek and Iris Possegger, Galerie Michael Werner, Cologne; Koichi Toyama, Toyama Memorial Museum, Kawajima, Japan; Masahiro Aoki, Toyota Municipal Museum of Art, Toyota City, Japan; Thomas Deecke, Neues Museum Weserburg Bremen; Michelle Elligott and Eve Lambert, The Museum of Modern Art Archives, New York; Callie Angell, Whitney Museum of American Art, New York; Thomas C. Padon, American Federation of Arts, New York; Sara Seagull and Larry Miller, Robert Watts Studio Archive, New York; Carsten Ahrens, Kestner Gesellschaft, Hanover; Steve Bell, Santa Fe Storage & Transfer Co., Inc.; Julie Baranes; Marie-Puck Broodthaers; Murray Gell-Mann; Robin Kaye Goodman; Brigitte Horstmann; Miani Johnson; Stephan Koehler; Robert Landsman; Viola Michely; Barbara Moore; Yvonne Rainer; Jean-Michel Ribette; Dr. Reiner Speck; Kunié Sugiura; and Mako Wakasa.

Robert Watts Studio Archive, New York; Carsten Ahrens, Kestner Gesellschaft, Hannover; Steve Bell, Santa Fe Storage & Transfer Co., Inc.; Julie Baranes; Marie-Puck Broodthaers; Murray Gell-Mann; Robin Kaye Goodman; Brigitte Horstmann; Miani Johnson; Stephan Koehler; Robert Landsman; Viola Michely; Barbara Moore; Yvonne Rainer; Jean-Michel Ribette; Dr. Reiner Speck; Kunié Sugiura; und Mako Wakasa.

Ich möchte allen Leihgeberinnen und Leihgebern dieser Ausstellung meine tiefste Dankbarkeit ausdrücken. Für ihre Hilfe bei der Präsentation der Ausstellung in der Schirn Kunsthalle Frankfurt, beim Lektorat und der Herausgabe des die Ausstellung begleitenden Kataloges möchte ich besonders der Kuratorin Martina Weinhart und Carla Orthen als wissenschaftlicher Volontärin danken. Es war eine Freude, wieder mit dem Hatje Cantz Verlag zu arbeiten; ich danke besonders Markus Hartmann, der bereits zu Beginn meiner Recherchen an einer Publikation über Byars Interesse zeigte, sowie Annette Kulenkampff und den Lektoren des Kataloges, Tas Skorupa und Christiane Wagner. Nicht zuletzt schulde ich meiner Frau, Leslie Tonkonow, großen Dank, für ihre Sachkenntnis und den gedankenvollen Rat bei der Recherche und Verwirklichung dieses Kataloges.

Klaus Ottmann

I would like to express my deepest gratitude to all the lenders to the exhibition. For their help with the presentation of the exhibition at the Schirn Kunsthalle Frankfurt and with the editing and publication of its accompanying catalogue, I would especially like to thank curator Martina Weinhart and curatorial assistant Carla Orthen. It has been a pleasure once again to work with Hatje Cantz Publishers; I especially thank Markus Hartmann who expressed interest in a publication on Byars already at the very beginning of my research, as well as Annette Kulenkampff and the copy editors of the catalogue, Tas Skorupa and Christiane Wagner. Lastly, as always, I owe a great debt of thanks to my wife, Leslie Tonkonow, for her expertise and thoughtful advice during the research and writing of this catalogue.

Klaus Ottmann

FOTONACHWEIS
PHOTO CREDITS

Peter Accettola: S. / p. 62

Shigeo Anzai: S. / pp. 21, 132

Flor Bex: S. / pp. 152

George Bylik: S. / p. 135

J. Fliegner: S. / pp. 83, 89, 103

Yves Gevaert: S. / pp. 50, 122

Thomas Hesterberg: S. / p. 142

Heyne, Neusüss / Pfaffe: S. / p. 14

Manfred Jade: S. / pp. 46, 117

Dave Olsen (Courtesy Robert Watts Studio Archive, NYC): S. / p. 23

Klaus Ottmann: S. / pp. 42, 55, 63

Heinz Preute: S. / p. 91

Ralph-B. Quinke: S. / p. 124

Bernhard Schaub: S. / pp. 75, 79

Lothar Schnepf: S. / pp. 26, 30, 36, 37, 41, 54, 57, 59, 61, 65, 66, 67, 69, 70, 73, 77, 78, 80, 81, 85, 87, 95, 97, 98, 99, 101, 105, 107, 109, 111, 112, 113, 115, 119, 120, 123, 126, 129, 133, 134, 138, 142

Diese Publikation erscheint anlässlich der Ausstellung
»Leben, Liebe und Tod: Das Werk von James Lee Byars«.
This catalogue is published in conjunction with the exhibition
Life, Love, and Death: The Work of James Lee Byars.
Schirn Kunsthalle Frankfurt **13. Mai – 18. Juli 2004** 13 May–18 July 2004

Herausgeber Editors
Klaus Ottmann, Max Hollein

Redaktion Coeditor
Martina Weinhart

Redaktionsassistenz Editing Assistance
Carla Orthen

Verlagslektorat Copyediting
Christiane Wagner (**Deutsch** German), Tas Skorupa (**Englisch** English)

Übersetzungen Translations
Steven Lindberg, Brigitte Horstmann

Grafische Gestaltung und Herstellung Graphic Design and Production
white.room productions, New York

Reproduktion Reproduction
Produktionsservice Stroucken

Gesamtherstellung Printed by
Dr. Cantz'sche Druckerei, Ostfildern-Ruit

© 2004 Hatje Cantz Verlag, Ostfildern-Ruit, **und Autoren** and authors
© 2004 **für die abgebildeten Werke von** for the reproduced works by
James Lee Byars: Estate James Lee Byars. Courtesy Galerie Michael Werner,
Köln/New York

Erschienen im Published by
Hatje Cantz Verlag
Senefelderstraße 12
73760 Ostfildern-Ruit
Deutschland / Germany
Tel. +49 711 440 50
Fax +49 711 440 52 20
www.hatjecantz.de

Hatje Cantz books are available internationally at selected bookstores and
from the following distribution partners:

USA/North America – D.A.P., Distributed Art Publishers, New York,
www.artbook.com
France – Interart, Paris, interart.paris@wanadoo.fr
UK – Art Books International, London, sales@art-bks.com
Belgium – Exhibitions International, Leuven, www.exhibitionsinternational.de
Australia – Towerbooks, French Forest (Sydney), towerbks@zipworld.com.au

For Asia, Japan, South America, and Africa, as well as for general questions,
please contact Hatje Cantz directly at sales@hatjecantz.de or visit our
homepage www.hatjecantz.com for further information.

ISBN 3-7757-1368-9

Printed in Germany

Umschlagabbildung Cover illustration
Ausschnitt aus Detail from *The Rose Table of Perfect,* 1989
(**Kat**. cat. XXIX)

Gravity Probe B, sitting atop a rocket at Vandenberg Air Force Base in California . . . is to be launched into orbit next Monday on an 18-month mission . . . By all accounts the experiment . . . is a technical tour de force. At its heart, isolated as much as possible from the universe, are the gyroscopes: four quartz spheres slightly larger than golf balls. They are said to be the most perfectly spherical objects ever made by humans—out of round by only 40 layers of atoms.
(*The New York Times*, April 13, 2004)

WHAT'S ABOVE PERFECT